Secret Cities
The Haunted Beauty

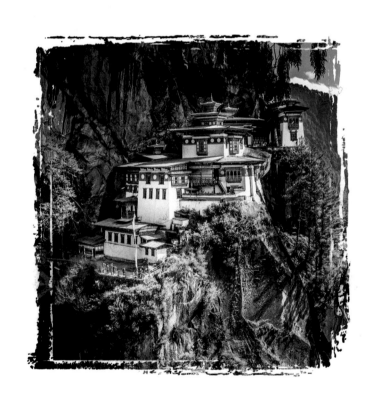

Publisher and Creative Director: Nick Wells
Commissioning Editor and Picture Research: Polly Prior
Senior Project Editor: Catherine Taylor
Art Director & Layout Design: Mike Spender
Digital Design and Production: Chris Herbert
Copy Editor: Anna Groves
Proofreader: Amanda Crook
Indexer: Helen Snaith
Special thanks to: Aïsha Diomandé and Taylor Bentley

FLAME TREE PUBLISHING
6 Melbray Mews
Fulham, London SW6 3NS
United Kingdom

www.flametreepublishing.com

First published 2018

18 20 22 21 19
1 3 5 7 9 10 8 6 4 2

Image Credits: Courtesy of **Shutterstock.com** and © the following: 1 & 20 Chr. Offenberg; 3 & 98, 81, 109 Fotokon; 6 Donatas Dabravolskas; 12 Andreas
Juergensmeier; 15 Yury Birukov; 19 Georgios Tsichlis; 22 Alf Manciagli; 23 picattos; 24 Horizonman; 31, 36 Everett Historical; 40 Arseniy Kotov; 50 Maxim
Tupikov; 52 Dominic Dudley; 54 Josef Hanus; 54 Truba7113; 60 Jon Bilous; 61 Grand Warszawski; 63 varandah; 65 Sean Pavone; 66 Jakrit Jiraratwaro; 69
Fabian Plock; 70 Costa Fernandes; 71 Marco Richter; 73 StevenK; 74 godrick; 78 isa_ozdere; 80 Nina Lishchuk; 82 Grisha Burev; 86 Pictureguy; 96 FrimuFilms;
97 & back cover Kanuman; 110 ALEXEY KOIMSHIDI; 111 Gilmanshin; 113 Cherry-hai; 117 Anze Furlan; 118 A_Lesik; 122 Mikhail Sidorov; 126 IURII BURIAK ;
131 JMitchellPhotog ; 132 Daboost; 138 Claude Huot; 140 Alexander Erdbeer; 141 MintImages; 147 Nordroden; 150 Max Forgues; 152 Vadim Nefedoff; 157
demamiel62 ; 158 Katiekk; 159 Graeme Snow; 161 Anibal Trejo; 162 StephanScherhag; 163 Aleksandra H. Kossowska; 167, 168 DemarK; 169 trevor kittelty;
171 ederica Violin; 172 cpaulfell; 173 dinosmichail ; 174 Sophie James; 175 LIUSHENGFILM ; 176 emperorcosar; 178 Tupungato; 180 Evan Austen ; 182
pikselstock; 183 Parshina Marina; 185 Seqoya; 187 eiqianbao; 188 Julia Panchyzhna; 192 & 93 David M Zavala. Courtesy of **Getty Images** and © the following:
4 & 181, 184 Yann Arthus-Bertrand; 10 gionnixxx/E+; 16 Insights/Universal Images Group; 17 Nigel Pavitt/AWL Images; 27 Corbis Historical; 28 Los Alamos
National Laboratory/The LIFE Picture Collection; 30 Galerie Bilderwelt/Hulton Archive; 32 Ted Soqui/Corbis Historical; 34 Walter Bibikow/AWL Images; 35 Opla/
iStock/Getty Images Plus; 37 DOE/The LIFE Picture Collection; 39 DigitalGlobe/ScapeWare3d; 43 Sergei Fadeichev/TASS; 44 John van Hasselt/Corbis Historical;
46 VIKTOR DRACHEV/AFP; 57 Christopher Furlong/Getty Images News; 62 Leber/ullstein bild; 72 Frank Bienewald/LightRocket; 76 Raffaele Nicolussi (www.
MadGrin.com)/Moment; 84 vofpalabra/iStock Editorial/Getty Images Plus; 85 DEA/M. SANTINI/DeAgostini; 89 Brian Vander Brug/Los Angeles Times; 92 Jeff
Greenberg/Universal Images Group; 94 Andrew Watson/AWL Images; 99 Travis Dove/The Boston Globe; 100 Keith Myers/Kansas City Star/MCT/Tribune News
Service; 101 Michele Limina/Bloomberg; 105 Alex Wong/Getty Images News; 107 & front cover Pictorial Parade/Archive Photos; 115 Bryan Chan/Los Angeles
Times; 136 Paul Williams - Funkystock/imageBROKER; 139 Geoff Renner/robertharding; 143 JODY AMIET/AFP; 144, 154, 155 Johnny Haglund/Lonely Planet
Images; 146 Amos Chapple/Lonely Planet Images; 164 George Steinmetz/Corbis Documentary ; 179 Jason Vigneron/Moment. © **Rex/Shutterstock** and the
following: 67; 29 ZUMA; 32 Jim Lo Scalzo; 33 George Frey/Epa; 53 Granger; 58 hwo/imageBROKER; 90 Alys Tomlinson/Shutterstock; 102 Kerstin Langenberger/
imageBROKER; 106, 107 Jamie Wiseman/Associated Newspapers; 123 Sipa Press; 135 Michael Runkel/robertharding; 151 Design Pics Inc; 170 Richey Miller/
CSM; © **Li Yang**: 47, 48. © **Holger.Ellgaard**/Wikimedia Commons/CC-BY-SA 4.0: 121. © **Stephen Alvarez/National Geographic Creative**: 134.

ISBN: 978-1-78664-796-2

Printed in Hong Kong

Secret Cities
The Haunted Beauty

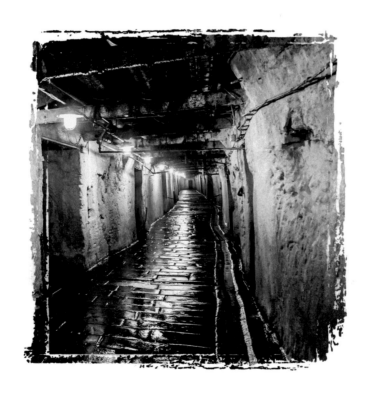

Julian Beecroft

FLAME TREE
PUBLISHING

Contents

Introduction

Humans are the most inquisitive creatures. It's been the key to our success as a species, but it's a blessing that is also a curse. We now have access to knowledge like never before in history, yet still our ignorance haunts us. In fact, the limitless resources available online, far from assuaging our hunger, have made more of us more curious about the world than ever before, enticing and tormenting us with what we don't yet know, or what we feel we're not being told.

Below: Rio de Janeiro favela, Brazil – such habitations can exist cheek-by-jowl with wealthy residential areas, but may as well be invisible to those who live in the latter.

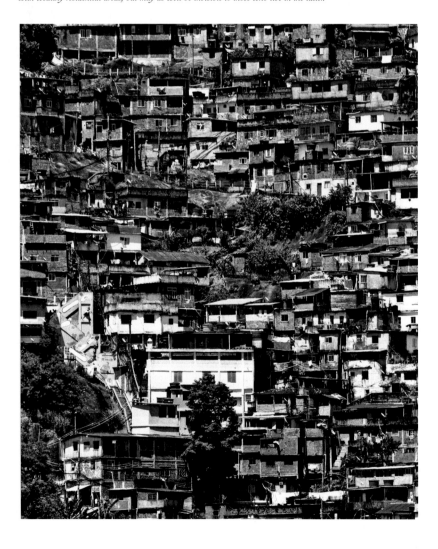

The Age of Conspiracy

We might suspect governments or immoral corporations of running secret experiments with intentions that are not in the public interest. The exponential rise of conspiracy theories in recent times betrays the fears of millions – fears of a kind that are eagerly exploited by the snake-oil sellers of populist politics – that what ought to worry us is kept secret by those with something to hide. Given the secrecy that cloaks places such as Area 51 in Nevada or the closed cities of the former Soviet Union, it's hardly surprising that we long to know what goes on there that requires such clear concealment.

The Global Village

If curiosity drives us, then the accompanying urge to tell has been enabled in ever more elaborate ways. What we now call the communications revolution is at the heart of the radical changes in the way we live that have taken place over the past two centuries. The train, the steamship, the telephone, the aeroplane, radio and television have helped spread people and knowledge across the planet at accelerating speeds. The advent of mass long-haul flights in the 1970s made it possible to reach almost anywhere on Earth within a day's journey, and now virtual access to anywhere we choose is near instantaneous through the worldwide web.

The global reach implicit in the name gulls us into thinking that nothing should be secret, that our basic rights extend to knowing whatever we want to know, as mostly they do. In the age of apparent openness and global exchange the internet has brought with it, the idea that anywhere should not be accessible to us seems almost an infringement of those rights. What's more, any community that declines to be part of the global village, with its fickle public gaze, is dismissed as insular – even backward – in an age of borderless markets.

The Secluded Life

For many groups, however, like the monastic communities which throughout history have lived separate from the rest of society, seclusion is or has often been a positive choice. For those still officially uncontacted tribes in the Amazon rainforest, or the Sentinelese of the Andaman and Nicobar Islands in the Indian Ocean, history tells us that any contact with the outside world is likely to endanger their way of life. Not for them the mantra of progress and improvement when they have lived successfully and in harmony with their surroundings since time before memory. Outsiders are entranced, and possibly envious, that people still live this way, so apparently contented that they remain oblivious to our interest while we look on, perhaps longing for a simpler life that seems beyond our power to achieve.

European adventurers whose efforts revealed so many civilizations previously unknown to European nations, took a hard-headed view of the societies they found, looting or destroying so much of the evidence and bending the conquered peoples to their will. Today, the haunted ruins of Incan cities secreted among verdant mountains for hundreds of years, are again reoccupied, tramped upon by thousands of tourists drawn by the mystique of lost civilizations, their celebrity spread through millions of near-identical images across the wastes of social media and websites like TripAdvisor, exciting our compulsion to see them and tick them off our lists.

At the Court of the Great Khan

The secret's long been out about places like Peru's Machu Picchu or Petra in Jordan – ancient cities which lay hidden, forgotten, for hundreds of years after being abandoned by those who built them. But even in cities like these which are now so familiar, there is a sense of drama – a mystical marriage of history, topography and aesthetics – by which it is hard not to be impressed. Images of these places now form part of the collective consciousness of

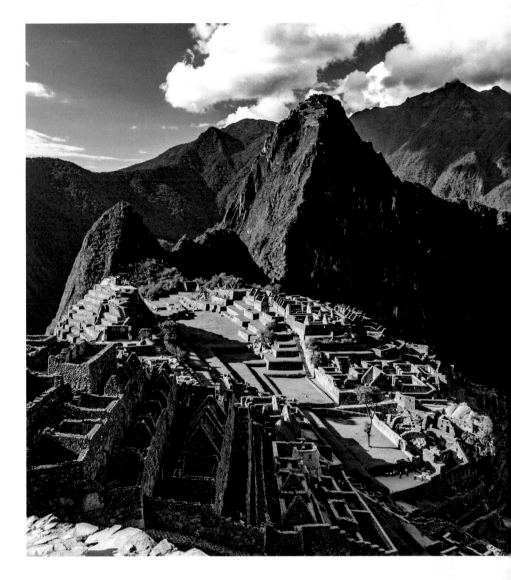

Above: *Machu Picchu, Peru.*

an interconnected world, filling us with the same insatiable hunger for knowledge suffered by the great Kublai Khan in Italo Calvino's novel *Invisible Cities* (1972).

The novel takes the form of a dialogue between Khan and the explorer Marco Polo, the Venetian traveller, who, having journeyed through Asia to the court of the great Mongol emperor, is charged to give an account of the places he has seen, the far-flung settlements of a vast empire, much of which Khan has never set eyes on himself. The cities Polo describes are places whose architectural

wonders embody the fears and desires of those who have built them, their implausible plans and impossible constructions reflecting a sense of purpose that appears both utterly impractical and perfectly suited to their needs. Then at one point in Calvino's book we learn that the endlessly various places of which the traveller tells are in fact concealed descriptions of the rich potential of a single self-contained site – that most arcane of all cities, Polo's hometown of Venice.

Cities of the Mind

The remarkable settlements that appear in this book are in their own way as rich and as startling as the fantastical creations of Calvino's Venetian traveller: cities we may not have imagined were there or had not imagined could ever exist; cities that by most practical measures have no right to be there, yet defy the worst of conditions and even thrive; cities that cling on grimly when for the sake of their inhabitants they should have been abandoned years ago. And there are also cities we might have daydreamed into being had they not already been there for hundreds of years, as well as those whose existence rekindles our hopes of a better way of life.

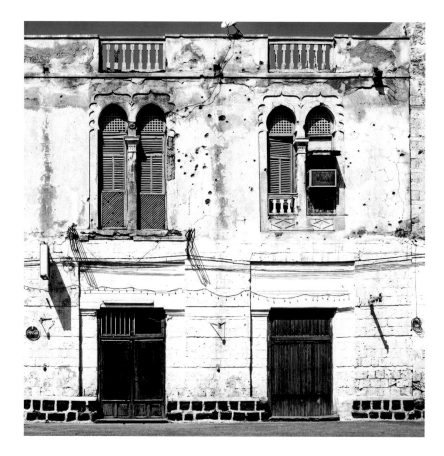

Above: Massawa, Eritrea. Eritrea is notoriously challenging to visit, and obtaining a visa can take months.

The Secret Society

But if these marvellous places remain secret merely because we have yet to find them, with others access is deliberately restricted. Countries such as Eritrea and Equatorial Guinea are extremely difficult for foreigners to visit, while in some places religion is the bar, as in the case of Mecca, the holiest city in Islam, which non-Muslims are forbidden to enter. But while these places have a direct policy to prevent outsiders getting in, some have closed their borders to stop the movement of people going the other way – the reality for several decades for so many citizens of nations in the former Soviet Empire. And sometimes such places are built with the idea of secrecy baked in to the basic concept, when activities that take place there have such lethal potential that they are hidden from public view.

Life Underground

Such secret programmes can be so dangerous, indeed, that they are concealed below ground in labyrinthine cities, though these are far from the first societies to take to subterranean living. In fact, since long before recorded history, people have sought refuge in the Earth's dark places, mostly in networks of caves which in some cases spread out for miles. Today, people still choose to live in remarkable cave villages like Guadix in southern Spain or Meymand in Iran.

Of course, as time went by, improvements in technology made it easier to build strong defensive structures like castles or forts, though still there were times when the only option was to dive underground or be killed. In the same vein, in the past century, as well as hiding offensive capacity,

subterranean complexes have been vital to governments needing to maintain essential functions in time of war. And similar locations have also played host for hundreds of years to commercial activities of all kinds, offering shelter from a hostile climate or from the prying eyes of the law.

The Pursuit of a Vision

These places, while hidden, are usually temporary havens close enough to the centres of culture above ground. And in a world with nigh on eight billion people, it is hard to believe that anywhere now is hard to get to. Yet it is only a few hundred years since almost everywhere on the planet was remote, when to any traveller most of the places they came across would be a discovery, being previously unknown to them. Marco Polo could have written what he liked about the places he saw on his travels and no one in

thirteenth-century Venice would have been any the wiser. Indeed, some early examples of travel writing, such as the fantastical *Travels of Sir John Mandeville* from a century later, are largely works of fiction accepted at the time as fact.

Over recent centuries, technological advances that Polo would have marvelled at have helped people explore places in the world's most distant corners, and led many to settle in areas where living conditions seem challenging to say the least. These settlements epitomize the stubborn ingenuity of human beings, our ability to realize improbable, even reckless dreams, doing battle with our environment and making peace with it in turn, pursuing a still more miraculous vision that is only a secret to those who have yet to see it.

Below: The people of Guadix in Andalucia, Spain, have lived in these white-washed cave houses for centuries. Offering welcome respite from the summer heat, the houses' turreted chimneys poking out of the rock suggest they are also cosy places in winter.

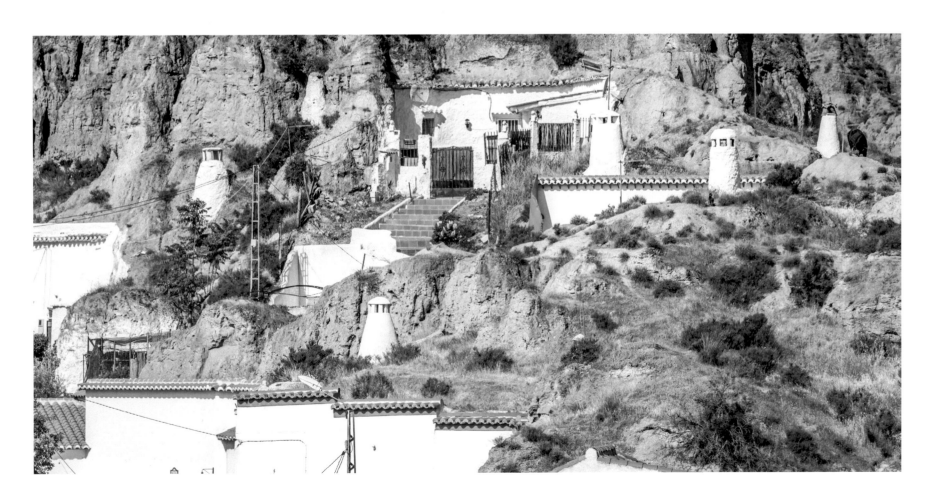

Forbidden Cities

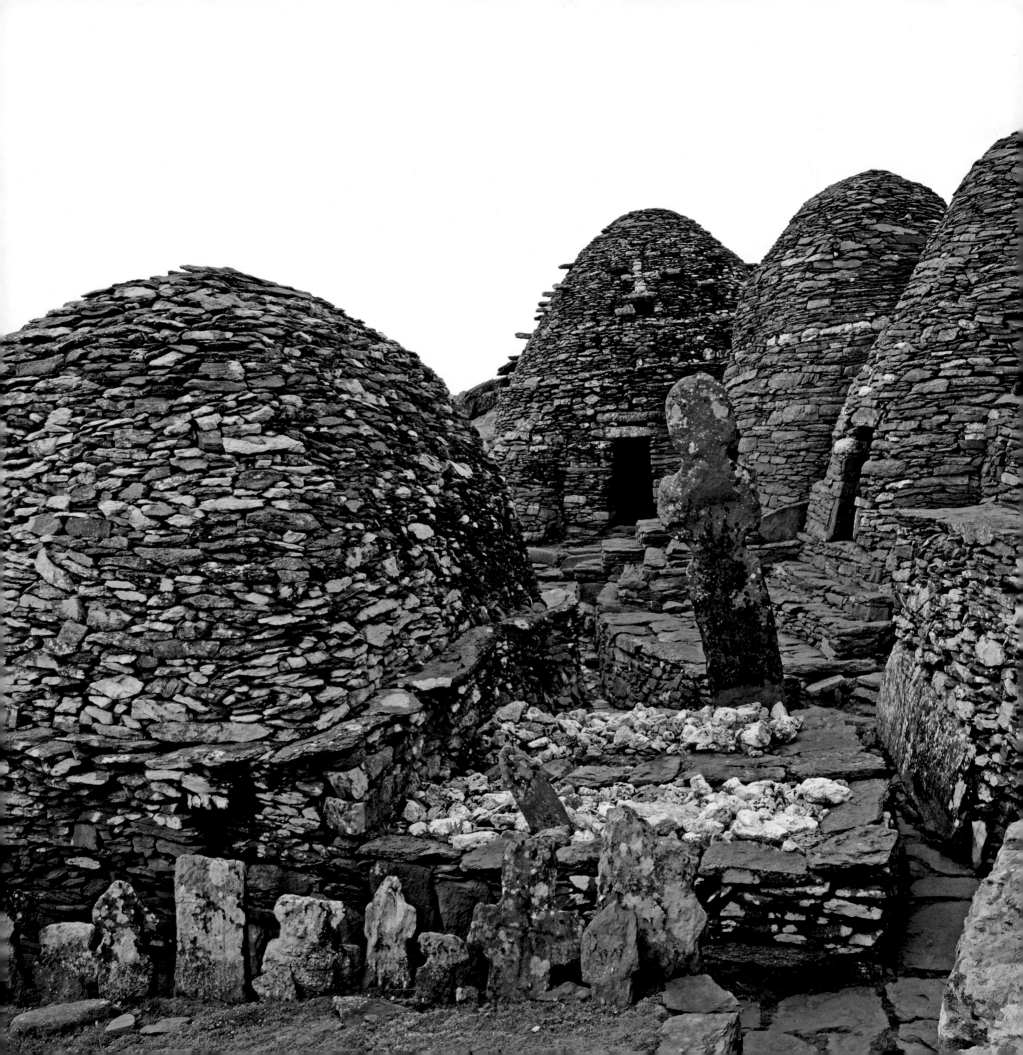

Monastic Cities

Humans are a social species but for millennia religious ascetics, either singly or in monastic groups, have opted to live apart from the ordinary world in pursuit of an extraordinary truth.

The Beehive Cells of Skellig Michael

Fans of the recent *Star Wars* movie will now be familiar with the towering rocky island where Luke Skywalker, the ageing hero of the earlier films, has settled to try to escape the past. In reality, the monastic cells of Skellig Michael were built by sixth-century monks who chose this remote and forbidding island off the south-west coast of the Irish Republic to be closer to God. Celtic Ireland was by then already among the most Christian places on Earth, but these monks sought even greater solitude on a rocky coastal island to help them forget the world.

Of the many island-based monastic communities around the British and Irish coasts, such as Iona off the west coast of Scotland or Lindisfarne off the coast of Northumbria, Skellig Michael is the most dramatically sited, perched on a cliff some 180 metres (590 feet) above the raging Atlantic Ocean. In terms of ascetic self-denial it had much to recommend it, and must rank among the most forbidding places ever inhabited by human beings. Yet, like the seabirds that nest in the cliffs, the monks practised safety in numbers, as the half dozen beehive cells would have housed a small community of holy men, each one seeking personal salvation in collective isolation, their thoughts turned inwards to Augustine's City of God.

Previous page: *Badain Jaran Temple, China.*
Left: *The island of Skellig Michael off County Kerry, Ireland.*

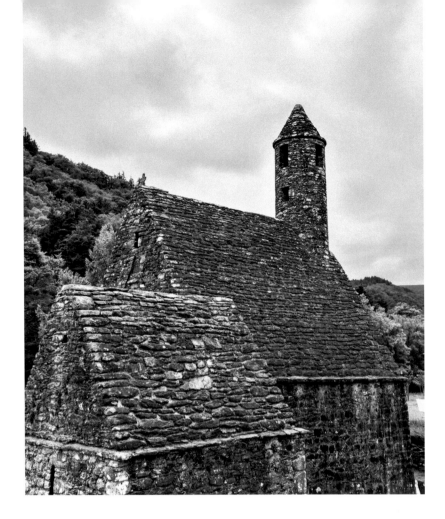

Above: On the outer edge of the early Christian world, Ireland was still among its most important centres when the monastery of Glendalough in County Wicklow was founded by the hermit St Kevin in the mid-sixth century.

The Hermit Caves of the Bahitawi

The town of Lalibela in northern Ethiopia is famous for its 11 rock churches, some built perhaps as early as the seventh century. Hewn from the same igneous rocky landscape in which they stand, they appear almost in camouflage and give the impression of having been deliberately hidden, though there is no reason to think they were. Christianity in the country goes back to the time of the Desert Fathers, the determined group of hermits who rejected the institution of the early Church and its ties to Rome, and instead took to places in the Egyptian desert. Wadi El-Natrun was one such settlement and today is still home to several of the tens of monasteries that once thrived

Right: The carved rock Church of St George in Lalibela, Ethiopia.

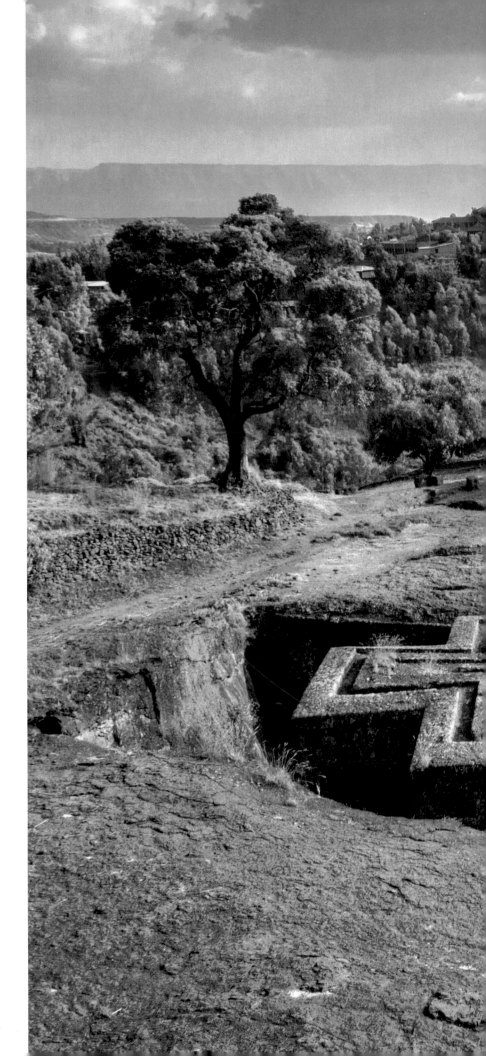

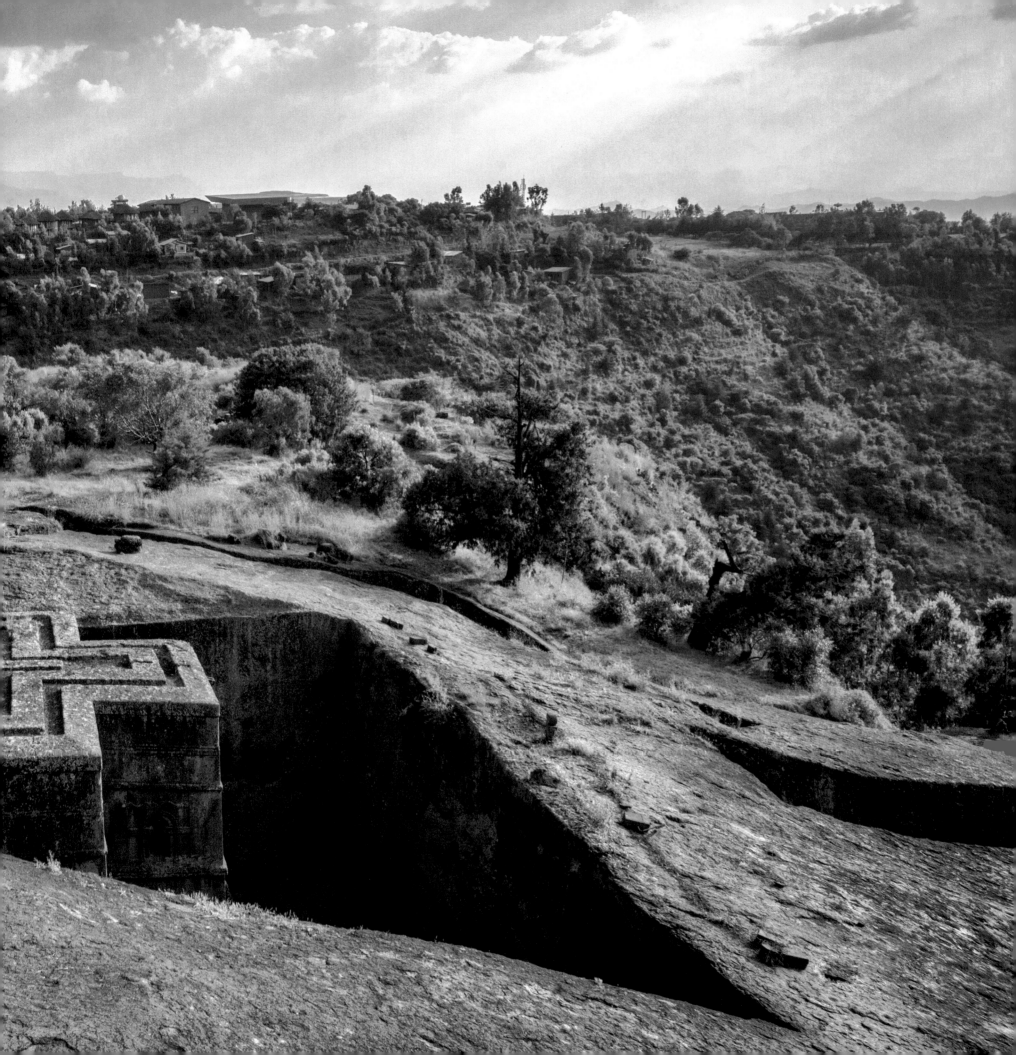

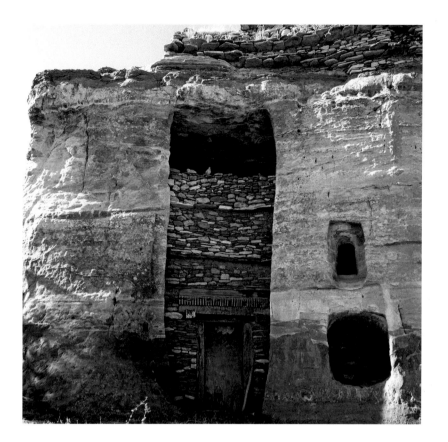

Above: Cave church, Tigray Province, Ethiopia.

in the area. Inspired by the example of St Anthony, before long thousands of hermits had followed him into the wilderness, leading Athanasius of Alexandria, Anthony's fourth-century biographer, to describe the desert as 'like a city', so many hermits had populated that desolate landscape.

In the same spirit, in modern Ethiopia a group of anchorites called the Bahitawi, looking to the example of John the Baptist, continue to renounce the world, observing the same ascetic life as the original Desert Fathers. Their caves in the Gheralta Mountains are barely large enough for a grown man to crouch in. The churches in the rock are somewhat bigger and frequently decorated with colourful frescoes proclaiming the strength of their faith.

Left: Walls of St Mary Coptic Orthodox Monastery (also known as the Syrian Monastery or Deir El-Sourian), Wadi El-Natrun, Egypt.

The Mountain Monasteries of Northern Greece

In the Orthodox faith of Greece, monastics have also sought the solace of mountains. In the middle of a large plain in the north of the country, a series of huge rock pillars rise impressively, making them an ideal place of retreat, as they have been now for more than a thousand years. Beginning with solitary hermits in the ninth century, eventually 24 monasteries were built at Meteora, the Greek name translating as 'suspended in the air'. Sited precariously on the tops of these limestone rocks, the six that remain today are visited by tourists of all kinds.

Access to the monastic enclave of Mount Athos, however, at the eastern tip of the Chalkidiki peninsula, is still heavily restricted – first by forbidding any women or children to access the territory, and then by allowing only a limited number of men to enter on any given day. Comprising a monastic state constitutionally separate from the Greek Republic and with special status under EU law, the Christian communities of Mount Athos are the oldest in Greece. The early hermits established the first Sketes, or monastic settlements, in the area at the time of the Desert Fathers some 17 centuries ago. Today there are 20 monasteries, some of them huge complexes like small cities overhanging the sea, with a total population of some 2,000 people in the most recent estimate.

The Cave City of Bamiyan

If ascetics no longer inhabit the caves in the mountains overlooking the fertile valley of Bamiyan in central Afghanistan, in recent decades these cliff dwellings have found a second use for people with reason to be grateful

Right: *Meteora monasteries, Greece.*
Next page: *The Tiger's Nest Monastery, high on a cliff in the upper Paro valley in Bhutan, is built around a cave where the saint Padmasambhava, the founder of Buddhism in Bhutan and Tibet, is said to have meditated for more than three years.*

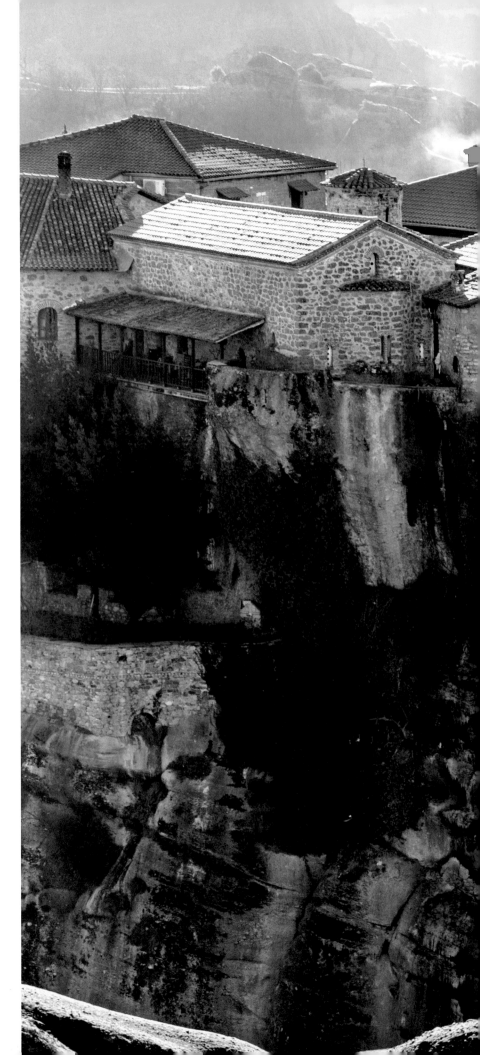

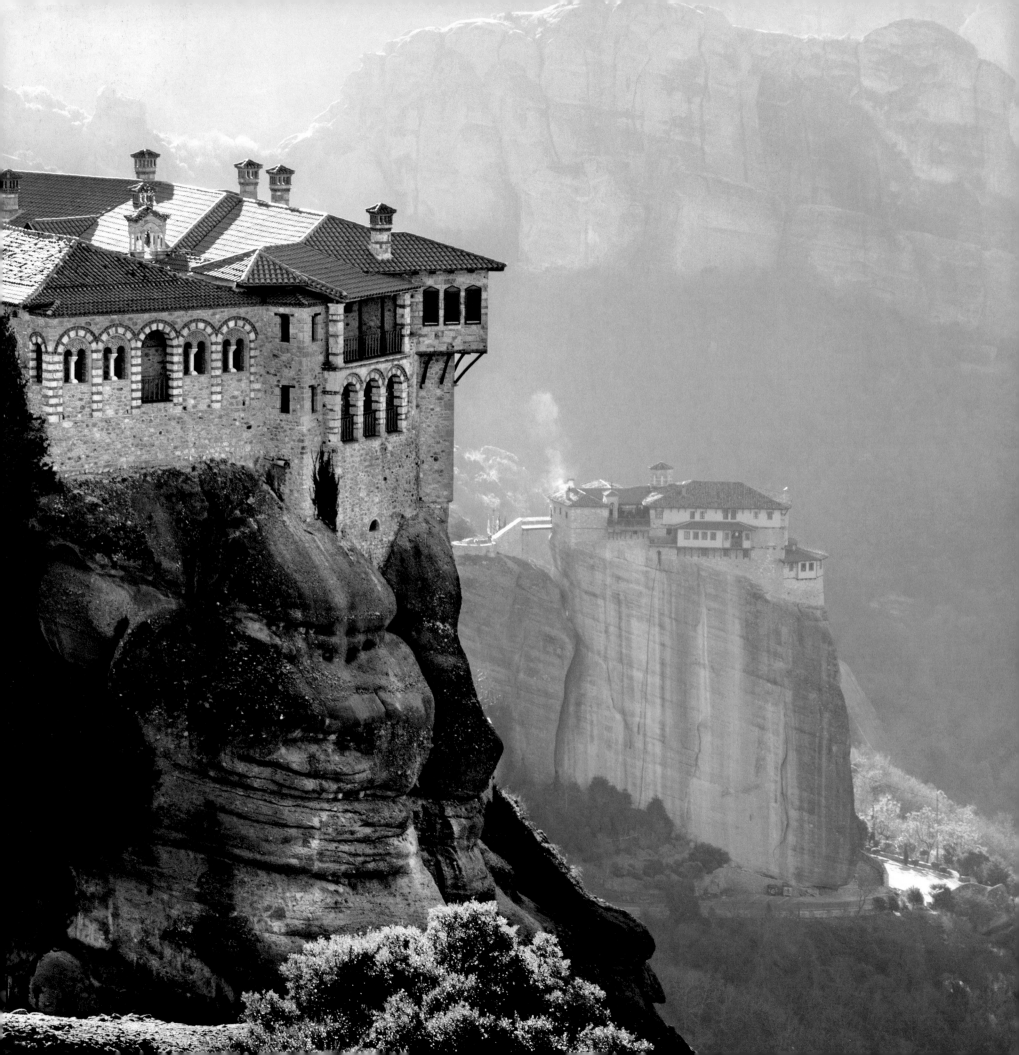

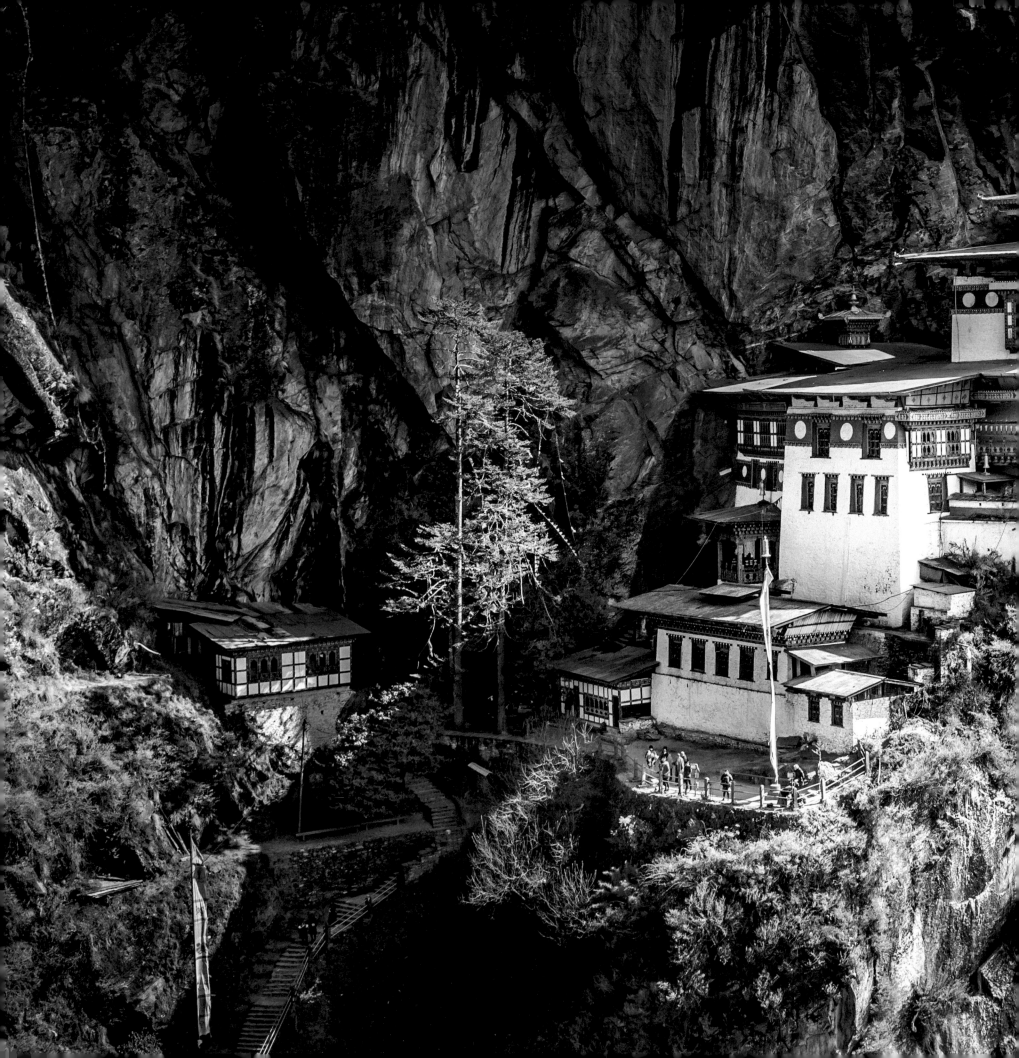

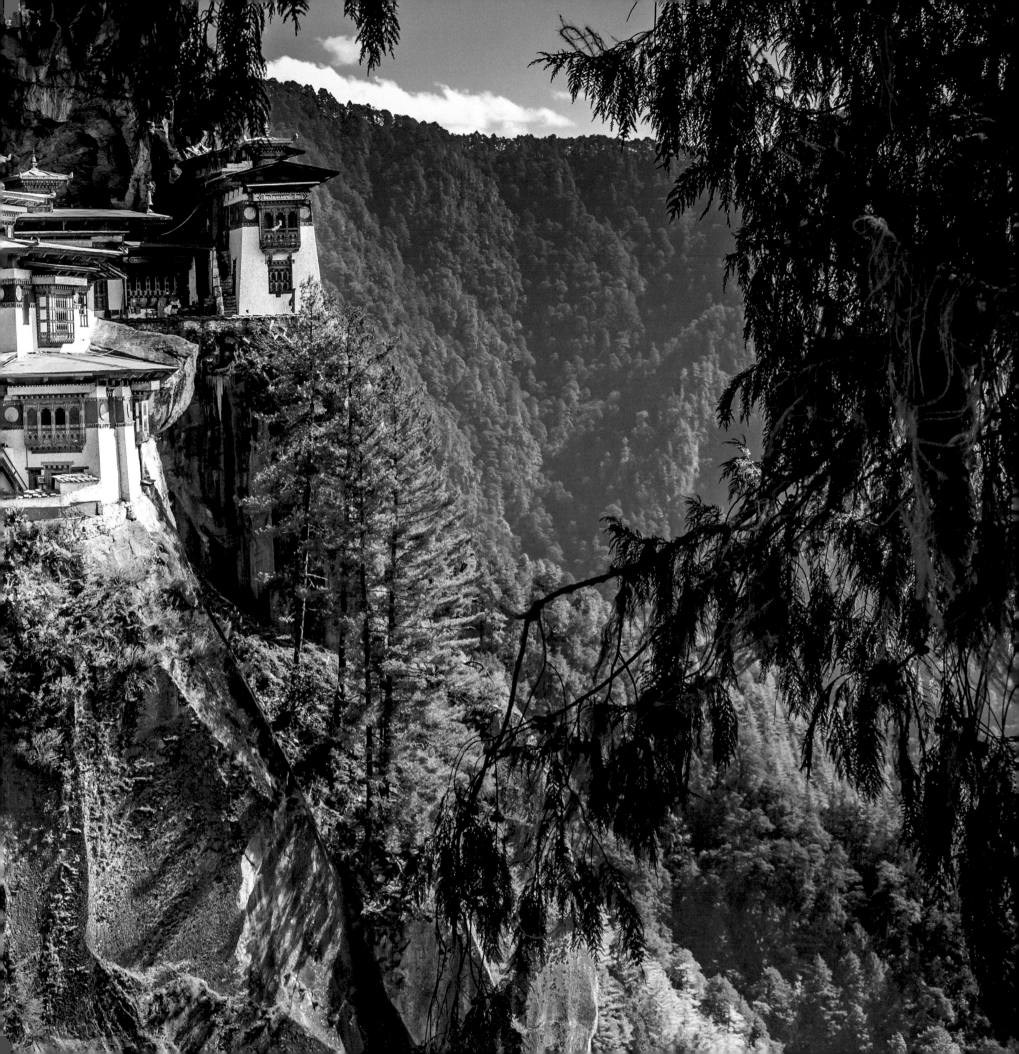

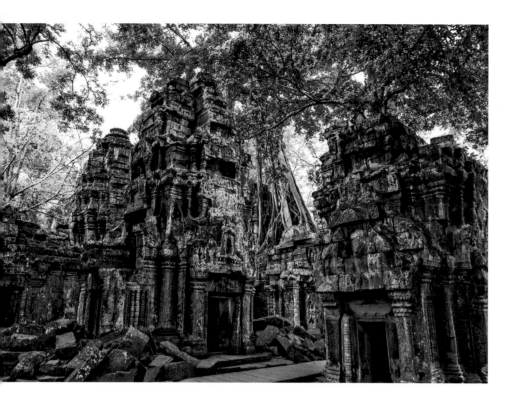

Above: Famous today for the intermingling of nature and architecture, as if each has grown out of the other, the temple of Ta Prohm was founded in 1186 in the vast city of Angkor, the ancient capital of the Khmer.

to those who made them. Once home to what must have been one of the largest monastic communities anywhere in the world during its heyday some 1,500 years ago, the 12,000 caves that pockmark the rock face surround two gaping wounds where the giant Buddhas of Bamiyan once stood, before the Taliban blew them up in 2001. Shortly after this gross desecration, the caves began to be inhabited once again by poor families from the Shiite minority who had come to work on the arable farms of this fertile valley.

Then a few years ago the Afghan government decided to restore the famous Buddhas and clear out the caves to attract the foreign tourists who would offer such a boost to the coffers of this troubled country. By this point hundreds of families were eking out a life in this one-time secret city, living in caves whose ceilings are sometimes decorated with ancient Buddhist frescoes that will

Right: The cave city of Bamiyan, where the monumental buddhas once stood.

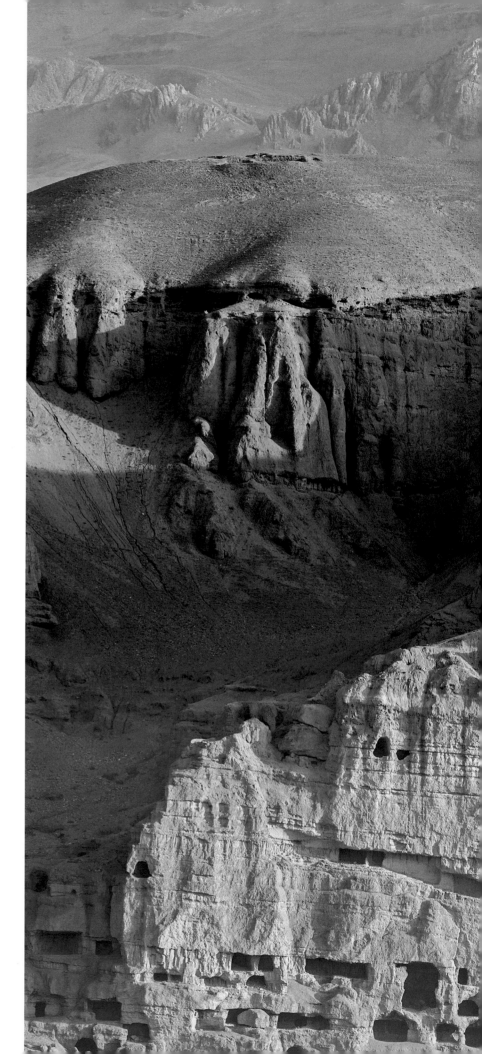

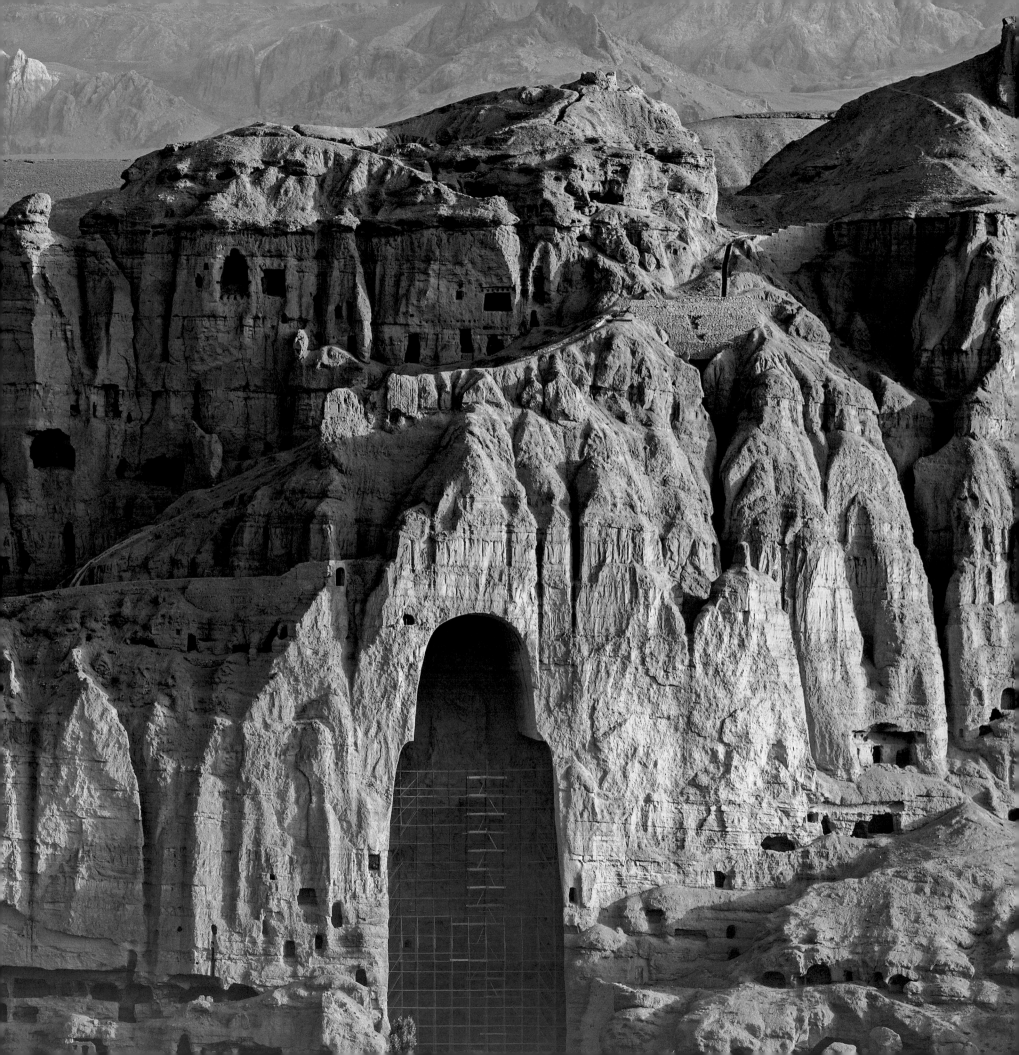

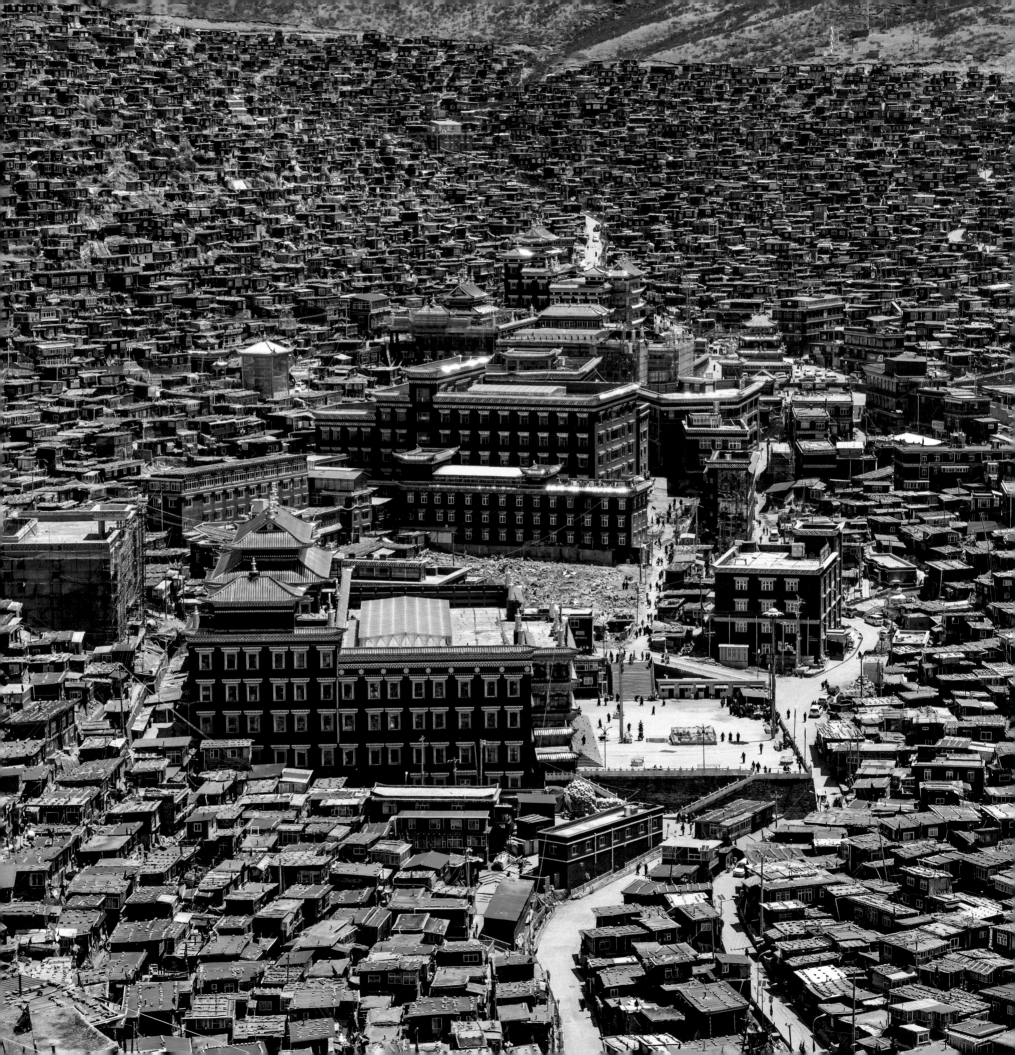

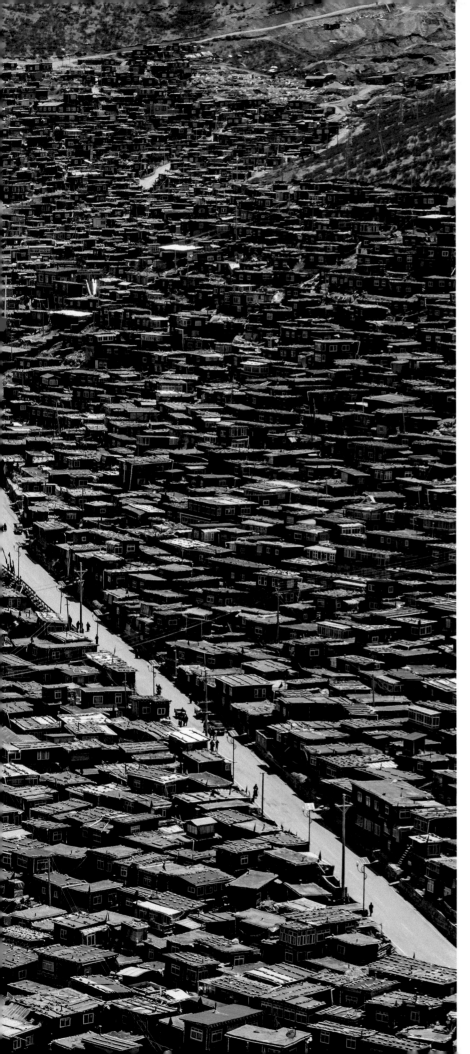

also be restored. The Afghan government has promised the families modern accommodation in nearby towns, which will surely be preferable to these holes in the rock. Whether those new dwellings will still offer shelter for people who may need it one thousand years from now, is another matter altogether.

The Monastic City of Larung Gar

Since its full annexation of Tibet in 1959, the Chinese government, following a strongly Marxist conception of history, has ruthlessly targeted the unique Buddhist culture of the country, most of whose thousands of ancient monasteries were destroyed during the Cultural Revolution of 1966–76. More recently, under the guise of development, a high-speed railway has been built across the Tibetan plateau to link the capital, Lhasa, with western China. In the name of such progress ethnic Chinese in large numbers have been settled in Tibet to accelerate the gradual dissolution of its culture. Religious freedom is officially tolerated but on terms strictly defined by the Chinese government; it is an offence even to possess an image of His Holiness the Fourteenth Dalai Lama, the spiritual leader of the Tibetan people.

Given these conditions, the existence of the monastic city of Larung Gar in Sichuan province, what used to be eastern Tibet, seems a remarkable anomaly. In all likelihood the world's largest monastic community, the city has grown in recent decades to some 40,000 monks and nuns, all living singly in small cabins clustered in multitudinous hordes on the hills surrounding the monastery on the floor of the Larung Valley. But the Chinese authorities, alarmed at the strength and independence of this spiritual community, and citing public health concerns, have recently given orders to tear down most of the dwellings, to reduce the population of the city to a tenth of its current size. It is thought that tourists will then be encouraged to visit the new, improved city to gain state-approved insights into Tibetan Buddhist culture.

Left: Larung Gar Buddhist Academy in Sichuan, China.

Out of Bounds in the Land of the Free

Societies with the most to hide are sometimes the most apparently open of all. Beginning in the Second World War and throughout the Cold War, the USA established military bases all over the country whose existence was a total secret.

PO Box 1663, New Mexico

By the latter years of the Second World War, the delivery drivers were getting suspicious at the amount of goods being ordered by the large family at PO Box 1663. At this point, the number of people living at the top-secret town behind that unassuming postcode – Los Alamos in New Mexico – exceeded 5,000 in total. Established in late 1942, the year after the USA joined the war, the Los Alamos Laboratory, headed by J. Robert Oppenheimer, was a key site in a network of secret institutions across the United States, all involved in different aspects of the Manhattan Project, which would lead to the making of the first atomic bomb.

Also known cryptically as 'Site Y', Los Alamos was only 56 kilometres northwest of Santa Fe but, situated atop four adjacent mesas, or table-top mountains, it was effectively in the middle of nowhere. Already the site of a ranch school with several dozen buildings, its existing residents were sworn to secrecy and anyone arriving to work there before the end of the war was not allowed to disclose anything about the place or the project,

Right: Los Alamos Checkpoint in New Mexico, USA.

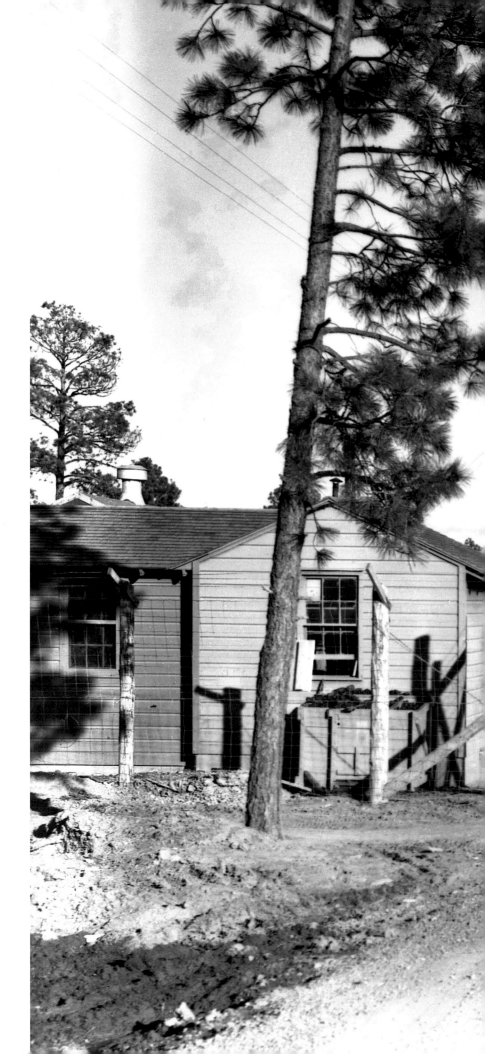

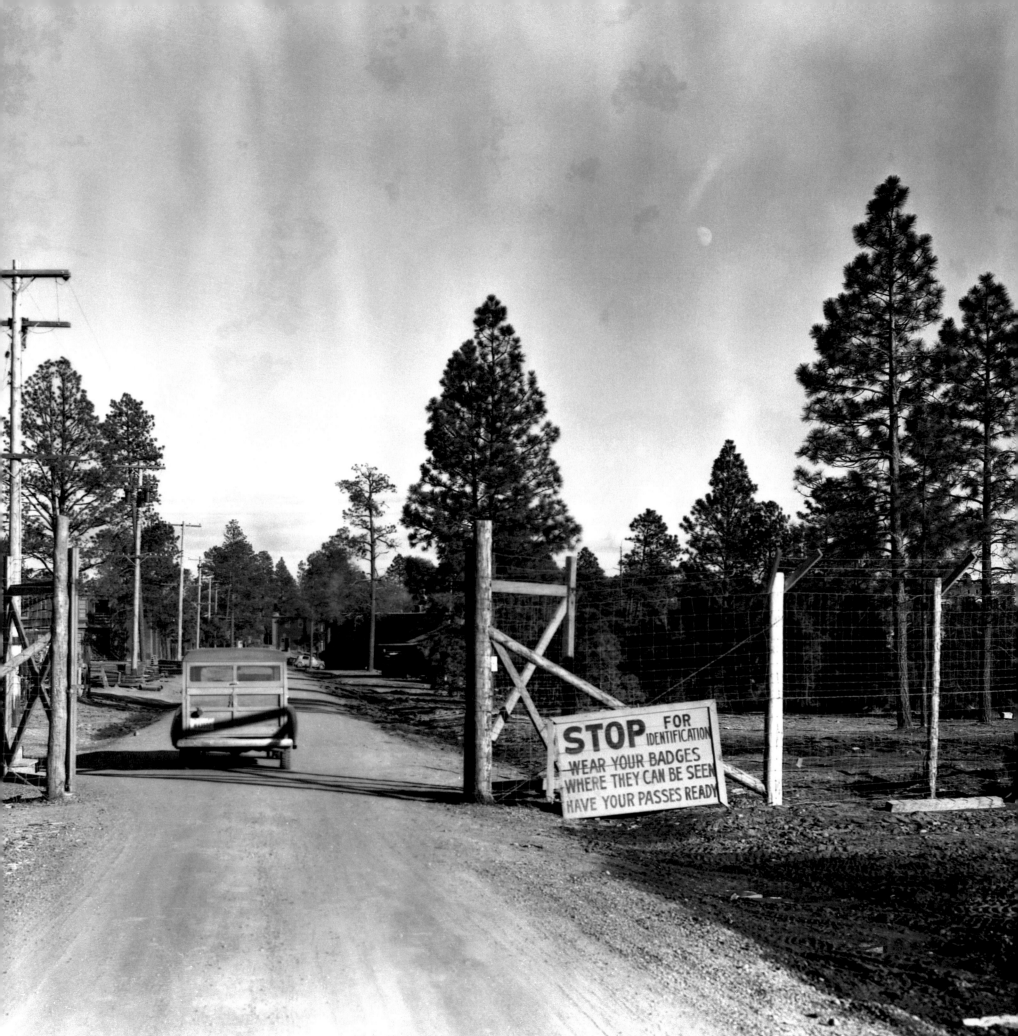

STOP FOR IDENTIFICATION
WEAR YOUR BADGES
WHERE THEY CAN BE SEEN
HAVE YOUR PASSES READY

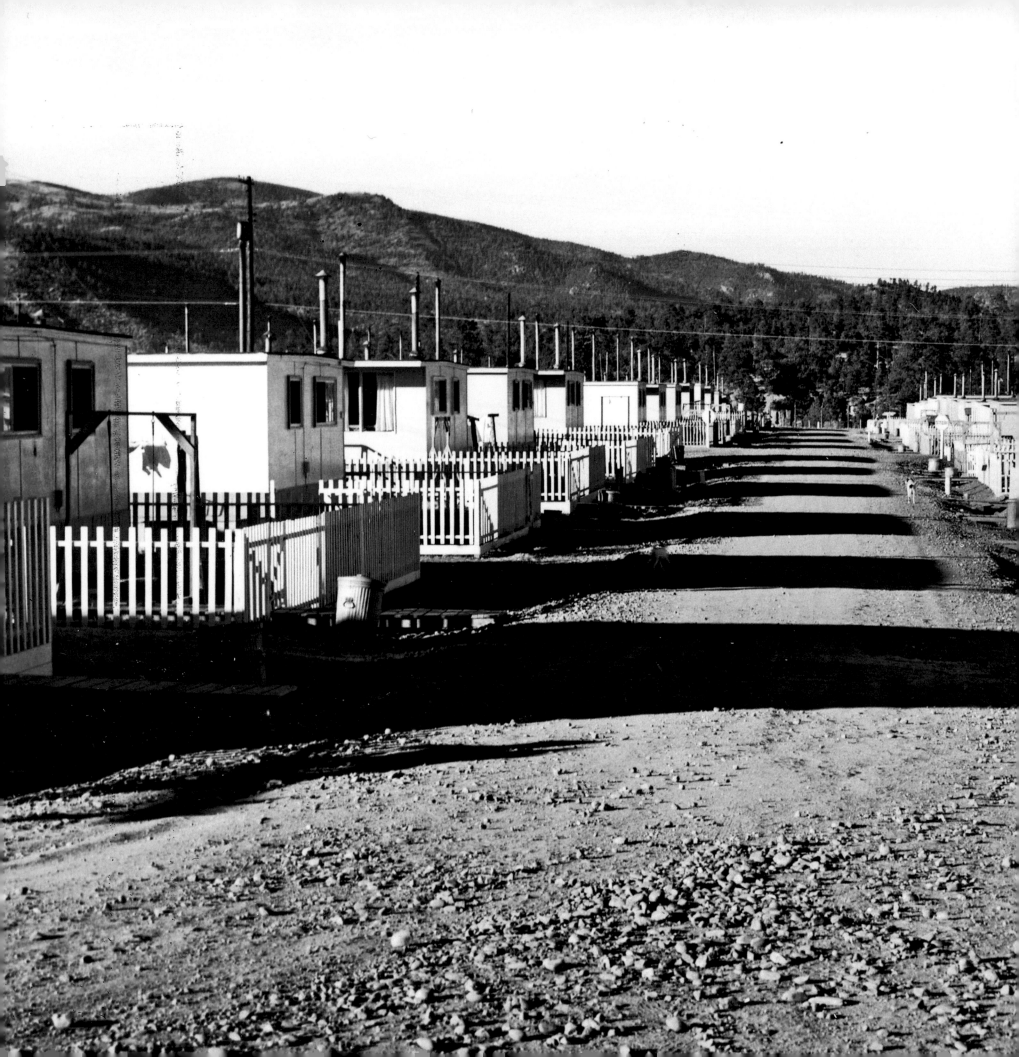

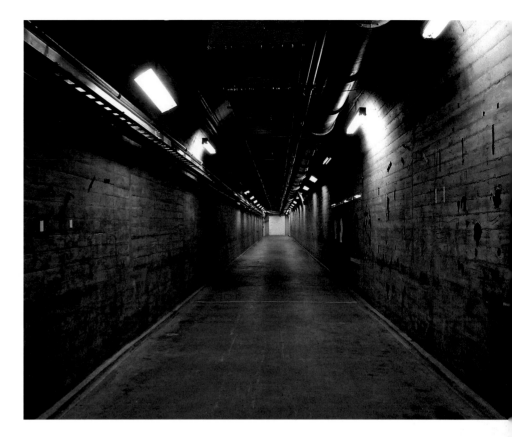

Above: Looking down the 70-metre (230-foot) tunnel to the entrance to the vault room at TA-41, Los Alamos, USA. In the late 1940s to the early 1950s, trucks would back into the tunnel and unload components.

even to their loved ones. Los Alamos did not appear on any maps made during the period and was known only by that anonymous postcode, while Oppenheimer and his team were busy creating the apocalyptic weapon that would usher in the Atomic Age.

A Jerry-built Town In Tennessee

If keeping the whereabouts of Los Alamos a secret was a challenge, then preventing any one of the resident workers of Oak Ridge, Tennessee – some 75,000 by 1945 – from letting slip what they knew should have been harder still. But the authorities revealed so little that it seems no one who worked

Left: Simple housing for the workers involved in the Manhattan Project, Los Alamos, USA.

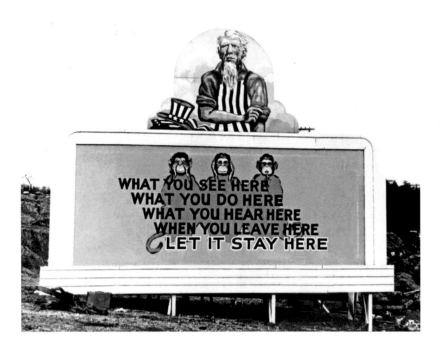

Above: A billboard posted in Oak Ridge, Tennessee, USA.

there grasped the true purpose of what they were doing until the dropping of the atomic bombs on Hiroshima and Nagasaki in August of that year.

The area was sparsely populated when, in 1942, the US government decided that this remote part of Tennessee had all the topographical attributes needed for building four plants, and sufficient housing for their workers, to develop materials for use in the ultimate weapon. The few farmers who lived thereabouts were soon resettled and buildings went up with the kind of speed only possible in wartime Meanwhile the huge production plants – a pilot plant housing a graphite reactor to produce plutonium and three dedicated to enriching uranium – were quickly erected and fitted out in a valley a short distance from the town. As many amenities as possible were provided in the straitened circumstances of the war, but inevitably with such a rapid growth in population, it was never a well-appointed place.

Right: The mile-long K-25 gaseous diffusion plant at Oak Ridge, Tennessee, part of the Manhattan Project to produce an atomic bomb, was the biggest building in the world at the time it was constructed in 1943.

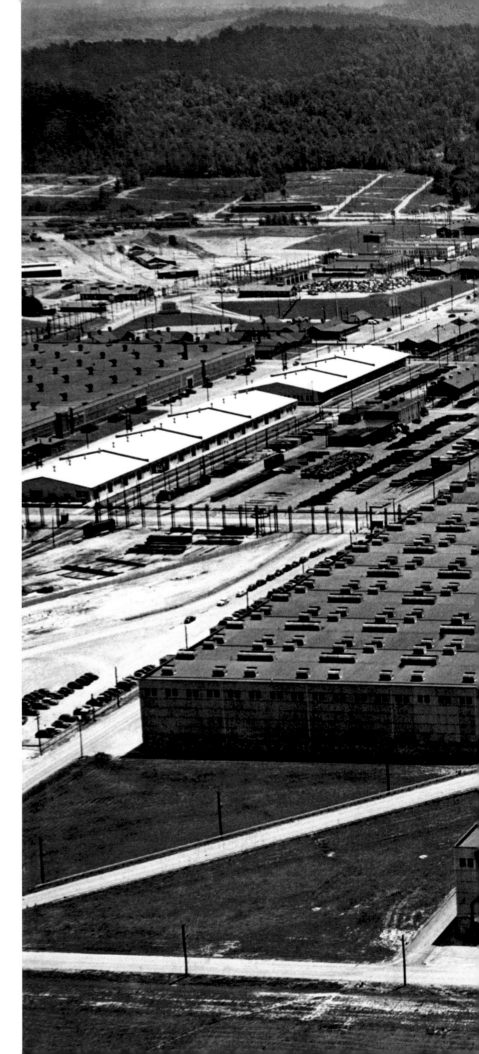

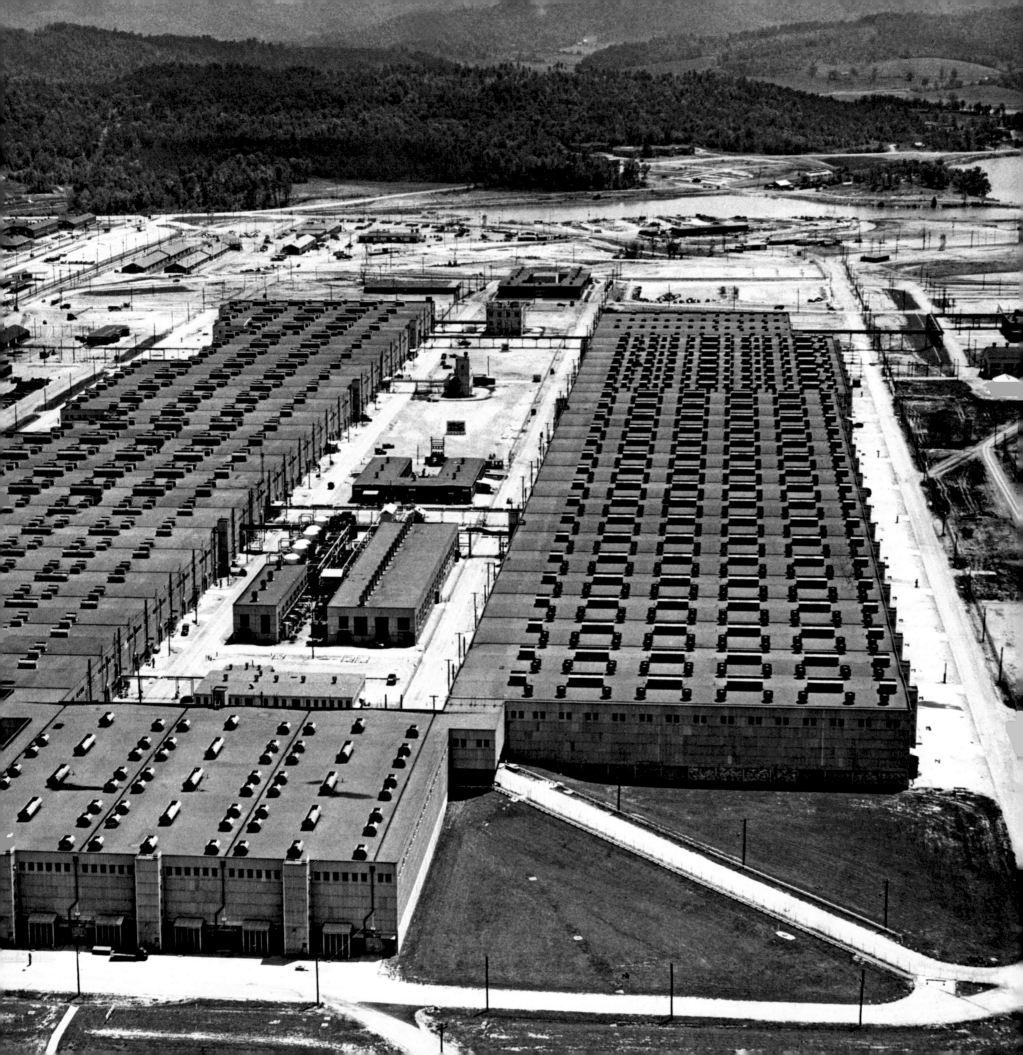

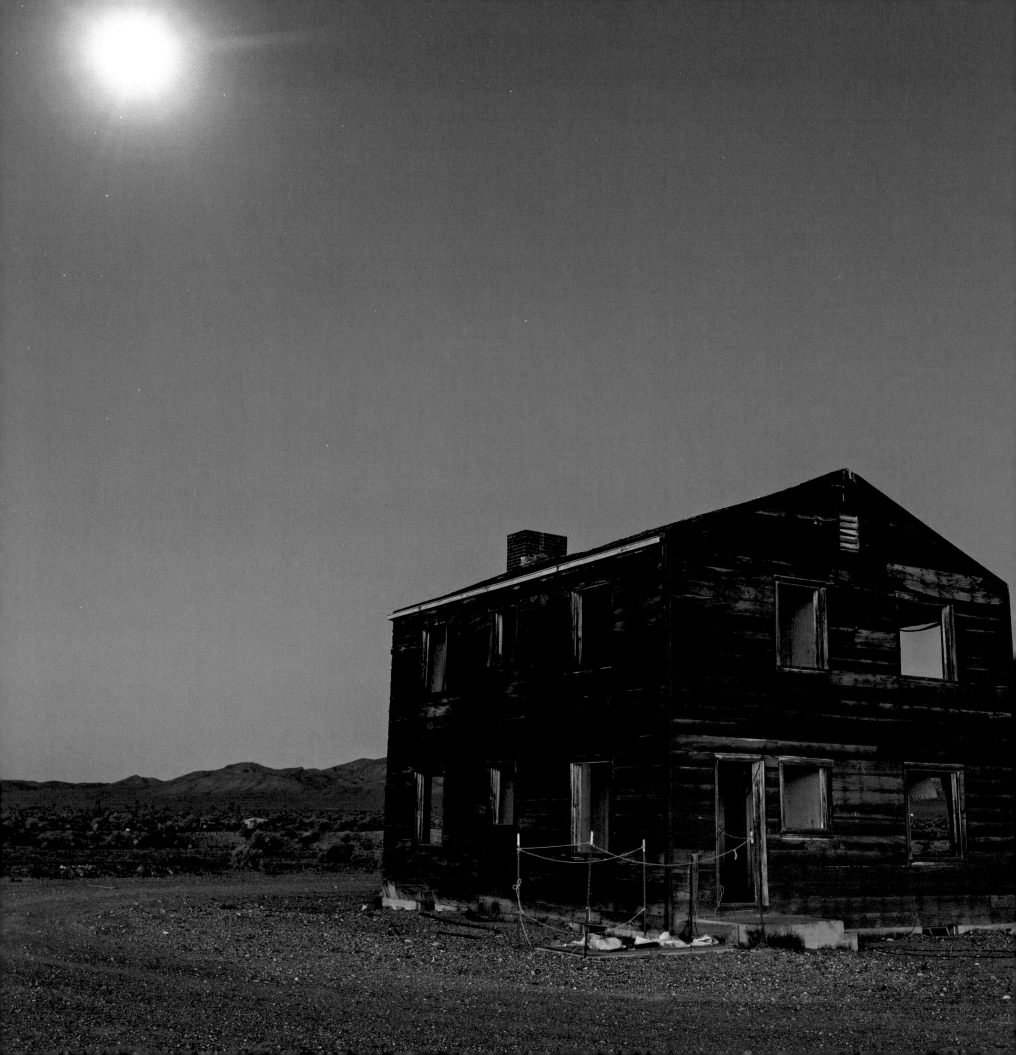

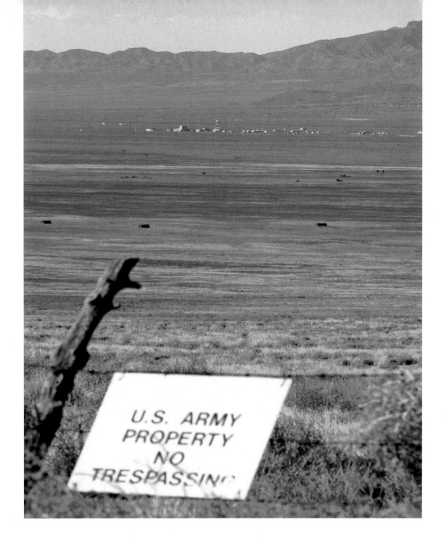

Above: The Dugway Proving Ground is the only community in the Great Salt Lake Desert in Utah. Covering an area the size of Rhode Island, the facility was established by the US Army in 1942 to test chemical and biological weapons.

With the end of the war, the population dropped to less than half its previous number, though today Oak Ridge is still home to a major government laboratory for nuclear research.

A Town Named Mercury

With the end of the war, Los Alamos and Oak Ridge could relax a bit and become towns more or less like any other. But the nuclear arms race had begun, and other sites even more remote than those of the Manhattan Project were

Left: In the middle of the Nevada Desert, Atomic Survival Town (or Doom Town) was a series of buildings, with mannequin families, constructed in the mid-1950s to test the ability of different building designs to withstand a nuclear strike. The so-called 'Apple-2 House' is one of two homes that remain.

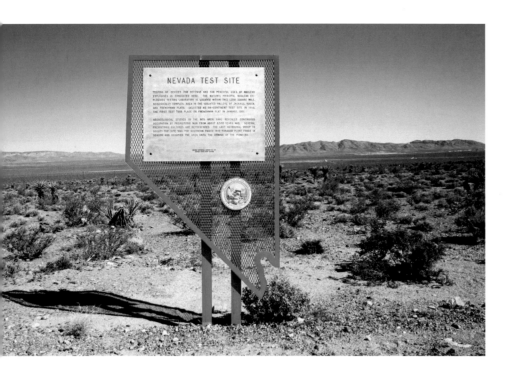

Above: Nevada Test Site sign, Mercury, Nevada, USA.

soon being selected for the development and testing of ever more powerful megaton bombs that would keep America one step ahead of its Communist rival. The town of Mercury, named for the liquid metal once mined in the area, is just over 100 kilometres (62 miles) northwest of Las Vegas at the southern edge of what's known as the Nevada Test Site (renamed the Nevada National Security Site as of 2010). Built in 1950 to house the people working at the site, it remains a closed city, with access to the public still strictly forbidden.

Despite this hermetic existence, by the 1960s the town's population had risen to more than 10,000 people, with facilities which most self-respecting settlements of that size would be happy to have. But the end of nuclear testing in 1992 saw most of those who lived there pack up and leave as quickly as they had come a generation earlier, and today there are believed to be no more than a few hundred scientists and military personnel still living in Mercury.

Right: Highway leading to the closed town of Mercury, Nevada, USA, the entrance to the Nevada Test Site Nevada is one of America's least densely populated states.

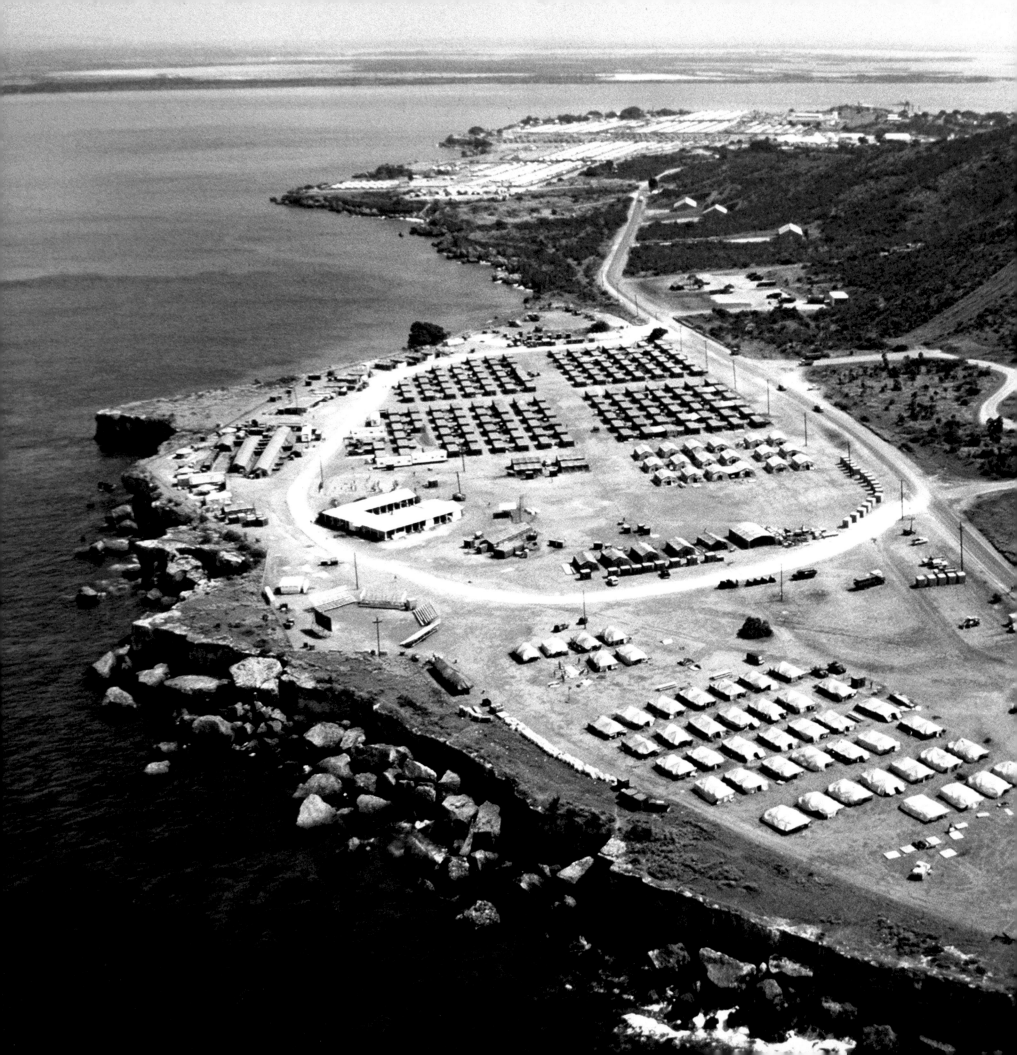

Area 22: Camp Desert Rock

Just a kilometre or so (half a mile) south of Mercury in Area 22 of the Nevada Test Site is Camp Desert Rock. We have all seen footage of the mushroom clouds of the nuclear test explosions of the early 1950s, but the troops who were stationed here had their lives put at risk as they cowered in trenches or even stood in the open when the bombs went off. Told that they were perfectly safe, and ordered to carry out exercises in the radioactive desert after each new test, it now seems that these raw recruits were little more than guinea pigs in the evolving strategy of a new kind of warfare. Constructed in double-quick time in September 1951 ahead of the first atom bomb test the following month, Camp Desert Rock could house as many as

Left: America's territories overseas have proved convenient places to locate its most controversial activities. No such facility has been more contentious in the twenty-first century than Camp Delta, the detention camp at Guantánamo Bay, Cuba.

6,000 troops in its hundreds of tents and temporary buildings. In 1964, following a treaty that banned above-ground testing, the camp was decommissioned, and today not much more than footings of the original buildings can be seen at the site. But troops who participated in the military manoeuvres have developed cancers at levels far higher than those of the general population, and in 1990 the US government paid significant compensation to those involved.

Area 51: A Conspiracy Theorist's Dream

Of all the different 'Areas' in the vast Nevada Test and Training Range, of which the Nevada Test Site is a part, there is one – close to a salt flat known as Groom Lake, and literally miles from anywhere – whose secret activities have endeared it to peddlers of the stories about extra-terrestrial visitors that became part of the mythology of post-war America. Area 51 was where the US Air Force began testing the U2 spy plane in the mid-1950s, an advanced aircraft that could fly at altitudes of up to 18,000 metres in order to evade Soviet radar. Around the same time, people began reporting seeing bright, unidentified objects in the skies above the Nevada Desert, and soon these sightings were being linked with other unexplained occurrences, such as the discovery of wreckage at Roswell, New Mexico in 1947.

It didn't help that the US government refused until recently even to acknowledge the existence of a facility at Area 51, despite the fences and warning signs that greet anyone foolish enough to attempt to get in. In the absence of real information, mistrust and imagination ran riot, so that Area 51 has become identified over time as both the place where the supposed Roswell aliens were taken for government experiments and the site of the fake moon landings that were apparently staged to hoodwink the world – a theory which inspired the film *Capricorn One* (1977). But history abhors a vacuum, so until the true purpose of this secret region is fully disclosed, the theories will doubtless persist and proliferate.

Right: A satellite image of Area 51, Nevada, USA.

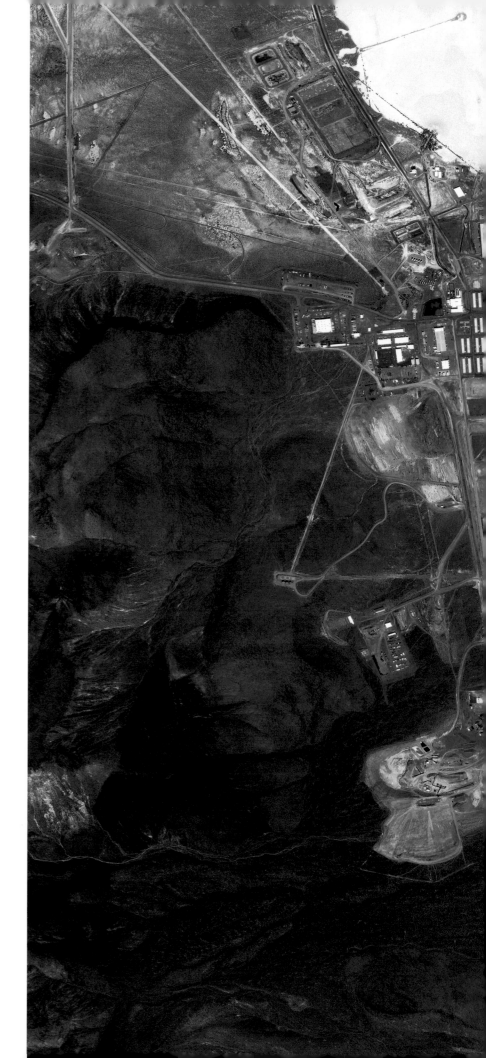

The Closed Cities of Communism

If America had secrets to keep throughout the Cold War, secrecy and suspicion were innate characteristics of the Communist system, whether in the former Soviet Empire or the Communist regimes of eastern Asia.

The Strange Disappearance of Nizhny Novgorod

Today Russia may be a democracy – in name at least – but old habits die hard and there are still legacies of its totalitarian past that have not gone away. One of these is the existence even today of more than 40 closed cities across Russia (and possibly more we don't know about). Cities were first officially closed in the late 1940s under the increasingly paranoid rule of . After the war ended, the need for secrecy was much the same as on the other side of the Iron Curtain, as many of these places hosted activities related to the Soviet space or nuclear programmes.

Closed cities were officially omitted from national maps, which in the case of remote places such as Vorkuta in Russia's Arctic North, newly built with forced labour from the notorious Gulag prison system, was not a difficult fiction to maintain. But long-established, centrally located cities like Nizhny Novgorod, home to strategic military facilities, must have been harder to hide, despite the change of name to Gorky in honour of the famous Russian

Left: The once-closed Russian Arctic city of Vorkuta was built by Gulag labour in the 1930s to mine the extensive coal reserves in this region. In recent decades, since the mines closed, its population has suffered a sharp decline.

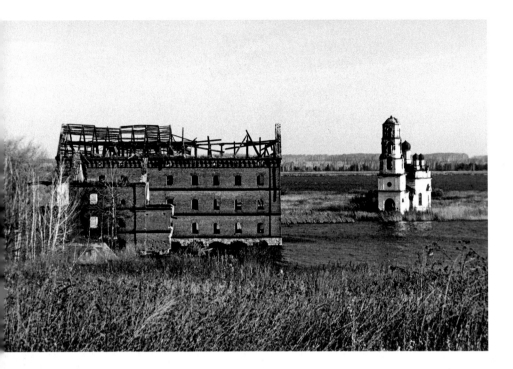

Above: Abandoned village of Mitlino in the Ozersk (Chelyabinsk-65) region of Russia.

writer who was born there. Throughout the Soviet era, foreigners and even out-of-towners without good reason were banned from visiting this historic place, and until the 1970s even locals were unable to purchase a map of this city of more than one million people.

The Most Contaminated City on Earth

The city of Ozersk in the southern Ural Mountains some 1,200 kilometres (746 miles) east of Nizhny Novgorod was one of those built by Gulag labour from scratch, at the time known as Chelyabinsk-40 before being later upgraded to Chelyabinsk-65 (numbered pseudonyms were common among the closed cities). Beginning as early as 1945, the 70,000-strong prisoner labour force built a nuclear reactor and research facility underground, known as the Mayak Complex, where they were also exposed to deadly levels of radiation from which, within five years, they would all die.

Right: Nizhny Novgorod, Russia.

At that early stage, the full effects of nuclear exposure and the safeguards needed to avoid it were not well understood, especially in the USSR, and the Mayak facility discharged large amounts of lethally contaminated water into the nearby Techa River, a vital resource for people from the 24 villages that line its banks. Then, following an underground explosion in 1957, crucial delays in evacuating people from the surrounding area, and especially from the by then well-populated city of Chelyabinsk-65, led to tens and possibly hundreds of thousands being exposed to radiation levels dozens of times higher than the recommended maximum, and many times worse than those of the Chernobyl disaster some 30 years later. The resulting spike in cancers has decimated some families, and the incidence of birth defects and levels of terminal illness have led to the people of the area being referred to as the 'dying generation'. Ozersk is still a nuclear city and remains closed to outsiders today.

Closed Cities of the Soviet Empire

Cities all over the former Soviet Empire were sealed off for a variety of reasons, but mostly because of military installations that needed to stay hidden. The port city of Sevastopol, home of the strategically important naval base of Russia's Black Sea fleet in the now contested region of Crimea in today's southern Ukraine, was closed during the Soviet era. Also closed was Dnipro, or Dnipropetrovsk, in the centre of Ukraine, widely known in the USSR as 'the rocket closed city' on account of the ballistic missiles and engines for Soviet space rockets that were developed and manufactured there.

On the Baltic coast, Estonia is now an independent member state of the European Union, but during the Soviet Occupation, the towns of Sillamäe and Paldiski were closed: the former because of the uranium production

Left: The remote city of Kurchatov, Kazakhstan. Originally only known by its postcode, Semipalatinsk-21, it was the centre of operations for the USSR's atomic testing at the Semipalatinsk Test Site. Though no longer a closed city, access is still partly restricted.

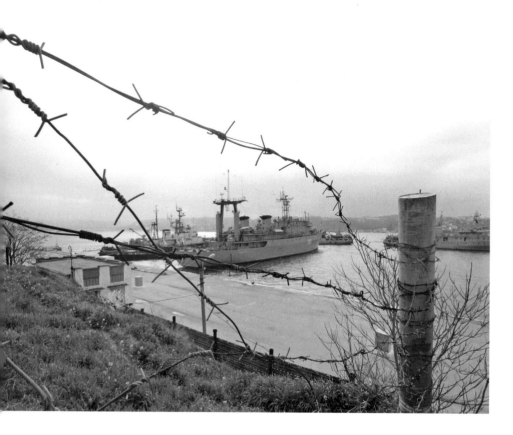

Above: The strategic port of Sevastopol was closed to outsiders during Soviet times, remained home to the Russian Black Sea Fleet while part of post-Soviet Ukraine, and was seized as part of the annexation of Crimea by Russia in 2014.

plant located in the predominantly Russian-speaking town; the latter on account of the nuclear submarine training centre which operated there. And further closed cities could be found in far-flung places, including Cobasna in Moldova in the Soviet Empire's southwest corner, in an area now claimed by the breakaway republic of Transnistria; and Priozersk in Kazakhstan in Central Asia, still home to the Russian anti-ballistic missile testing site. Both cities remain closed to outsiders today.

China's Nuclear Town

Deep in the Gobi Desert, China's Endless Sea, is where you might expect to find a city constructed by the Communist government in the late 1950s

Right: Apartment buildings in the derelict and abandoned secret nuclear city of 404 in the Gobi Desert, China.

to house the country's first nuclear reactor and to manufacture crucial parts for its first nuclear bombs. The town of No. 404 Factory of China National Nuclear Corp is known simply as 'Nuclear Town', and extensive facilities are said to have been constructed underground.

The city was closed to outsiders until the 1980s and, needless to say, does not appear on any map even today. But the people who grew up there know just where it is and remember vividly the dull existence they led in this dry and windy location in the back of beyond. There was a theatre and a zoo, but for the bored youth of 404 there was little else to do besides watch the stars and dream of getting out. With the development of new, more modern nuclear facilities elsewhere in China, in recent decades the city has been largely abandoned, as most of the thousands who once lived there have either died or left. By all accounts, only a few hundred elderly people drag out their lives there today.

Cities in Communist Korea

These closed cities belong to a different era which most of the world – at least in theory – has thankfully left behind. But one extreme nation state still operates on the same premise of secrecy and totalitarian control that typified the Communist system. Now on its third hereditary leader, the Democratic People's Republic of Korea, or North Korea, is among the most difficult countries in the world for any outsider to visit and the most dangerous for any of its citizens to try to escape.

While none of its cities is officially closed, access for foreigners is strictly chaperoned and some have been imprisoned for breaking the rules. In any case, North Korea's isolation has left it so impoverished that only a small percentage of the road network is paved and bicycles still vastly outnumber

Left: One of two now eerily empty kindergartens of the mysterious city of 404 in the Gobi Desert, China.

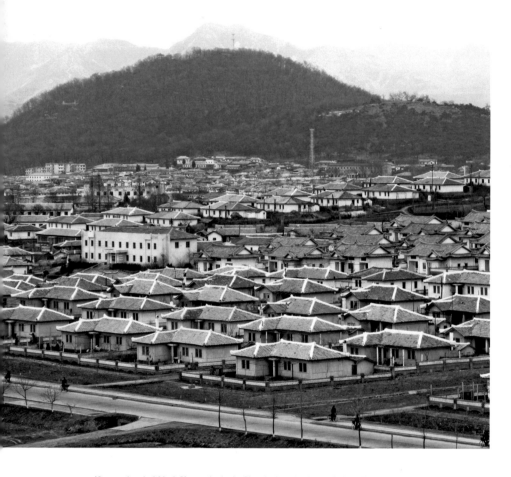

Above: A typical North Korean city, in the Changbaek-sanjulgi area of North Korea on the border with China.

cars in this faltering industrial state. Formerly reliant on outside support from other Communist countries, since the collapse of the Soviet Union the North Korean leadership has stuck to its stubborn goal of self-sufficiency, which in a small community might be idealogically admirable but seems unsustainable for a complex modern nation. The results have been disastrous, as millions have died from famine and its attendant diseases, with international sanctions piling misery on the failings of a command economy unable to relieve the country's desperate plight.

Right: Monument to the founding of the Labour Party of the Korean People's Democratic Republic in Pyongyang, North Korea.

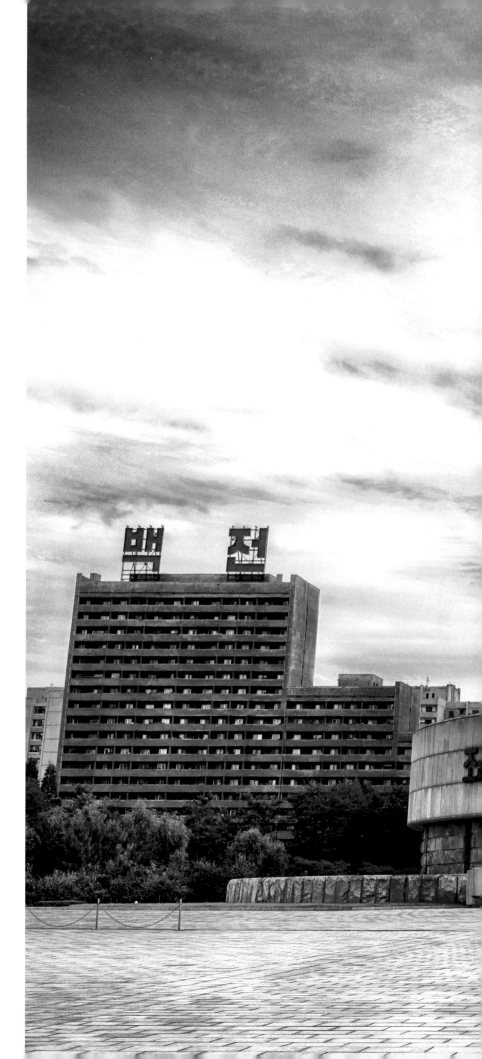

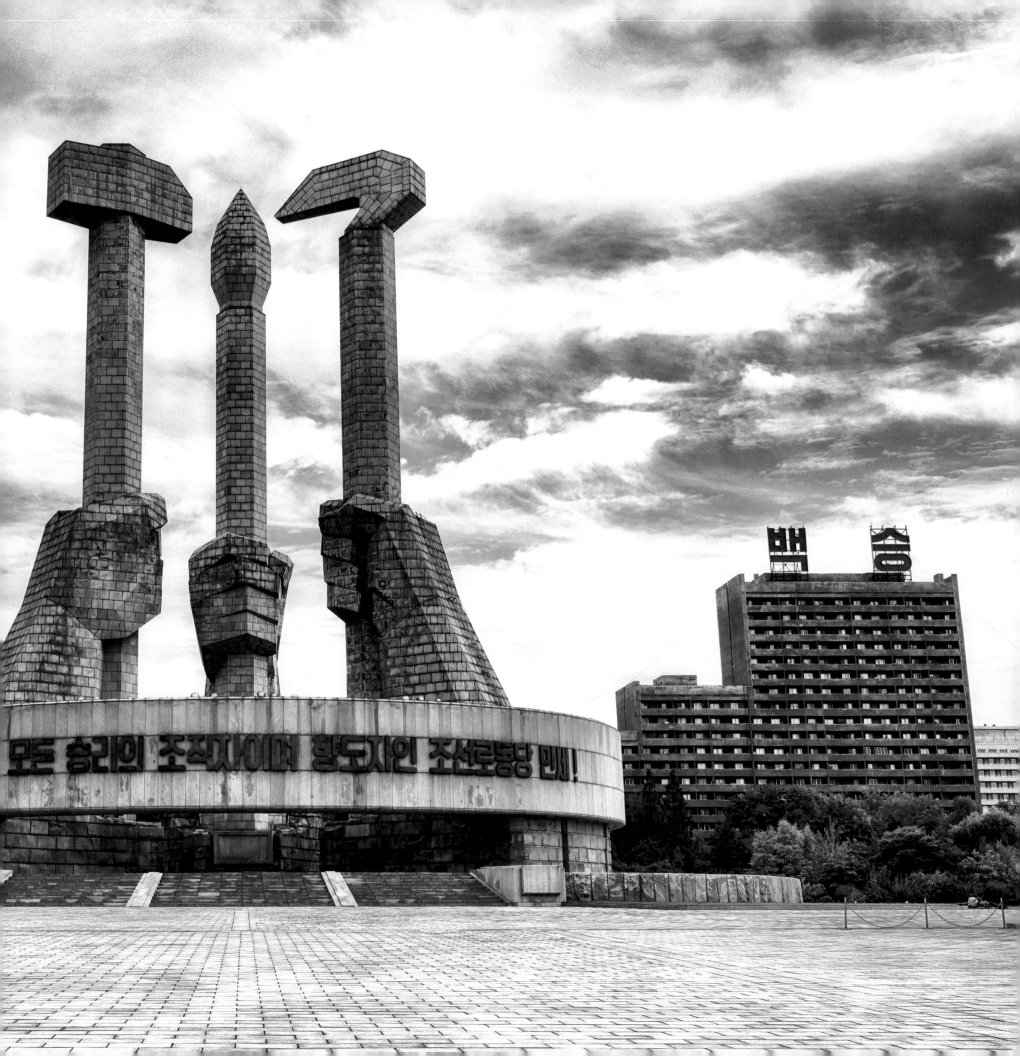

Walled Off

Cities can become divided for many reasons, with physical walls sometimes keeping different groups apart – the result of lax city planning, ideological rivalry or, in the worst cases, deliberate, racist policy.

Kowloon Walled City

The footprint of Kowloon Walled City in Hong Kong, once the most densely populated place on Earth, was an area of less than three hectares (seven acres) and the sole part of the territory that remained in Chinese hands after Hong Kong was leased to Britain in 1898. The Walled City of the early twentieth century was an unplanned settlement of ramshackle buildings and a few hundred squatters, but by 1950 this number had grown to more than 17,000 in what was now an overcrowded and mostly ungoverned place, where criminal gangs and drug dealers ruled the roost. This situation persisted until the early 1970s, when the gangs were finally rooted out.

Above: *All that remains of Kowloon Walled City, in what is now Kowloon Walled City Park.*
Right: *Apartments in Kowloon Walled City, China c. 1992.*

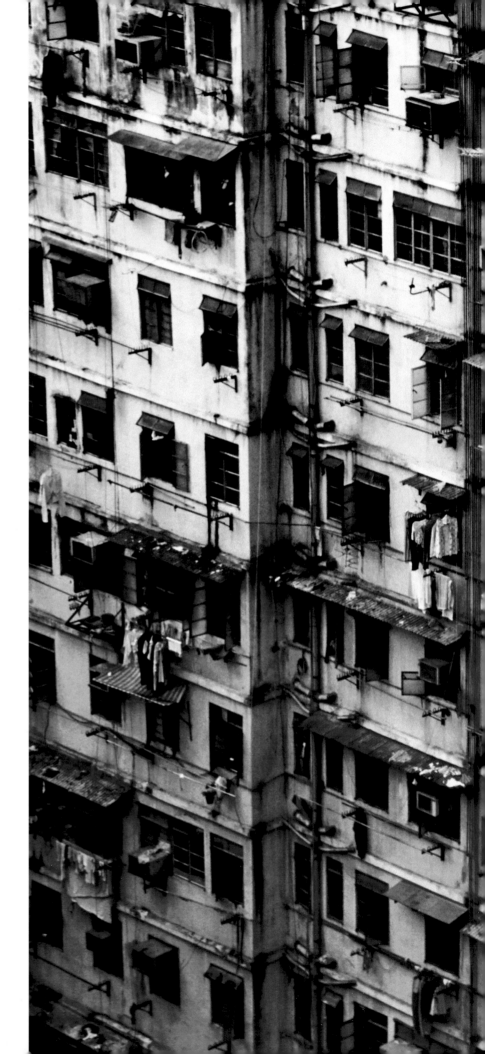

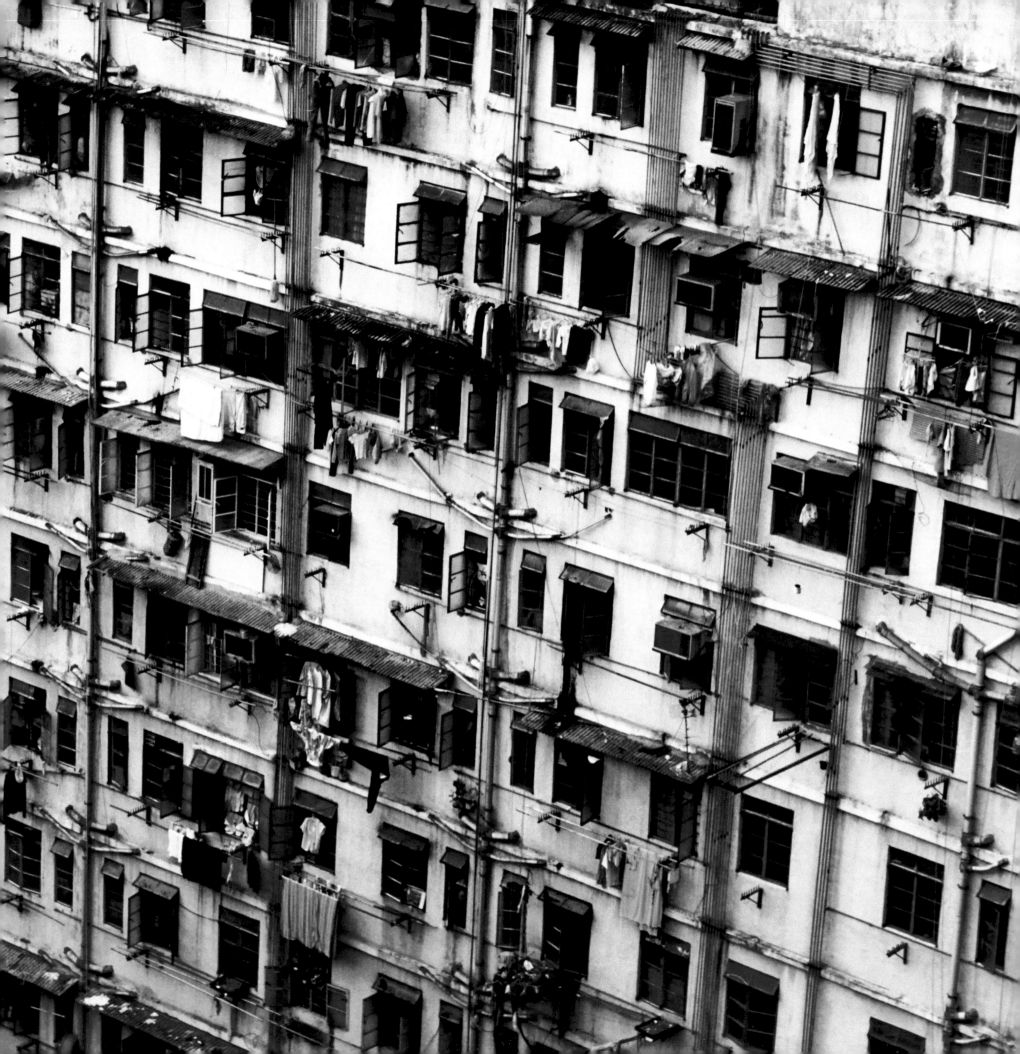

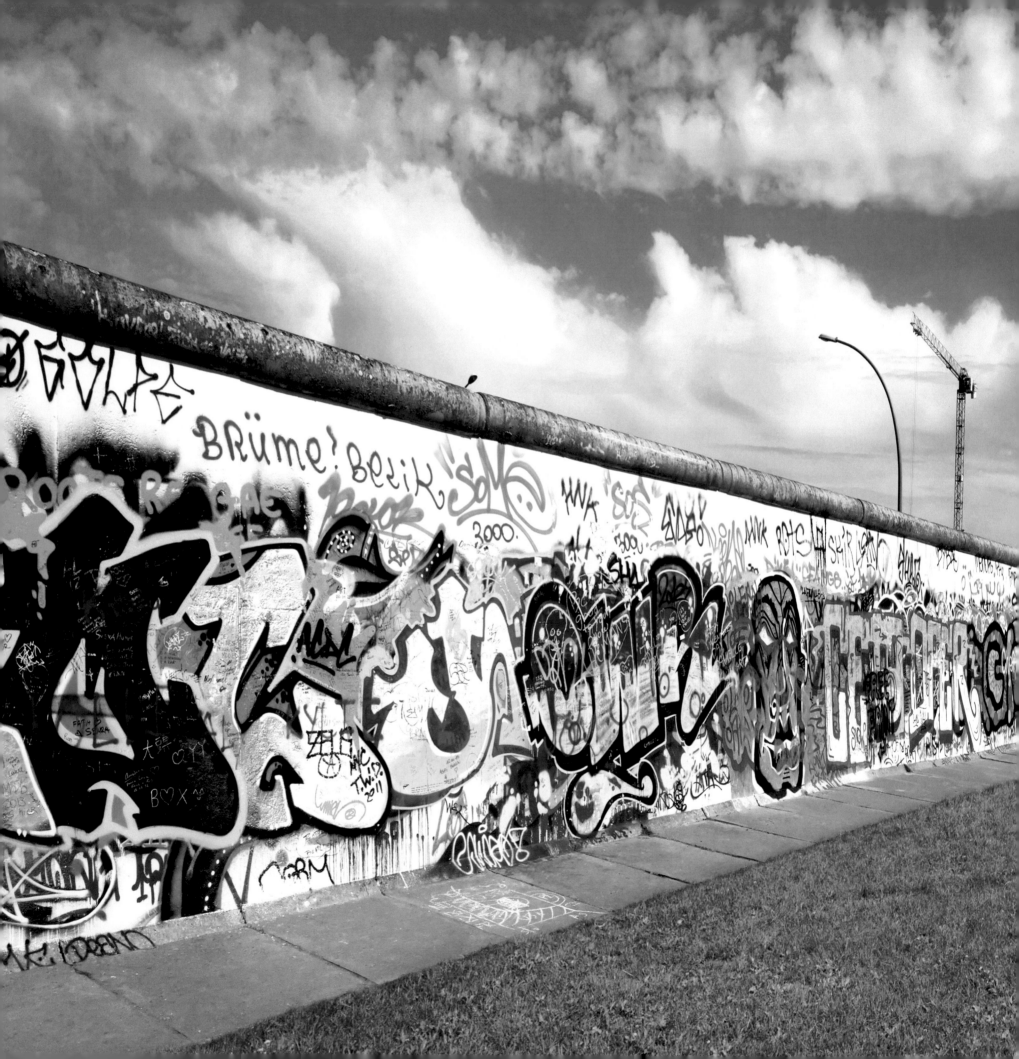

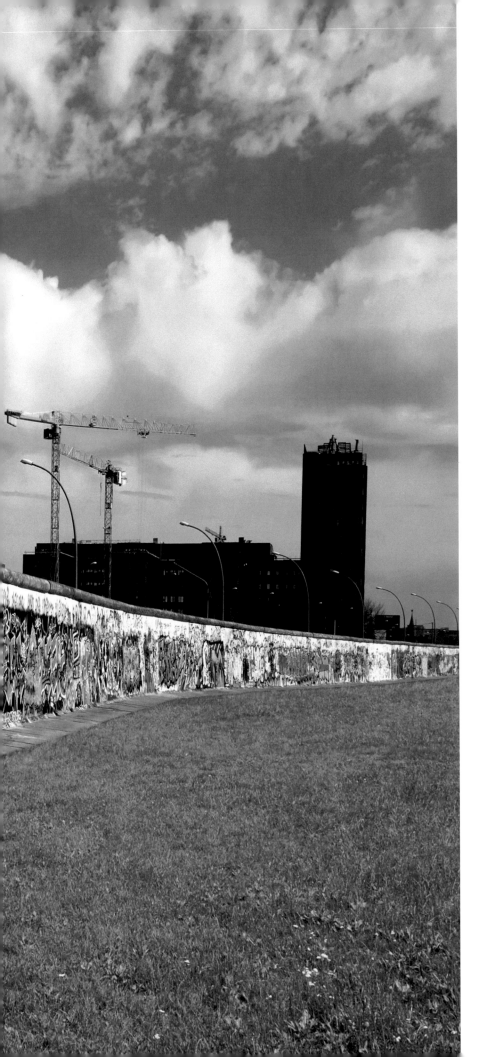

By this time the city's unauthorized buildings had grown in massed ranks up to 14 storeys high, and its streets were a labyrinth of narrow alleys with no natural light. The population had swelled to an incredible 50,000 people, many fleeing China during the Cultural Revolution to make a life for themselves in the booming capitalist enclave of Hong Kong. The people of the Walled City lived an existence largely separate from the prosperous harbour city around them, practising almost every conceivable trade within its walls. Despite the confined space and there being only one outlet for running water in the entire complex, former residents have insisted life there was happy. But it all ended when the Walled City was demolished in 1993 ahead of the handover of Hong Kong to the Chinese some four years later. A park now marks the site where this remarkable settlement once stood.

The Berlin Wall

Berlin had already been divided for 16 years, the frozen centre of the Cold War, when overnight on 13 August 1961 the government of the German Democratic Republic erected a wall to partition the city from top to bottom, adding a physical barrier to the ideological one which already existed. Between 1949 and the building of the Wall, some 3.5 million East Germans had defected to the West to escape the economic and political hardship of the Communist system. Most had come through West Berlin, and the Communists, on the pretext of keeping out capitalist influences, were determined to stop the flow.

The Berlin Wall, which grew over the next few years into a reinforced concrete structure some four metres (13 feet) high, was the most visible portion of the so-called Iron Curtain stretching from the Baltic Sea more or less to the Mediterranean.

Left: Segments of the Berlin Wall remain as a legacy of the past. During the Cold War the Wall became a focal point of graffiti and protest art.

Separating East from West, in Germany by the early 1960s it had become an increasingly formidable barrier of barbed wire and East German border guards with permission to shoot. Over the next almost three decades numerous individual attempts were made to escape from East Berlin to the democratic West, though only a handful succeeded. Families were split by the Wall, and the Communists were diligent in stopping information flowing in either direction. It was only when the Wall fell in 1989 that the two halves of a city that had been kept apart for a generation could begin the process of re-acquaintance which is still ongoing today.

The Belfast Peace Walls

One of the lingering scars of Britain's long colonial past is right on its own doorstep. In the 1960s, continuing sectarian divisions in Northern Ireland resulted in protests against the discrimination endured by the Catholic minority and then, from 1968, the beginning of a 30-year conflict, known as the Troubles, between the British Army, Loyalist paramilitaries and Nationalist groups such as the Provisional IRA.

The conflict officially ended in 1998 with the signing of the Good Friday Agreement, but the legacies of deep mistrust remain. The most visible of these are the so-called Peace Walls, built from 1969 to separate Catholic and Protestant areas across cities and towns such as Derry, Portadown and Belfast. Varying in length from a few hundred metres to some 5 kilometres (3 miles), the Peace Walls were built from a range of materials, including brick and steel, and have actually increased in both height (up to eight metres/26 feet) and number over the past 20 years. Anyone who lived in Belfast or even visited the city during the Troubles could not help but notice how far apart the two communities were by every possible measure, these isolating walls giving their deep divisions a physical dimension.

Right: The 'Peace Line' fence that still separates the Catholic and Protestant areas of West Belfast, Northern Ireland.

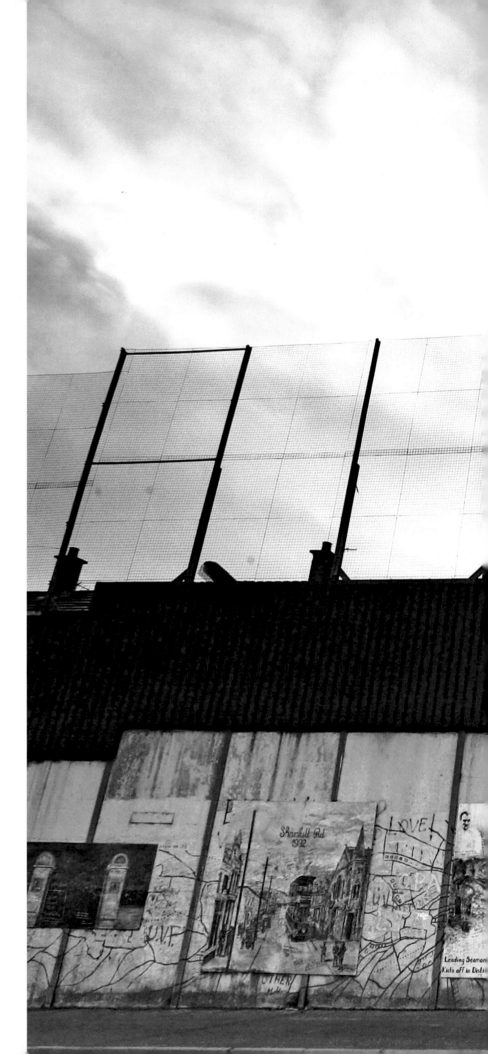

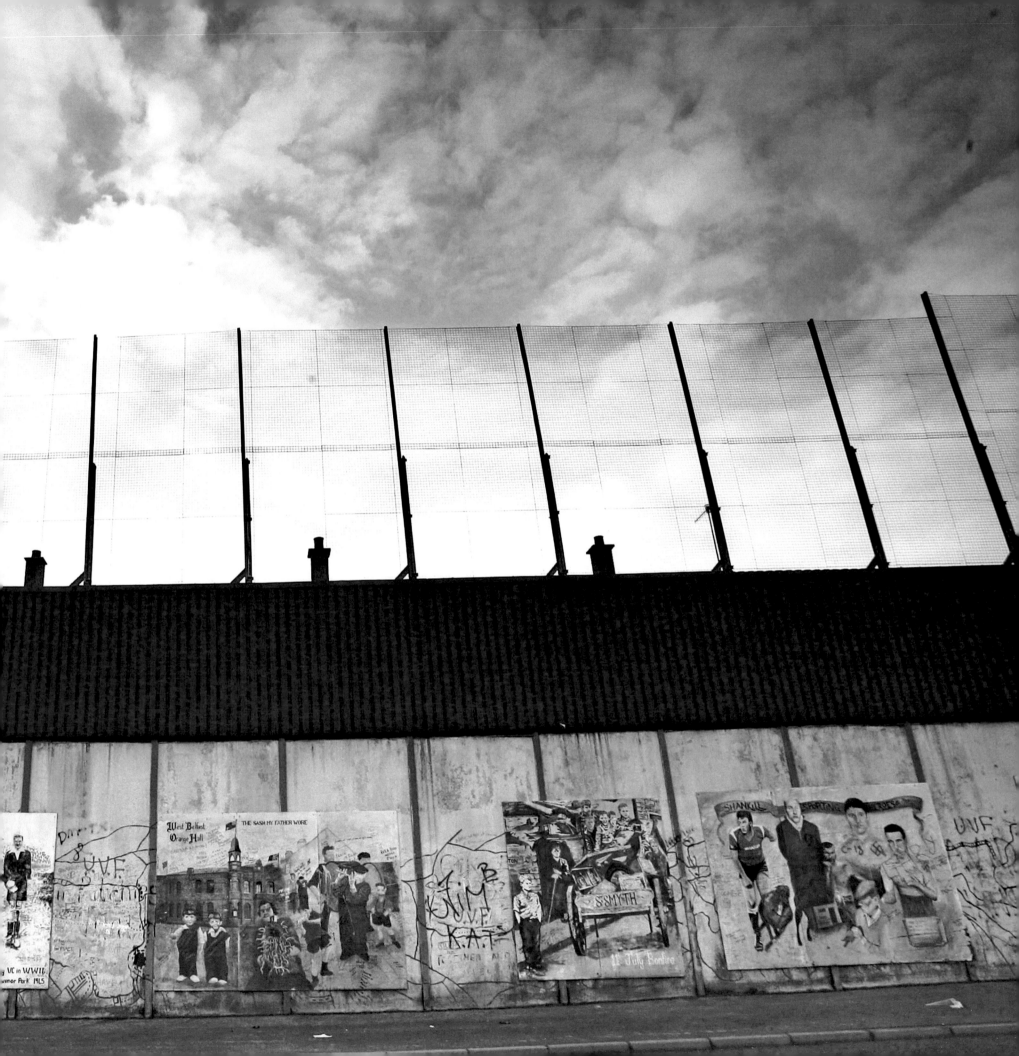

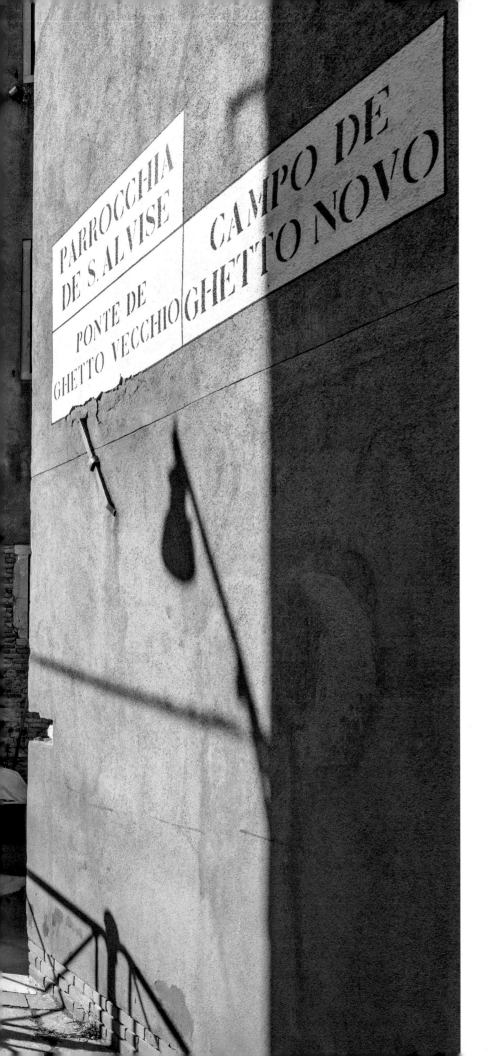

An agreement has been reached to remove the walls in the coming decade, but the majority of people in Belfast still believe they have a role to play in keeping the peace, and more than 100 remain standing today.

Venice: The Original Ghetto

The ghetto of Venice, founded in 1516 in the Cannaregio district in the northwest corner of the island city, was the first ghetto in the world. In the course of the sixteenth century, Jewish groups from all over Europe and the Levant settled in Venice, establishing five synagogues and many homes on a site where the city's foundries, or *geti*, had once stood. Indeed, the word 'ghetto' is thought by some to be an accurate rendering of *geto* as pronounced by the German-speaking Ashkenazim, one of the many groups to settle here, who could not pronounce the soft 'g' of the Italian word.

Jews have had a precarious status in Europe for more than a thousand years, and Spanish Sephardim who settled in Venice in the sixteenth century had been expelled from Spain as recently as 1492. Indeed, most of those who came to the city were fleeing persecution, but even here were permitted to practise only certain trades, such as moneylending and the selling of second-hand clothes. Furthermore, these occupations were governed by strict conditions, as every evening at 6 p.m. the gates of the ghetto were closed, obliging the Jews who lived there to retire behind them, where they would have to remain until midday the following day, when they could once more re-enter the gentile city.

The Return of a Bad Idea

The Jews of Venice became more integrated with the life of the city over time, a story that was true in cities all over Western Europe, so that by the late nineteenth century many of the leading businesspeople and intellectuals

Left: *The Ponte del Ghetto Vecchio over the Rio del Ghetto, once the Jewish ghetto area of Cannaregio, Venice, Italy.*

in cities like Vienna and Berlin were Jews. When the last ghetto in Western

Europe – in Rome, the heart of the Christian World – was demolished in 1888,

it seemed as if anti-Semitism might be consigned to history. Even the pogroms

that targeted Jewish communities in western Russia eventually ceased after

peaking in the years that followed the Russian Revolution and the dissolution

of the Pale of Settlement, the large area at what had been Imperial Russia's

western extent where, since 1791, Russian Jews had been obliged to live.

After 1917, now free to travel, many of them settled in Poland, a country

which historically had been far more tolerant of Jewish people than anywhere

in the West and had by far the biggest Jewish community in Europe.

But the German invasion of 1939 saw Poland's Jews herded into crowded

Right: *Warsaw ghetto building.*
Below: *In America from the 1960s, the word 'ghetto' came to describe African American neighbourhoods in cities such as Baltimore, where high levels of poverty and deprivation were common.*

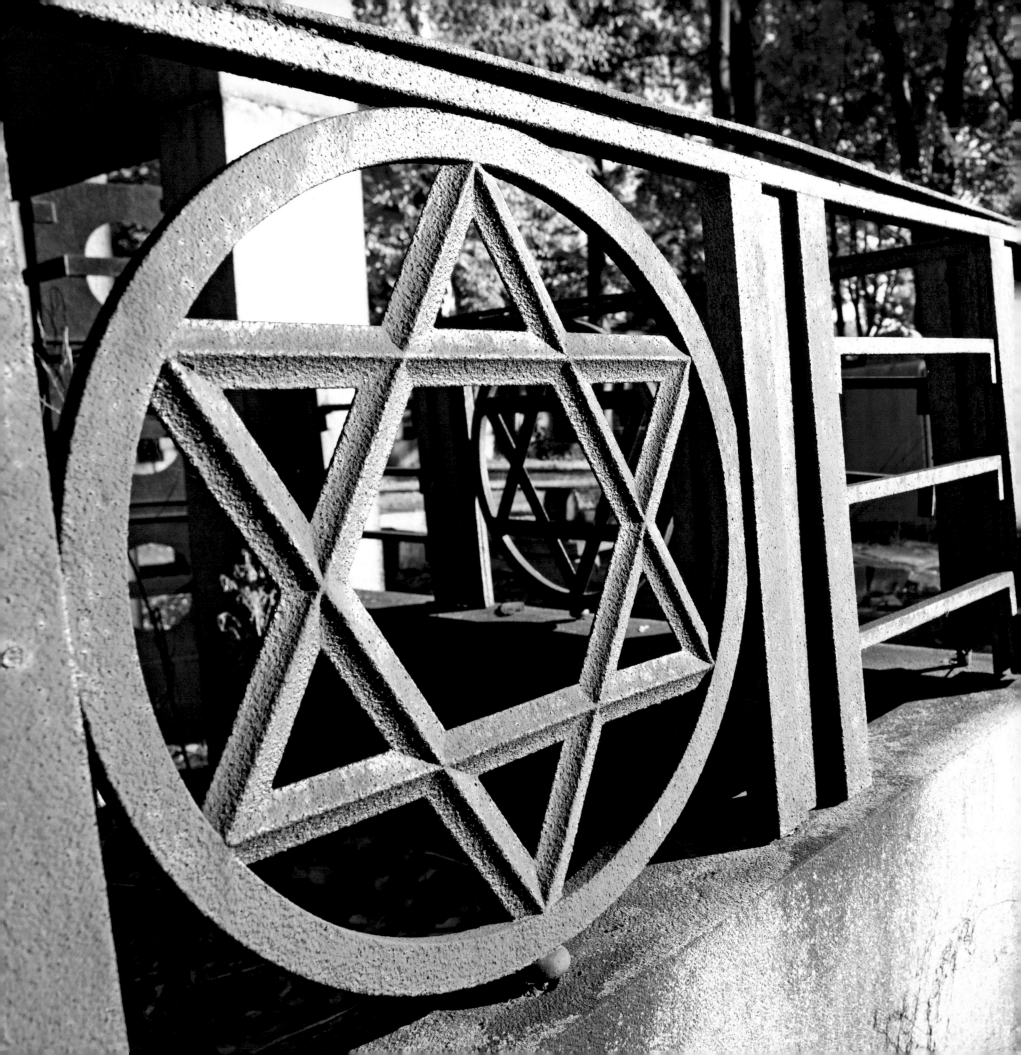

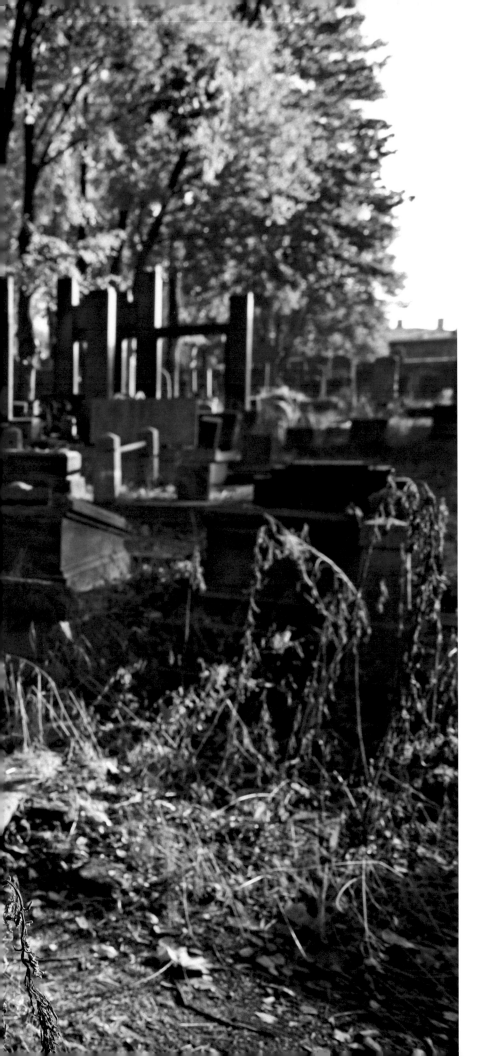

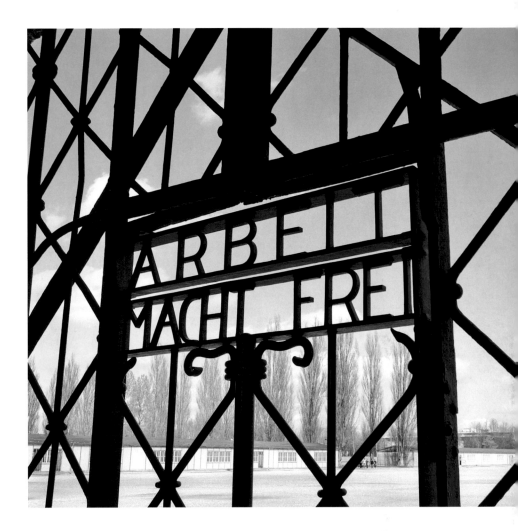

communities closed or 'sealed' by walls or barbed-wire fences in nearly 300 Polish towns and cities, such as Warsaw and Łódź. The appalling conditions they were forced to endure in the new ghettos were, of course, far better than what awaited them.

The Nazi death camps were a 'secret' that we can now be certain was widely known throughout Poland. Many Poles risked their lives to save their Jewish friends and neighbours, while others willingly took part in the slaughter. Half of the six million Jews who died in the Holocaust were from Poland.

Left: *A Jewish cemetery in Łódź, Poland.*

Elite Cities

Throughout history, and still today, the wealth of nations has tended to be concentrated in the hands of a fortunate few, who enjoy their riches behind the best security money can buy.

The Original Forbidden City

Today the largest palace complex in the world, the Forbidden City in the Chinese capital, Beijing, is one of the most frequently accessed places on Earth, visited annually by some 15 million people. But during the time of the emperors of the Ming and Qing dynasties – 24 rulers from 1420 to 1912 – entry to and even exit from this walled compound of less than a square kilometre (0.4 square miles), but some 90 palaces and almost 1,000 buildings in total, was strictly at the emperor's pleasure.

Like kings and emperors everywhere before the modern era, the Chinese emperor enjoyed a level of power and luxury in stark contrast to the impoverished circumstances of many of his subjects. In an echo of the Divine Right of Kings once claimed by European monarchs, he was said to be a son of heaven, so it was only natural that his palace should be a replica of the Purple Palace in heaven where God was believed to reside. Thus the city was originally called *Zijn Cheng*, meaning 'Purple Forbidden City', with the name being enough to tell citizens that inside its thick walls some 10 metres (33 feet) high was a secret, celestial realm which, as ordinary mortals, they had no right to enter.

The Ming Dynasty replaced the Yuan, proclaimed by Kublai Khan in 1271, the year that Marco Polo set out from Venice. In his *Travels*, Polo describes

Right: *City skyline at the Forbidden City, Beijing, China.*

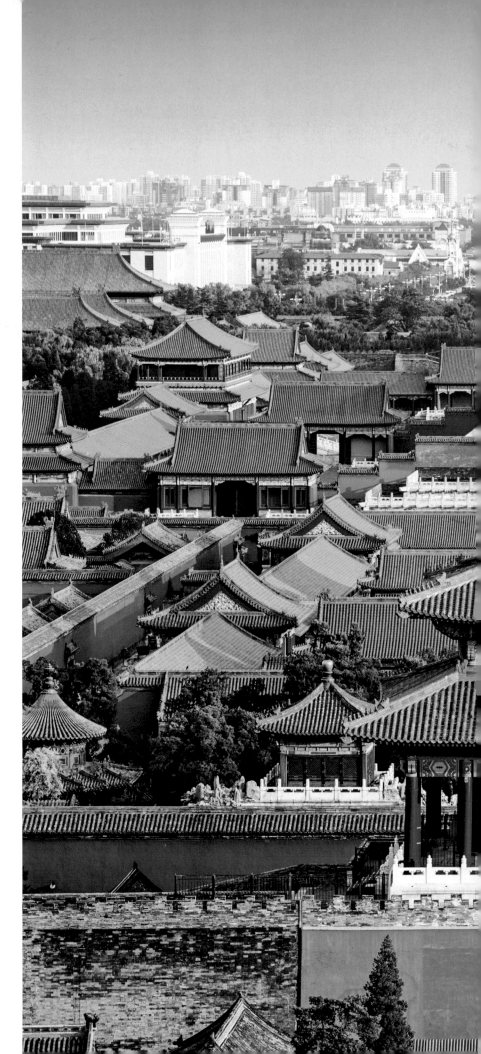

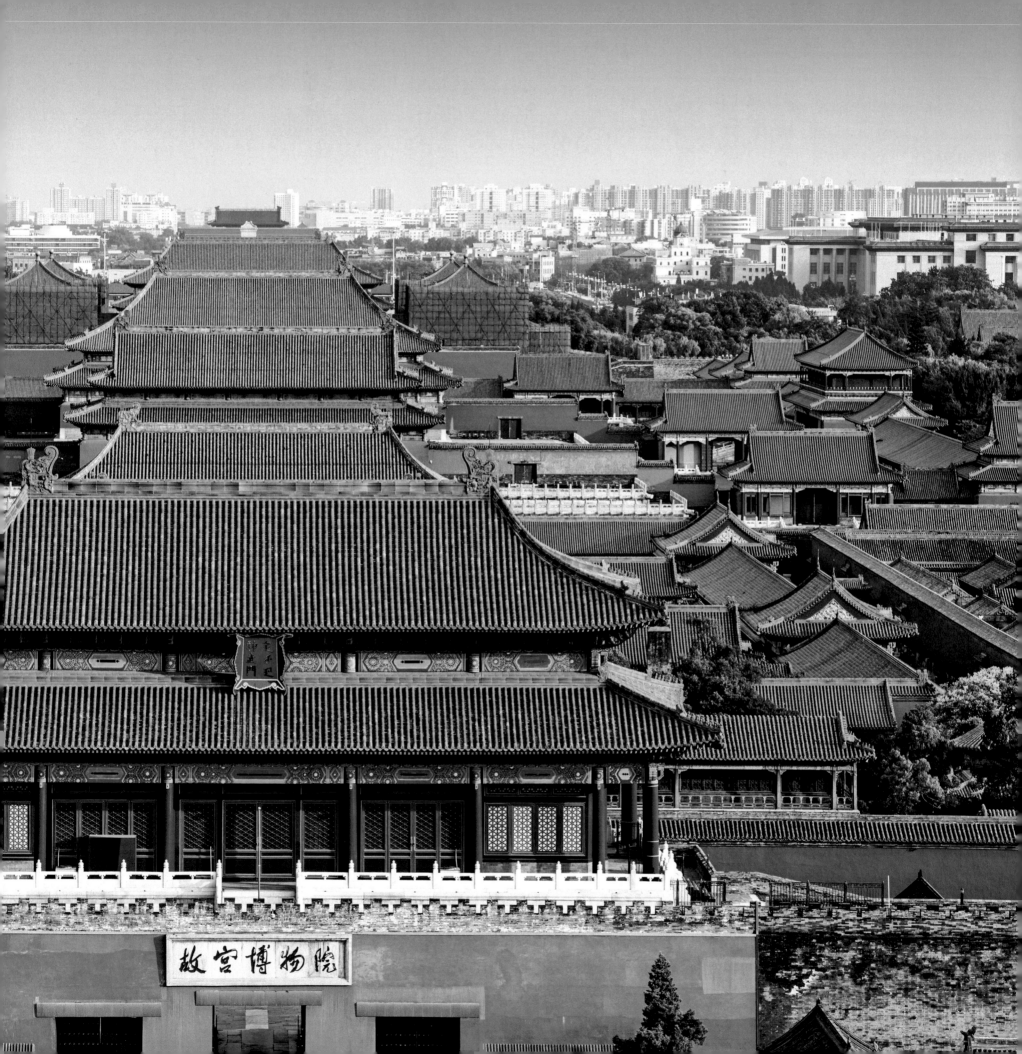

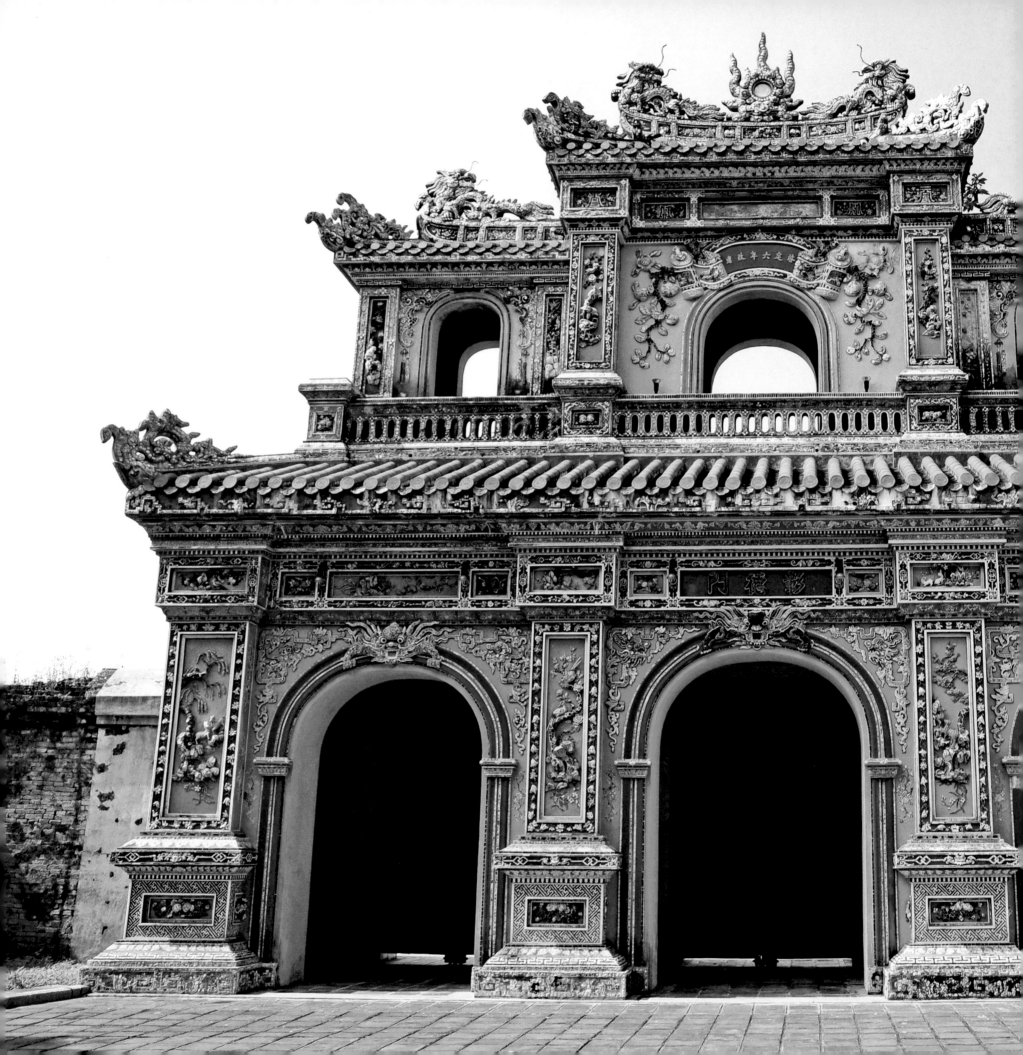

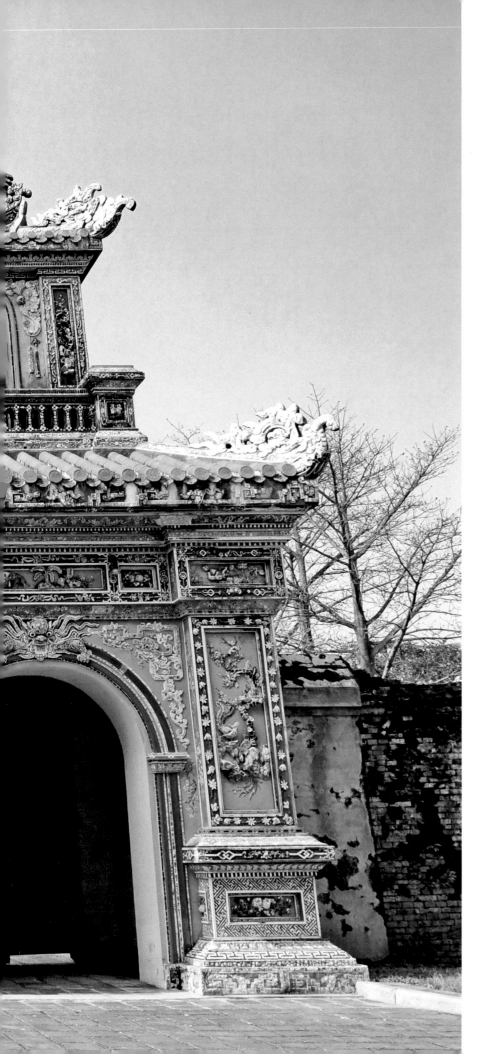

Khan's Yuan Palace as 'the greatest that ever there was', but until recently it was thought lost to history. Then in 2016, archaeologists working at the Forbidden City found evidence of what is likely to have been the palace of Kublai Khan, buried beneath the secret city that replaced it.

The Lifestyle Estate of Dainfern

Johannesburg was once notorious as a racially segregated city. In the early 1930s, using the infamous Urban Areas Act, the white government of South Africa began moving black citizens to a township on the edge of the city that became Soweto – short for 'South West Township'. Today a place synonymous with the struggle against apartheid, its standards of housing and sanitation reflected the contempt of the government for the black South Africans who lived there and who worked in the white-owned businesses and goldmines close to Johannesburg.

Left: Begun in 1804, the Imperial City of Huế, the former capital of Vietnam, has outer walls 10 kilometres (6.2 miles) long and an inner citadel, the Purple Forbidden City, like its Chinese equivalent, where the emperor and his family once lived.
Below: Dainfern luxury gated community, near Johannesburg, South Africa.

Meanwhile, white citizens lived in affluent suburbs not far away, reflecting the random privilege that followed from being of European descent – a fact reinforced by black people being forbidden to enter these areas under the pass laws by which the system of apartheid was enforced.

Today, despite the ending of apartheid and the introduction of black majority rule, the habit of segregation continues in the country, albeit along different lines. With fear of violent crime on the increase, the substantial suburb of Dainfern in Johannesburg is one of many gated communities, patrolled by security guards and with strict vetting of anyone trying to enter, which have emerged in South Africa since the ending of apartheid in 1992. Nationwide there are thought to be at least 6,500 such enclosed communities – referred to as 'lifestyle estates' – with many offering not just luxury housing but golf courses, equestrian and polo facilities, even coastal, country and wildlife spaces within their walled reserves.

The Expat Enclosures of Luanda

South Africa is the most unequal country on Earth, using the Gini coefficient – the standard way of measuring income inequality. But the title of most unequal city may well belong to the capital of another African nation. Like many countries in Sub-Saharan Africa, Angola is blessed with abundant natural resources – principally diamonds and the oil which expatriate outsiders working for multinational firms have been brought in to exploit.

Following a civil war that lasted nearly 30 years and severely damaged the country's infrastructure, conditions for the ordinary citizens of Luanda, Angola's capital, can be squalid, even desperate. As billions from the oil boom have been siphoned into the offshore bank accounts of the country's ruling family, half of Angola's population continue to live on less than two

Right: The colourful shantytown houses of Luanda, Angola, overshadowed by the gated-community tower blocks of expat workers.

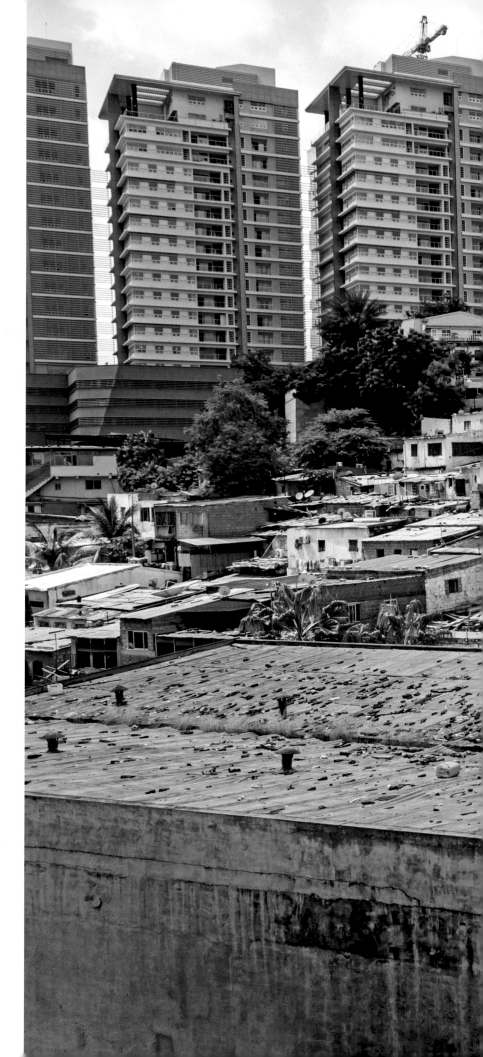

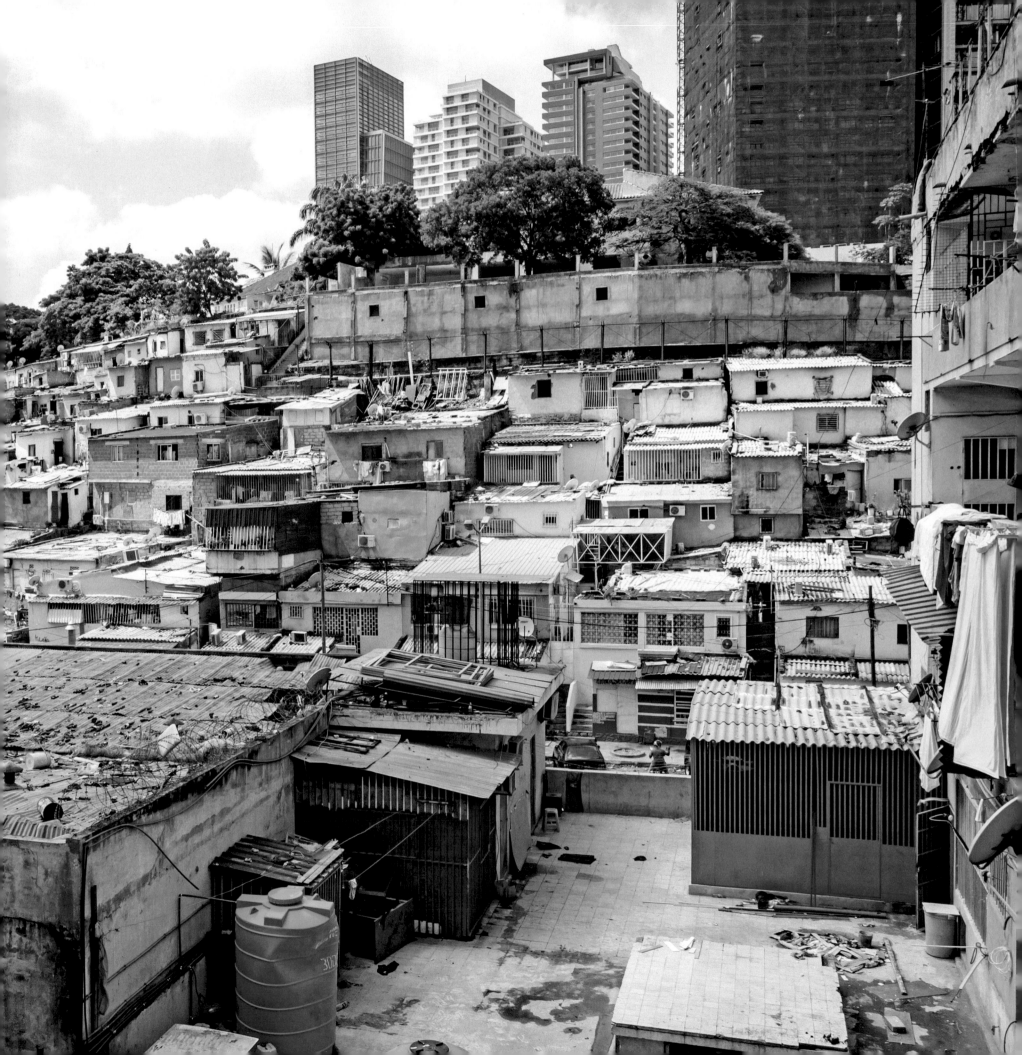

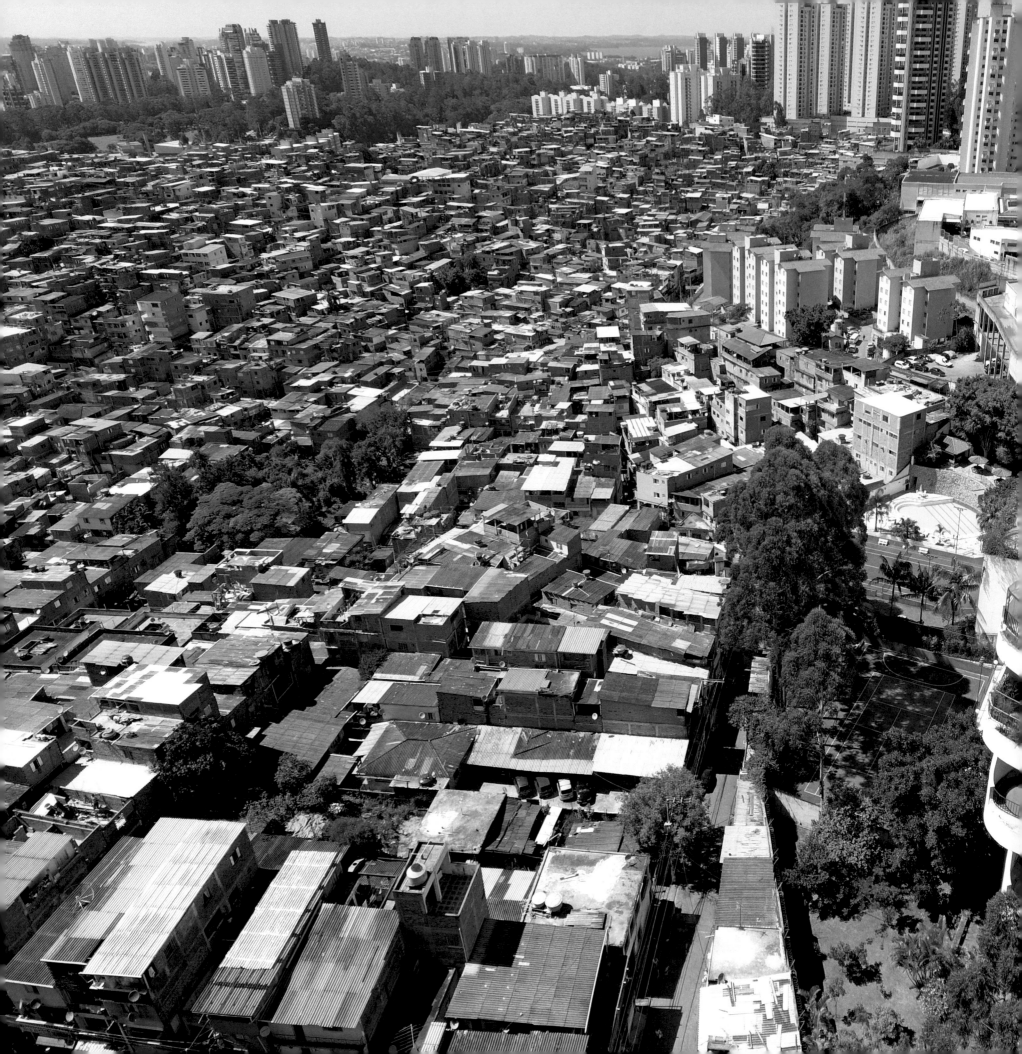

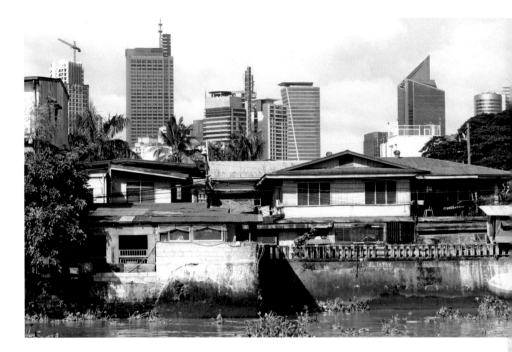

Above: Manila, in the Philippines, is one of many cities where income inequality is starkly visible.

dollars a day, while infant mortality and life expectancy are among the worst in the world. But the shantytowns of Luanda are overlooked by stands of massive tower blocks – gated communities in which most of the expat workers live. Their salaries are high but it's just as well, as Luanda is the most expensive city on Earth to move to – with living costs of more than $3,200 a month according to a survey conducted in early 2017. This is due to the need to import so much into a country that produces so little beyond the fruits of the extractive industries, but also because locals who can get away with it charge foreigners a premium for their luxury goods.

The Enduring Divisions of Kolkata

During much of the long period of British rule in the Indian Subcontinent, Kolkata was said to be the empire's second city after London. Founded as Calcutta by the East India Company in 1690 on the site of three existing

Left: Home to as many as 100,000 people, Paraisópolis is the second-biggest favela or slum in São Paulo, Brazil's most populous city. The neighbouring district of Morumbi is one of the wealthiest in São Paulo.

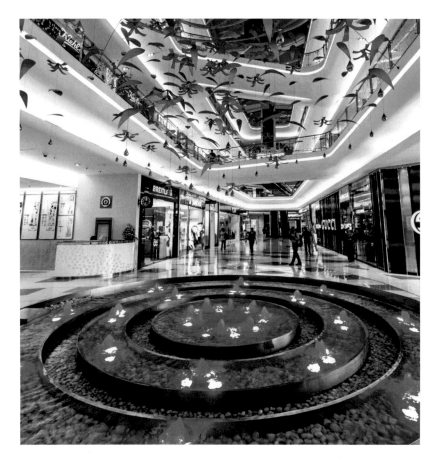

Above: The colourfully decorated entrance hall of the Quest Mall shopping centre, Kolkata, India.

villages, in 1773 the city was made the company's Indian headquarters, from which the colony was administered for almost a century until the government took it over after the Indian Rebellion of 1857. Thereafter Calcutta remained the capital of British India until it was supplanted by New Delhi about a half a century later.

By the 1850s, Calcutta was divided into two principal areas – Black Town and White Town – whose racial segregation was almost as crude as these names suggest. But if such stark divisions along racial lines helped to perpetuate the economic injustices of the colonial system, modern Kolkata suffers social disparities that are hardly less extreme. There is no doubt that a growing Indian middle class over the past 20 years has seen a huge rise in

Right: Inequality, of course, extends to other cities in India. Dhobi Ghat is the world's biggest open air laundry place in the slums of Mumbai.

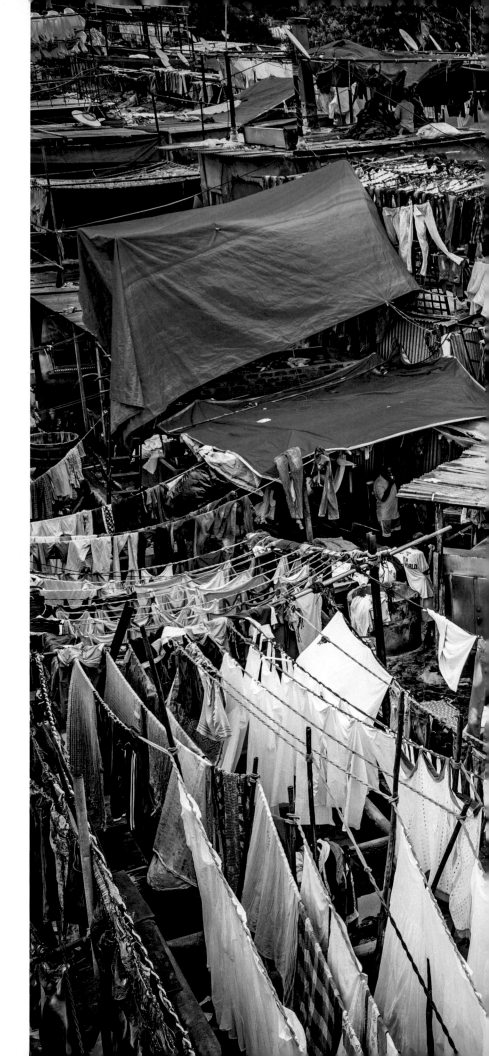

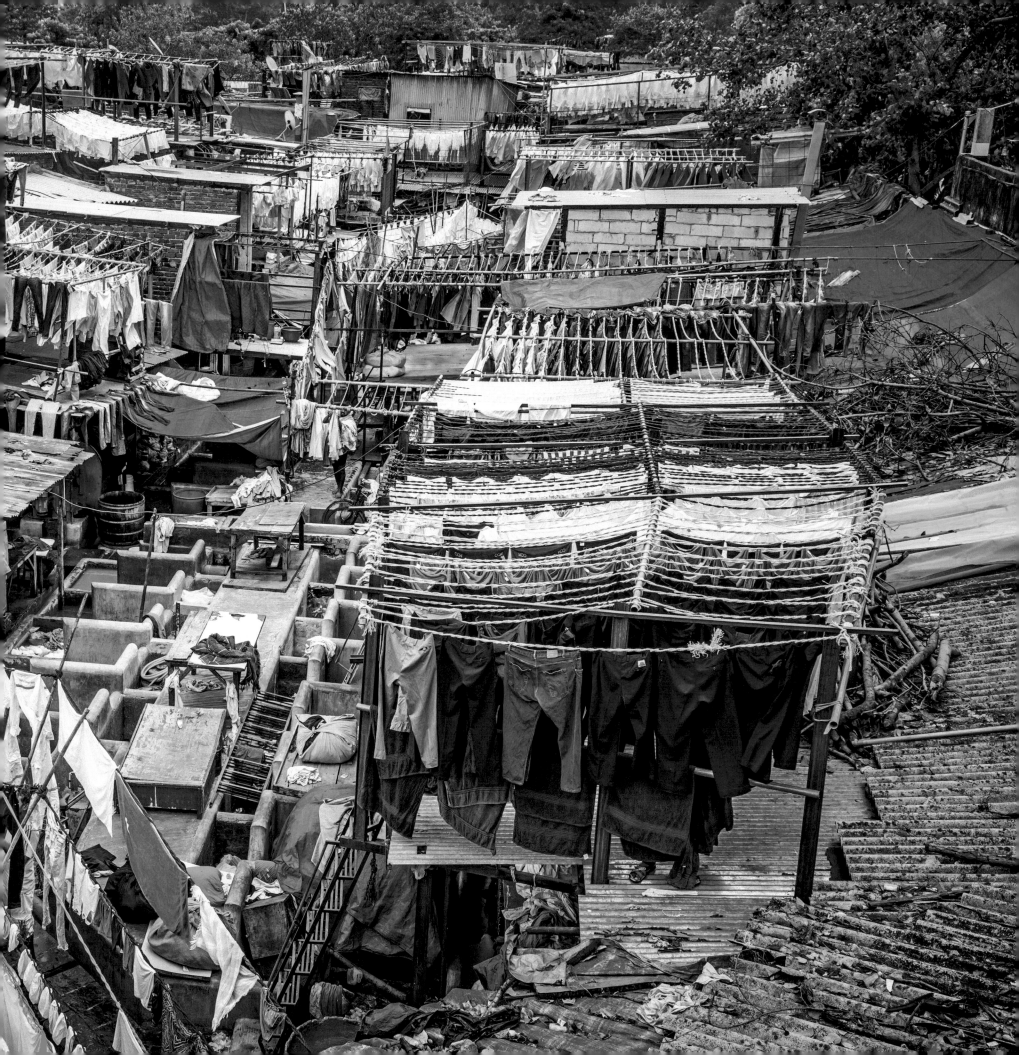

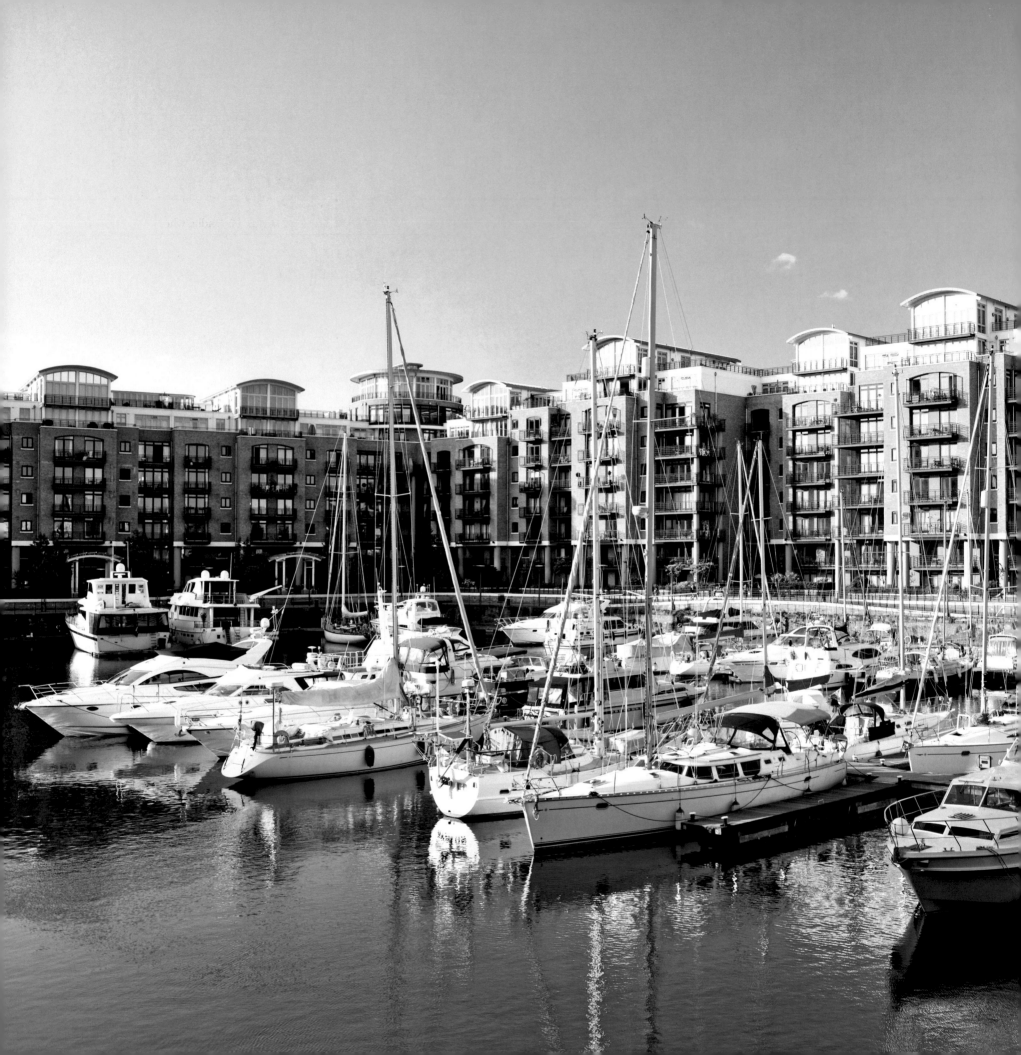

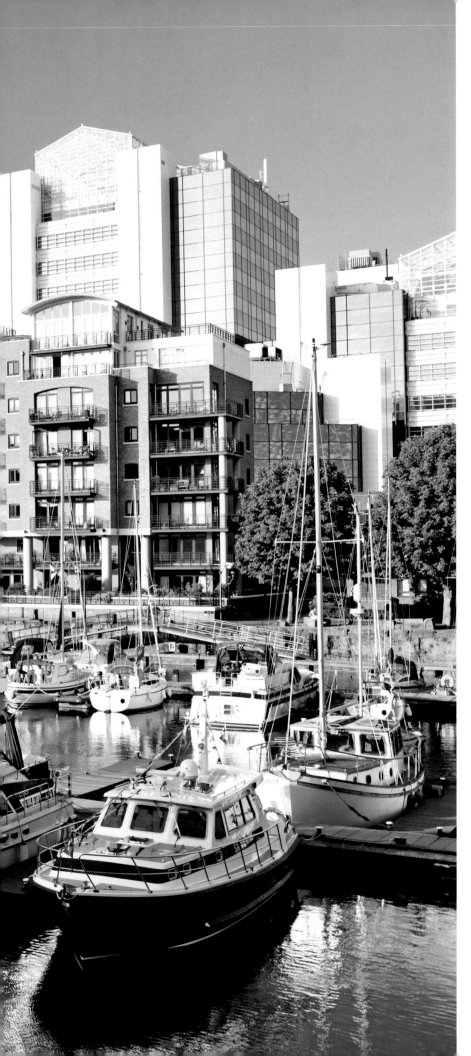

its income and living standards, allowing millions to shop in glitzy Western malls like the Quest Mall in the centre of Kolkata. But cheek by jowl with this modern retail city are slums containing some of the poorest people on Earth – one and a half million souls – trying to survive on just a few dollars a day. Even in an open and democratic country like India, where anyone is free to go shopping at somewhere like the Quest Mall, for the poor and the destitute such a place is a truly secret world.

The Streets of London

In recent years, London has seen an extraordinary building boom, with legions of residential towers going up all over the city, though even the most basic apartments in those buildings are still beyond the pockets of ordinary Londoners. It is well documented that many remain unoccupied, bought as investments by wealthy cash buyers with no intention of living in them and no need to rent them out for income.

At the same moment as all these shiny new blocks are going up and staying empty, London's homeless population is also on the rise, with more than 300,000 people classed as homeless in late 2017. One of the most striking sights of late twentieth-century London was an area known as Cardboard City, a concrete pedestrian underpass, beneath a roundabout next to Waterloo Station, where as many as 200 of the capital's rough sleepers would come together every evening for communal safety and warmth. In 1998, this very visible reminder of a problem that is alarming to contemplate in such a rich society was removed, and the people who gathered there were evicted and mostly rehoused. But if their secret city, rebuilt every evening from the only available material, was swept away for good, in recent years the social inequality that caused it has only worsened, as two decades later around 1,000 people still sleep rough every night on the streets of one of the wealthiest cities on Earth.

Left: Luxury flats, City Quay, and yachts moored in the east dock marina, St Katharine Docks, London, UK.

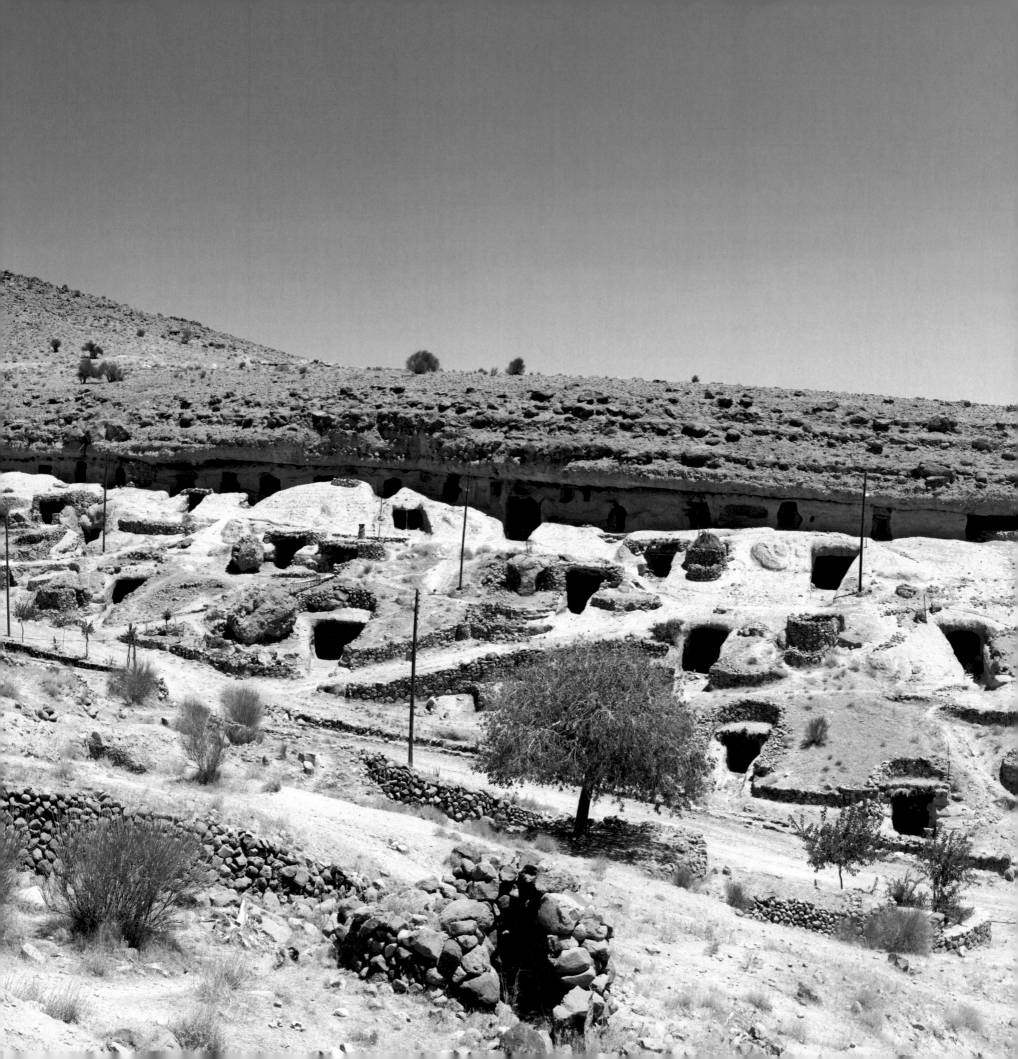

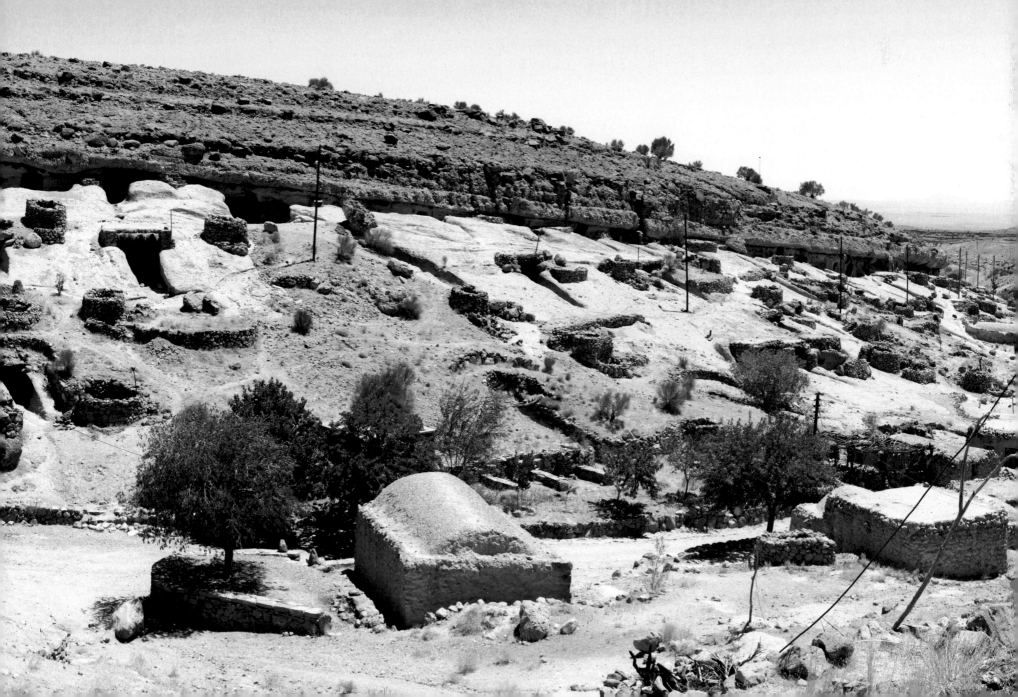

Going Underground

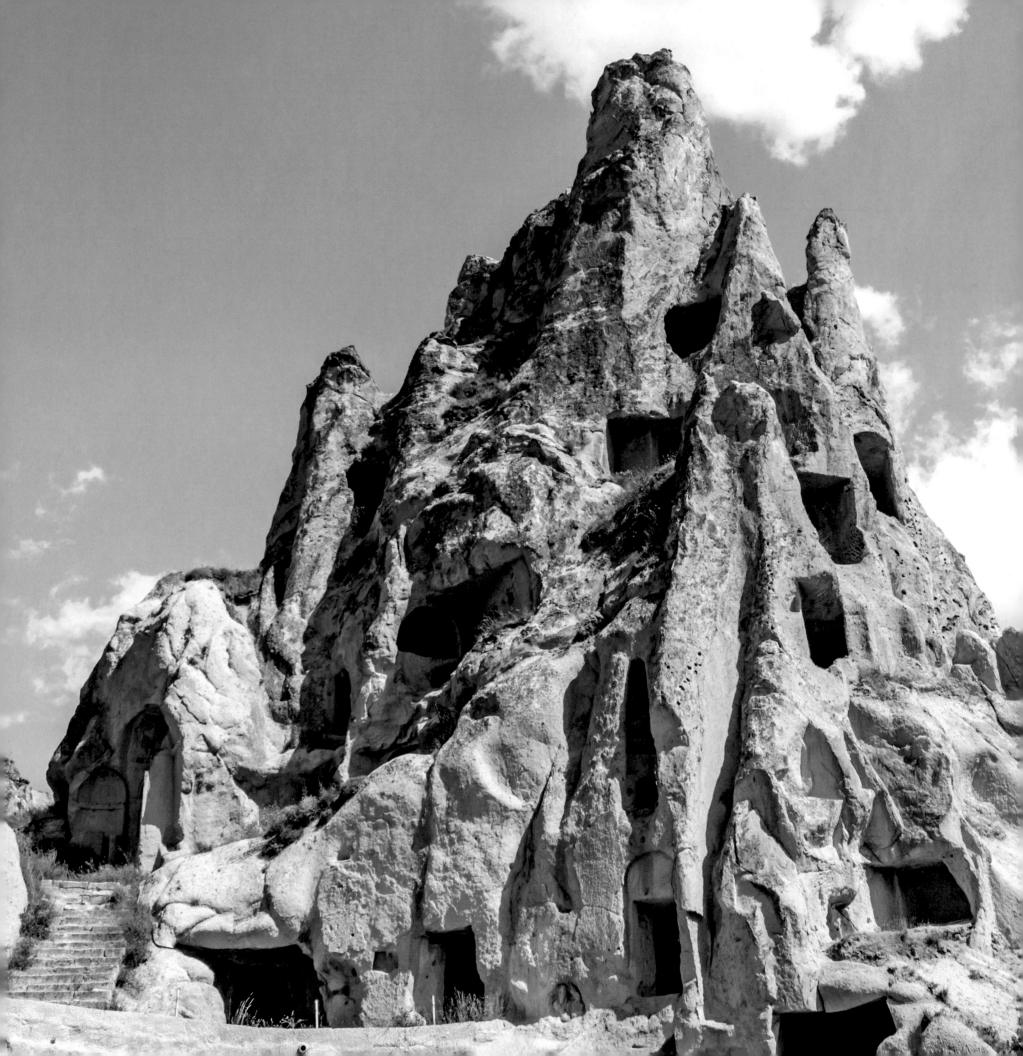

Underground Refuge

Humans are both an adaptable and a resourceful species. When life above ground becomes difficult, sometimes the only solution is to dig in and sit tight until things get better.

The Underground Cities of Cappadocia

Above ground in the Göreme National Park in Turkey, the evidence of unconventional living is striking enough. The area is famous for its fairy chimneys, towers of time-weathered rock in which early Christians fleeing persecution dug out extraordinary dwellings that seem to have come straight from some children's bedtime story.

In fact, the soft volcanic rock, known as 'tuff', was so easy to carve that the communities who'd found shelter in the chimneys began burrowing into the ground as outside threats increased. Over centuries, huge underground cities developed in the region, especially those at Derinkuyu, Kaymaklı and Özkonak – all close to the modern city of Nevşehir. Originally created to protect the inhabitants from attacks by various rampaging empires over many centuries, the entrances were concealed behind huge rolling rocks.

The habit of occasional subterranean living is thought to have continued until the twentieth century, when Christians were forced to leave modern Turkey after the First World War. In the largest of these cities, at Derinkuyu, it is estimated that as many as 20,000 people may have inhabited the network of chambers constructed over five levels, with such facilities as water

Previous page: Meymand troglodyte village, Kerman Province, Iran.
Left: Fairytale chimneys in Cappadocia, Turkey.

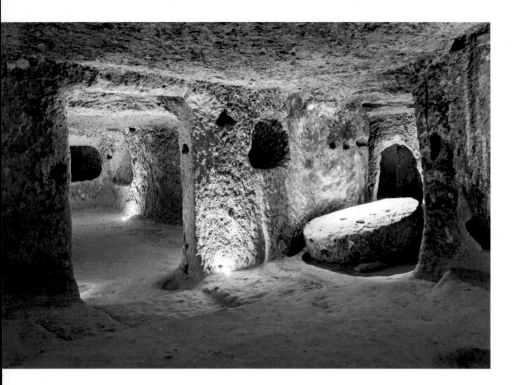

Above: The Derinkuyu underground city is an ancient multi-level cave city in Cappadocia, Turkey.

wells, wine cellars, olive presses, stables for livestock and, vitally, a ventilation system, allowing the huge population to survive in relative comfort for extended periods of time. When Turks took over the now-abandoned towns above ground in 1923, it was some 40 years before anyone discovered a secret entrance to this subterranean world. Since then more than 200 such cities have been unearthed in this part of southern Turkey.

The Refuge City of Ouyi

The underground city of Ouyi at Nushabad, in Isfahan province in central Iran, was originally carved on the orders of one of the Sassanian kings, whose dynasty was the last to rule ancient Persia, from the third to the seventh centuries, before the dramatic ascendancy of Islam. Temperatures in this region can reach extremes of heat in the daytime and cold at night,

Right: A passageway in Ouyi underground city, Nushabad, Iran.

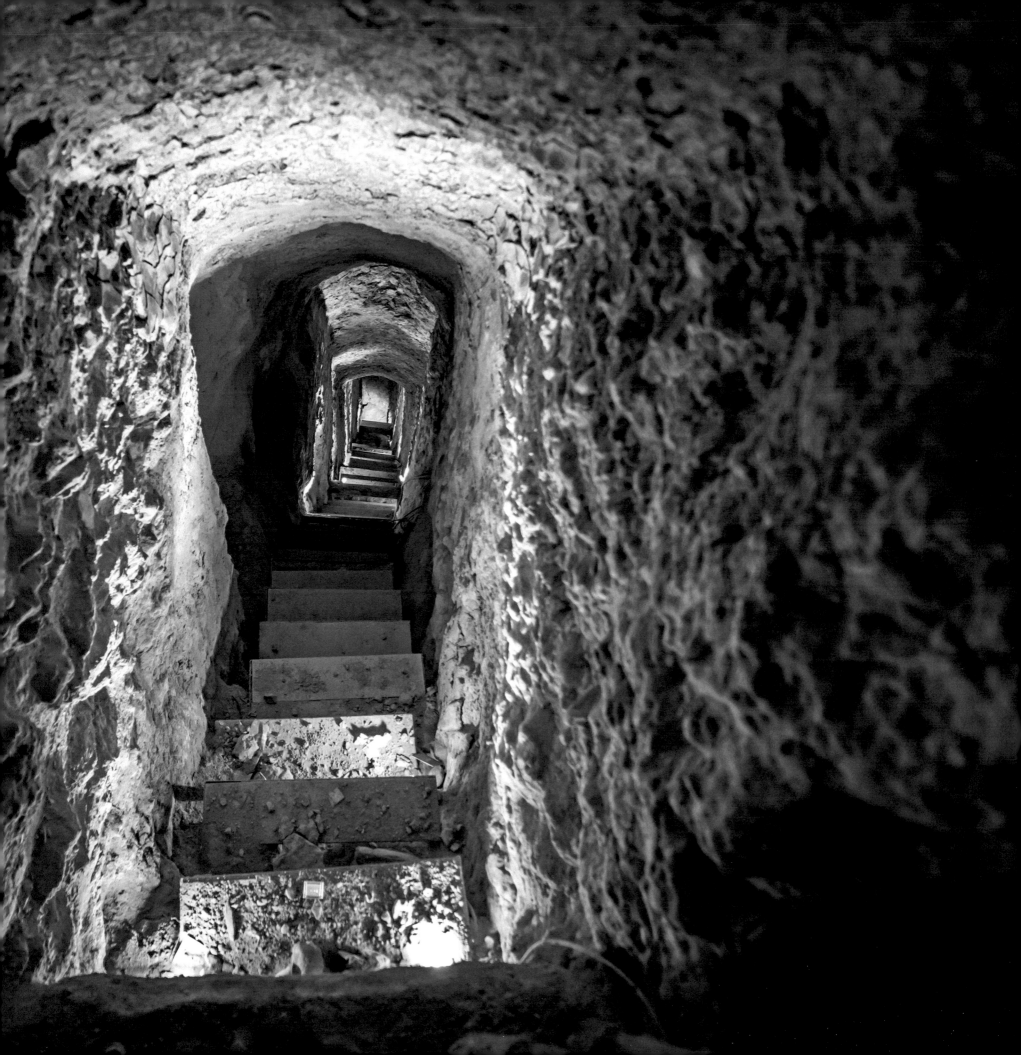

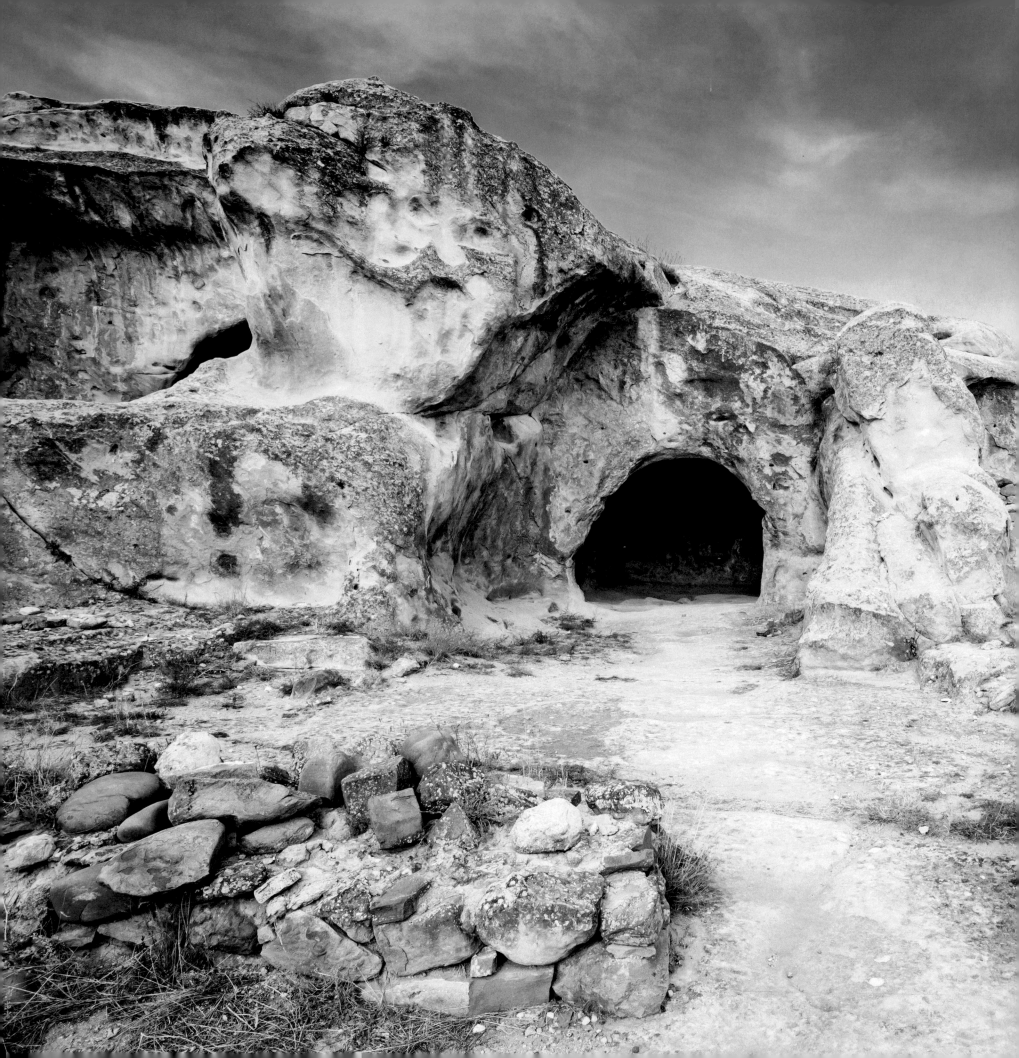

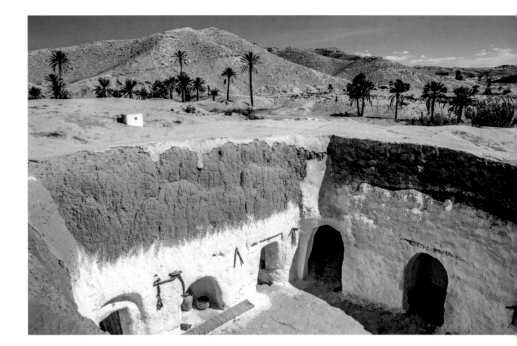

Above: *View of a traditional underground Berber house in the Sahara Desert, Tunisia.*

so the idea of creating an underground city as temporary refuge from harsh conditions made perfect sense. But as the citizens of Nushabad soon found, the hidden complex could also protect them from marauding attacks from the Muslim Arabs who succeeded the Sassanian Empire in this area. And when the Mongols invaded some six centuries later, just a few years before Marco Polo himself came this way *en route* to China, the subterranean city hid them again.

At some point in the 1920s the underground city was abandoned and for some reason completely forgotten by the residents of the town. Like the cities of Cappadocia, it was only rediscovered by accident, in this case a mere decade ago. Dug out on three separate levels between 4 and 18 metres (13 and 60 feet) deep, the ingeniously designed network of chambers and tunnels was excavated over time around a natural spring

Left: *Uplistsikhe was carved out 3,000 years ago by a pagan people inhabiting this region of modern Georgia. The arrival of Christianity and then Islam also left their mark on this troglodyte city, which at its height accommodated some 20,000 people.*

and was well equipped with water pipes and toilets. With a ventilation system and ample storage space for food, the town afforded its population a long-term underground shelter from the deadly threats above.

The Sanctuary City of Naours

More than 20 metres (66 feet) below ground in the village of Naours, near Amiens in northern France, is a network of 28 galleries and 300 rooms. For centuries these underground spaces served as a refuge from war, from shortly after local miners first created them in the Middle Ages to the unknown date when they were last occupied. Whenever that was, it must have been later than the Thirty Years' War of 1618–48, the deadliest European conflict prior to the twentieth century, when the population of the underground city swelled as a terrified populace took to the tunnels to escape the murderous hatred that was tearing the continent apart.

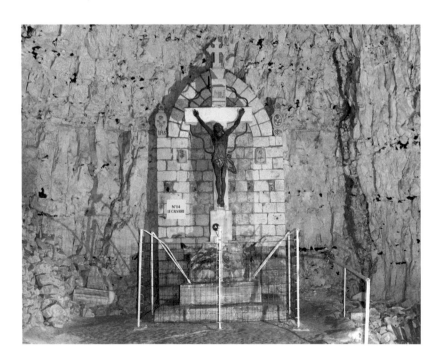

Above: Statue of the crucified Christ in the underground city of Naours, France.
Right: The residents of Orvieto, Italy, a city inhabited for more than 2,500 years, have been digging out spaces beneath its streets for almost as long. The underground city comprises more than 1,200 excavated spaces, including galleries, cellars and wells.

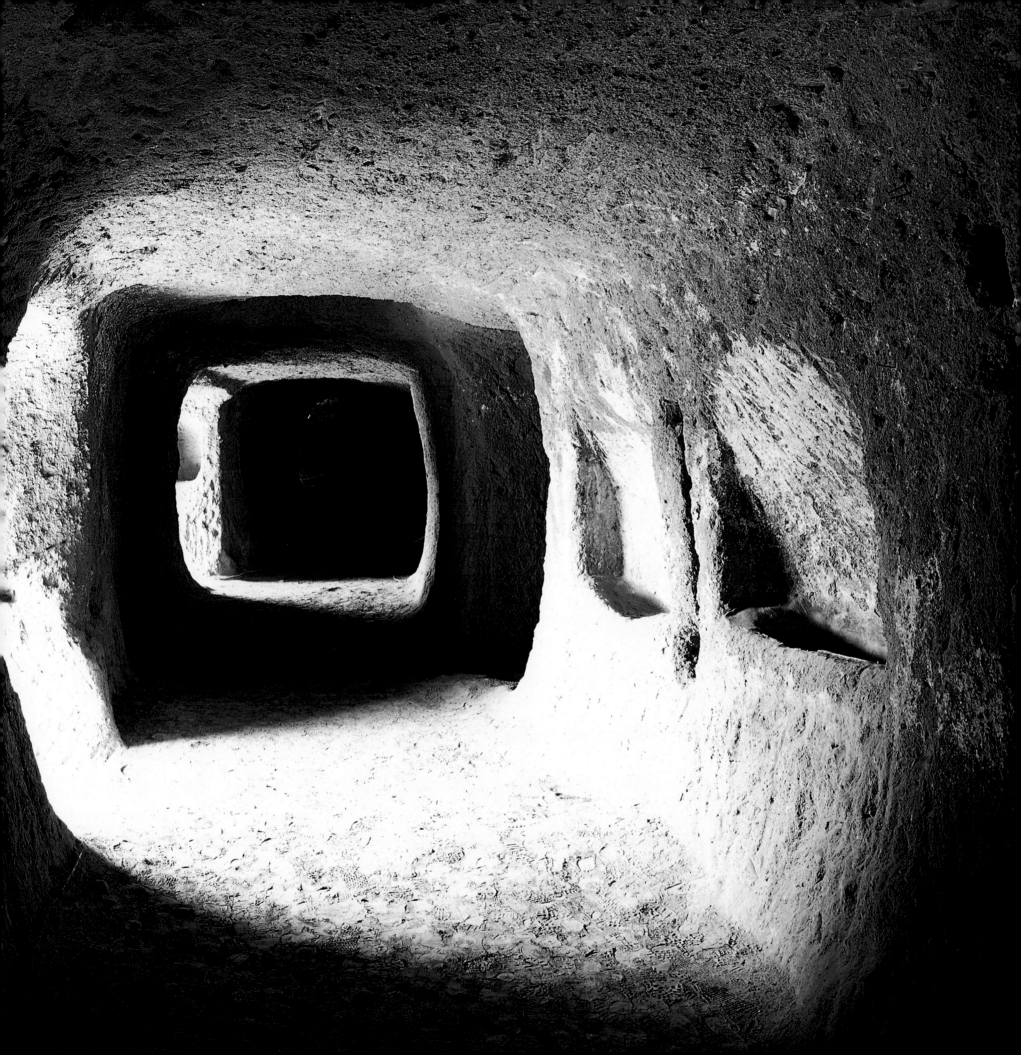

The extensive settlement included three chapels, several 'town squares' and even a bakery whose chimneys emerged above ground, concealed within existing structures in what even today is a deceptively small village. Forgotten like those elsewhere when it was no longer needed, the hypogeal city was rediscovered in the late 1880s and soon became a tourist attraction. Less than 30 years later its location placed it very close to Allied lines on the Western Front, where tunnelling had become a lethal technique of war. But for Allied soldiers stationed on the Somme, a visit to the historic tunnel city of Naours proved a welcome diversion in the periods of rest before they returned to the trenches, and the English names graffiti-ed on the walls date from this time.

The Outlaw Tunnels of Little Chicago

Today's Canada is a beacon of liberal tolerance, but it wasn't always so. Chinese labour had been vital in the building of the Canadian Pacific Railway, but as soon as it was finished, legislation in the form of a 'Chinese head tax' was passed to restrict immigration into the country. By the early twentieth century, anti-Chinese sentiment had got so bad that poor Chinese immigrants in Moose Jaw, Saskatchewan – today a city of some 34,000 people but then a true frontier town – began to dig themselves an underground refuge to escape the unpayable tax and the hostile and sometimes violent attentions of white Canadians.

Whole families lived in this provincial underworld, as Chinese immigrants worked illegally in Chinese-owned laundries and restaurants above ground, which they accessed through secret doors unknown to the Moose Jaw city police. Then in the 1920s, during the years of Prohibition in the USA and large parts of Canada, gangsters from Chicago, including the legendary Al Capone, used the obscurity of this Prairie city to unload their shipments of

Left: A dilapidated store front in Moose Jaw, Canada. Premises such as these were connected by the underground tunnels that protected illegal Chinese immigrants.

bootleg booze, and would while away whole days and nights in the safety of the tunnels, gambling and enjoying prostitutes in the Stygian gloom. As elsewhere, the tunnels were eventually forgotten by the people of Moose Jaw, until a hole in the road in the 1970s revealed the existence of 'Little Chicago', the secret city beneath their feet.

The Storm-Drain City of Las Vegas

Throughout its history the United States has often been a cruel place to live, where the American Dream of making a better life is set against the not uncommon prospect that failure or hard luck will serve up something worse. In the 1930s, the destitution of millions during the Great Depression led to President Roosevelt's New Deal and a post-war settlement that brought rising prosperity to a growing middle class. However, the erosion of that settlement in recent decades has led to as many as half a million people living homeless in America, many of them very visible in places like the infamous Skid Row in Los Angeles, where the poor and the desperate have gathered in droves since the 1880s, and where as many as 8,000 homeless people live today.

In any society, to be homeless is to be vulnerable to abuse and ill treatment. So in Las Vegas storm drains beneath the city have offered refuge in recent years to an increasing number of people whose often tragic circumstances – unemployment or bereavement, drug addiction or divorce – have forced them on to the streets. The storm drains are wide enough for people to set up home in this dingy environment. But given the purpose they were built for, the subterranean homesteaders well understand that heavy rain in the city could wash away the few possessions they have. Meanwhile, every night in the casinos above their heads, millions are gambled as if the good times that were promised are just one big win away.

Right: A homeless services case manager looks around inside an underground storm drain beneath the city of Las Vegas, USA.

Business as Usual

In commerce and trade, a hostile climate or simply a need for more space than is available on the surface has led many to move their activities below ground, where business has often thrived.

The Underground Mall Cities of Toronto and Montreal

Canada is one of the coldest countries on the planet but also one of the wealthiest. Even Canadians can be put off shopping at street level when the temperature is 20 degrees below zero, so several of the major cities have extensive retail and other facilities spread out beneath the streets. In Toronto in Ontario the first underground walkway was built as long ago as 1900, but by the 1960s this was a crowded city in wintertime, as well as a cold one. By then, too, the new office blocks that today loom large in downtown Toronto were forcing out small business owners, so the city planner at the time decided to develop the few existing walkways into an extensive underground city of concourses and retail spaces, known as PATH. Today this has grown into a shoppers' paradise, a city beneath the city, with over 30 kilometres (18.5 miles) of shopping arcades and more than 1,200 separate retail outlets, linking several hotels and entertainment venues, as well as subway stations and above-ground department stores.

It is claimed that PATH is the largest retail complex in the world, an accolade which might in fact apply to RÉSO, the underground city below the streets of Montreal, Canada's second-biggest city, in the neighbouring

Left: PATH underground shopping complex and tunnel network, Toronto, Canada.

Above: RÉSO Underground City, the world's largest tunnel complex, which connects 60 buildings in Montreal, Canada.

Canadian province of Quebec. Its various subterranean neighbourhoods were built at different periods and as such are not all linked into a single, continuous whole. But with some 2,000 shops and restaurants and 32 kilometres (20 miles) of walkways connecting to the city's major attractions, 'La Ville Souteraine', as it is known, is where many Montrealers prefer to hang out during the long Canadian winter.

The Opal Capital of the World

If extreme cold is a problem in Canada, extreme heat is what forced the denizens of Coober Pedy in South Australia below the surface. Being a community used to working below ground, this has not proved much of

Right: The Chicago Pedway is a system of tunnels, concourses and covered bridges across more than 40 blocks in the centre of the Windy City, allowing people to access stations, shops and restaurants without having to brave Chicago's bracing weather.

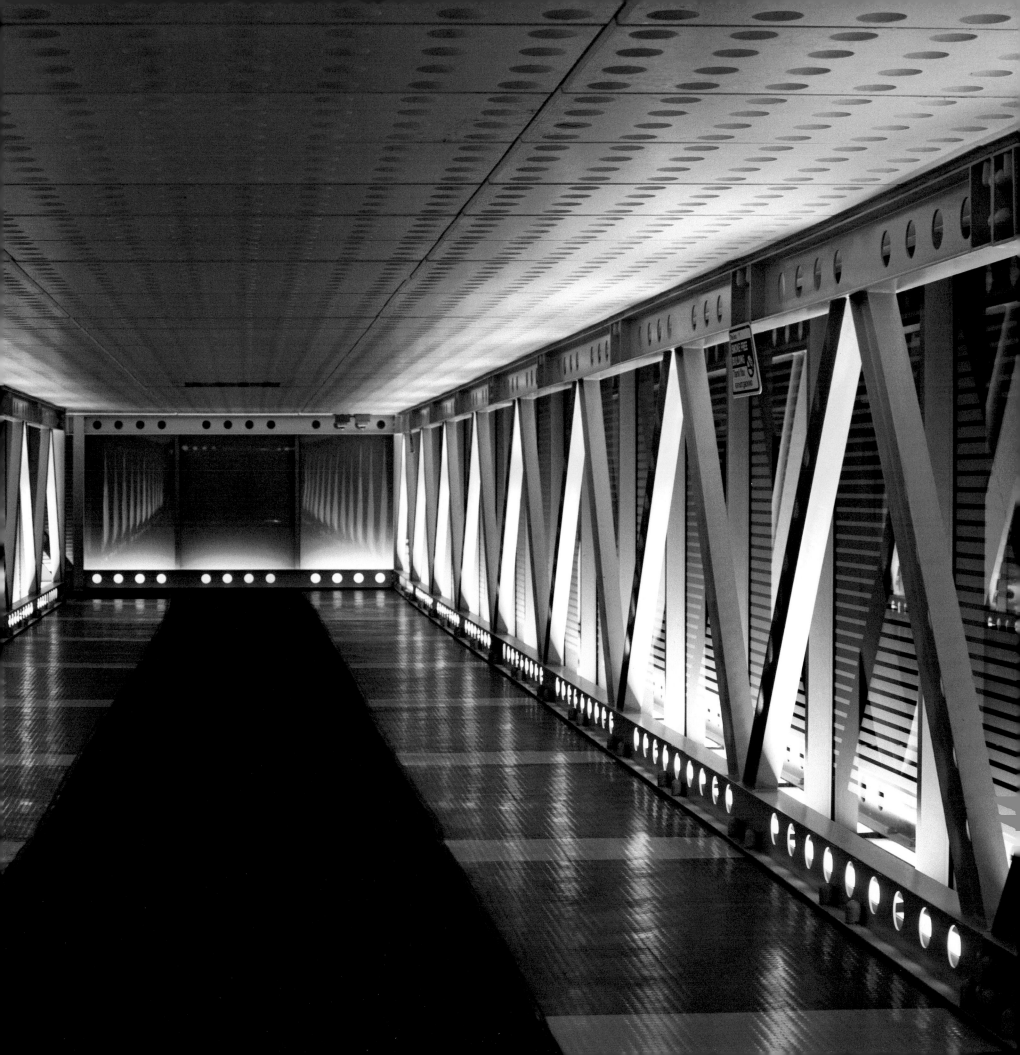

a hardship, and the underground town is well equipped with shops, a bar, a restaurant, even a hotel, and various other trappings of a normal, modern life.

Known as the 'opal capital of the world' for the quantity of gem-quality opals that are mined here every year – amounting to most of the global supply – the desert town lies some 850 kilometres (528 miles) north of Adelaide on the road to Alice Springs. It was founded in 1915 when the first opal was discovered by a 14-year-old boy, and soon there were hordes of prospectors flocking to the area. Unusually perhaps, the bonanza lasted throughout the ensuing century and today there are some 70 separate fields still being actively worked. But with daytime temperatures often rising above 40°C (104°F) and humidity of sometimes no more than 20 per cent, it is not surprising that the residents of Coober Pedy choose to live in the cool sanctuary of underground dwellings known as dugouts. A town of fewer than 2,000 people of 45 nationalities, mostly of European descent, in the local Aboriginal language – and with more than a hint of irony – its name means 'white fella's hole in the ground'. Even today, it is possible to turn up here, stake a claim and start digging for the gems that could make you rich, though given the conditions perhaps the first thing to dig yourself is a home.

Wieliczka Salt Mine

If the miners of Coober Pedy can hope of one day striking it lucky, then the salt miners of Wieliczka near Kraków in southern Poland could only look forward to decades of the same daily toil, 300 metres (980 feet) underground. Worked continuously from the thirteenth century until it closed in 2007, the Wieliczka mine has a long history beginning with the legend of a medieval Hungarian Princess named Kinga. It is said of her that she dropped her ring into a mine in Hungary, then arriving in

Left: Underground bar, Coober Pedy, Australia.

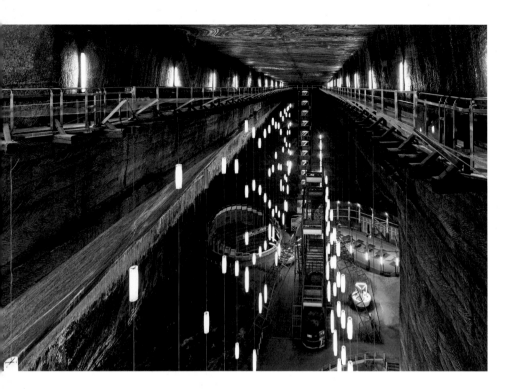

Above: Another re-purposed former salt mine, Salina Turda, in Turda, Romania.

Kraków to marry her future husband she instructed the miners to dig in a certain spot at Wieliczka, where of course they found the ring. As the story goes, they immediately carved a salt statue to the future St Kinga. This now stands in the chapel in the mine that is dedicated to the saint. With its cavernous space and lit chandeliers, again carved from crystal rock salt, the chapel of St Kinga is perhaps the most impressive of the four carved chapels of Wieliczka, which collectively are often referred to as an underground salt cathedral.

Though pieces by contemporary artists have been added in recent years, in truth, some of the miners who fashioned salt artworks in the preceding centuries were every bit their equal, and the mine's fame over time has drawn eminent visitors like Copernicus and Goethe. During the Second

Right: The Chapel of St Kinga is the most famous chamber in the underground Wieliczka salt mine, now museum, in Poland.

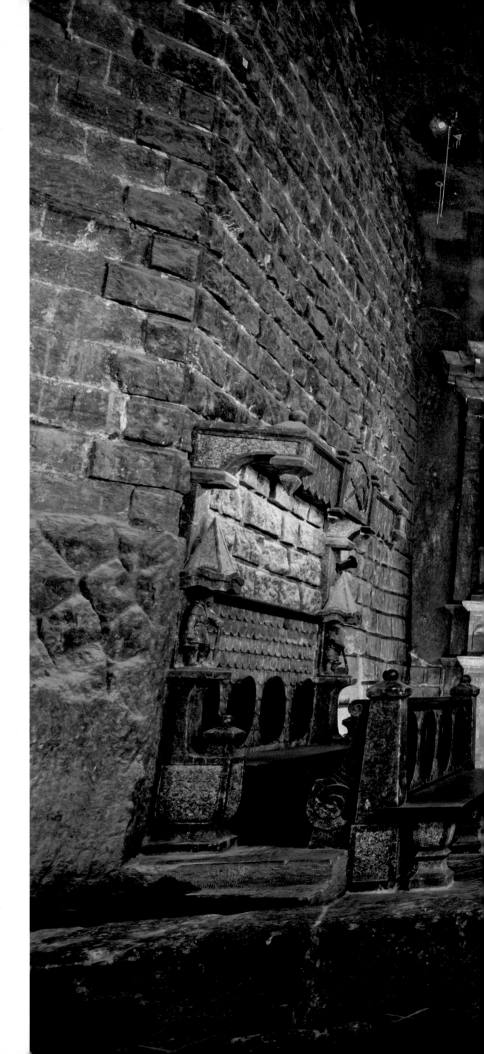

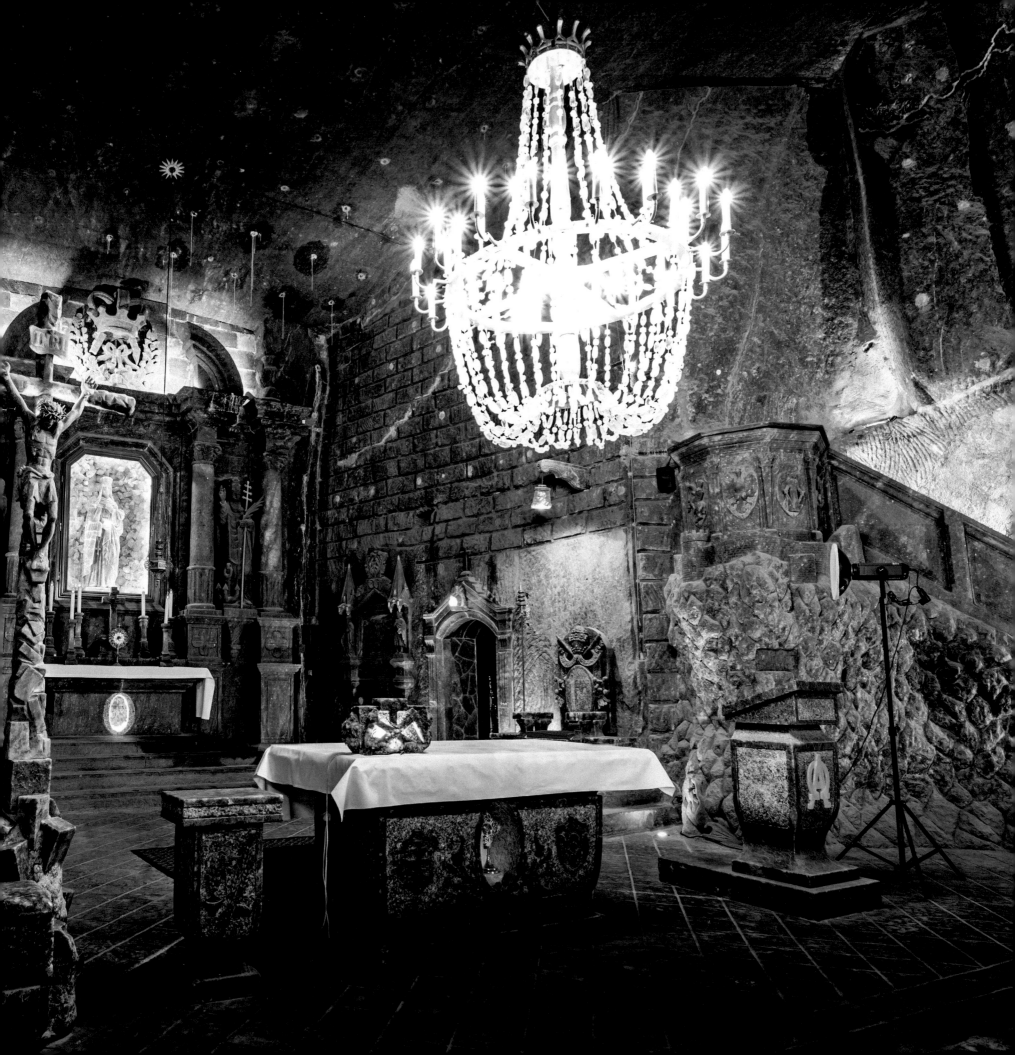

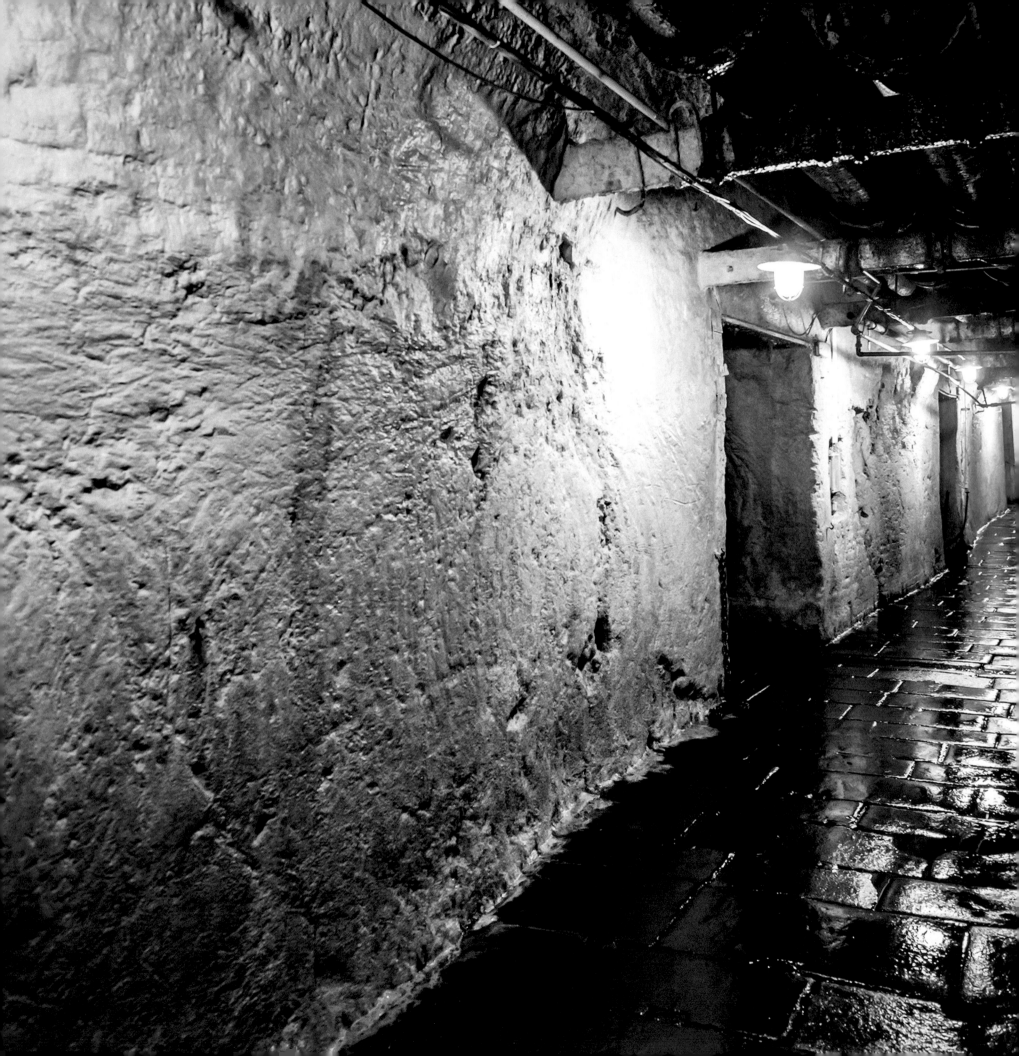

World War, Wieliczka would have become a secret Nazi armaments factory worked by forced Jewish labour had the Soviet advance not put a stop to the plan. The mine survived the experience and today is admired around the world as an artistic masterpiece fashioned by a thousand hands.

US Data Mines

Some old mines find a second life when whatever was being extracted there finally runs out. In Livingston, New York State in 1951, a mushroom grower named Herman Knaust bought a depleted iron ore mine for $9,000 to turn it into an underground farm in what would have been ideal conditions for growing mushrooms. But he soon identified a more lucrative

Left: In the town of Pilsen in the Czech Republic, beginning in the thirteenth century, a 19-kilometre (12-mile) network of tunnels for storage and transportation – the largest in Central Europe – was constructed beneath the world-famous brewery.
Below: Iron Mountain's storage facilities, housed in a former limestone mine in Pennsylvania, USA.

opportunity – exploiting fears about an imminent nuclear war – and set about converting the former mine to an underground storage space, which he called the Iron Mountain. The business, Iron Mountain Atomic Storage Inc., took off, and three years later Knaust bought a former limestone mine, this time in Boyers, Pennsylvania, where today, among others, the United States Office of Personnel Management houses vast archives of records of government employees.

In Kansas City, meanwhile, in America's Midwest, a man-made cave dug into another old limestone mine is claimed to be the largest underground

Above: The unused portion of a working salt mine nearly 200 metres (650 feet) below Hutchinson, Kansas, houses Strataca (the Kansas Underground Salt Museum) and the Underground Vaults & Storage business.
Right: A former military bunker in the alpine village of Amsteg in Switzerland is now the Swiss Data Safe AG, a secure underground storage facility housing data, files and archives, works of art and other assets for an international clientele.

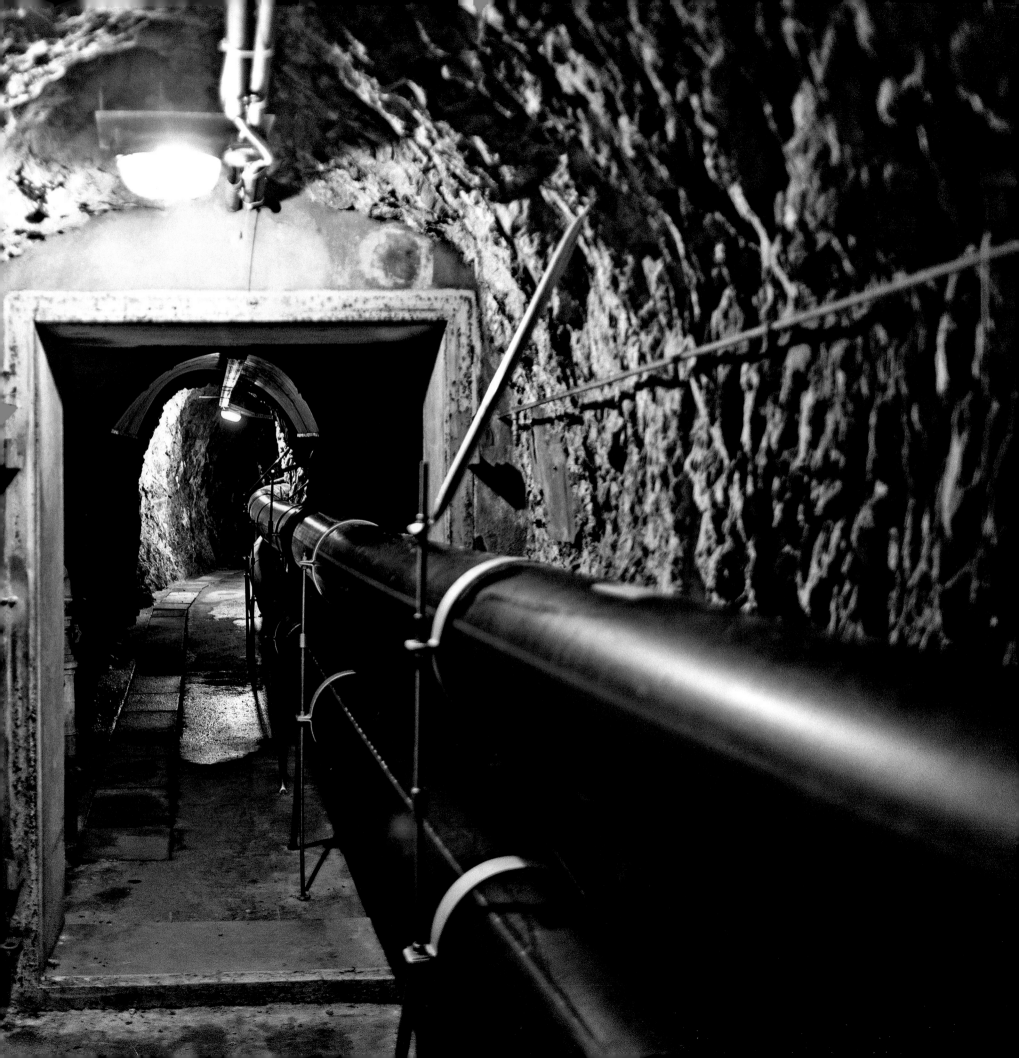

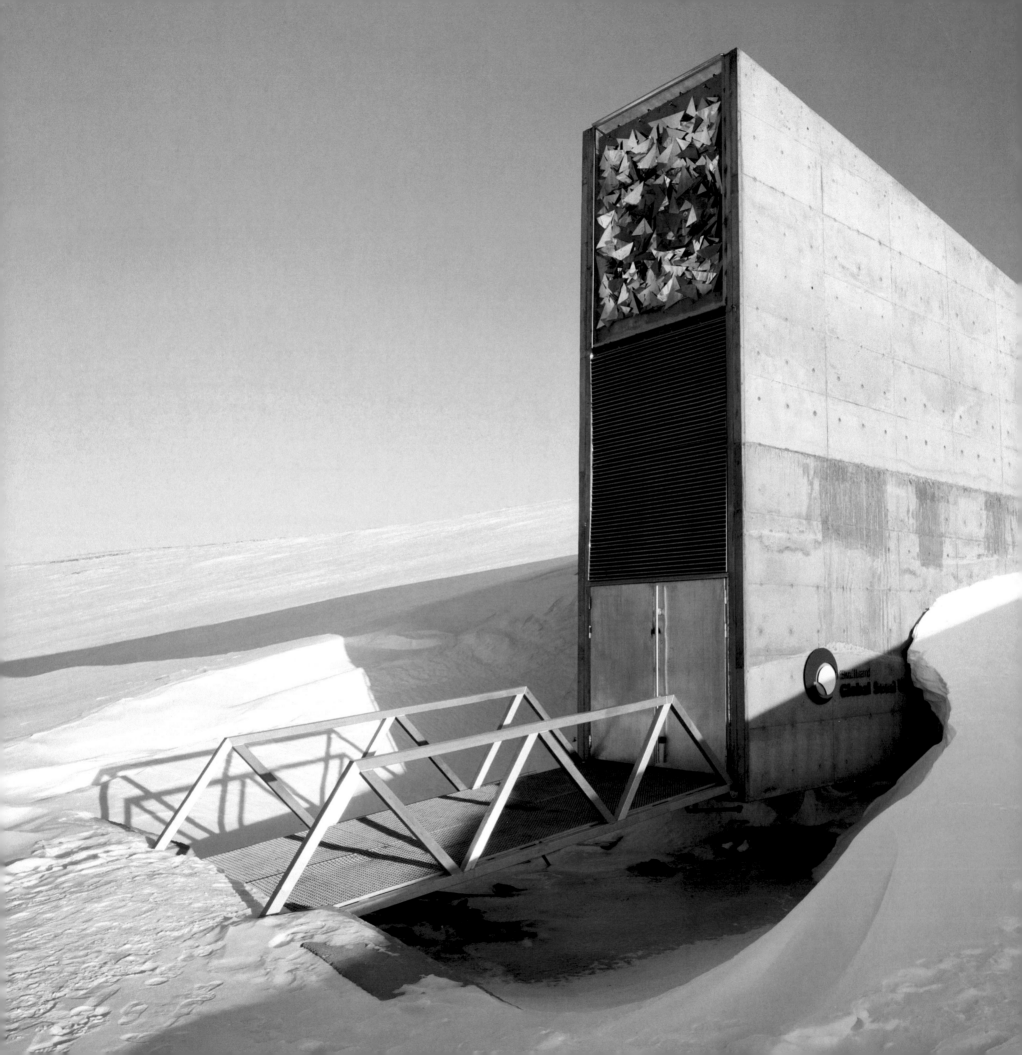

storage space in the world, a vast data city whose many clients include several more agencies of the US government as well as dozens of private firms. Known as SubTropolis, its 11 kilometres (6.8 miles) of lit tunnels and several kilometres of railway track serve a facility with 1.4 million square metres (0.5 square miles) of space, which are added to every year through active, ongoing mining.

Svalbard Global Seed Vault

Underground storage space has been hollowed out in every conceivable location, from smugglers' caves in the rocky coastline of southern England to the high-tech Svalbard Global Seed Vault deep inside the Arctic Circle. This visionary complex, which opened in February 2008, is colloquially known as the 'Doomsday Seed Vault'. It was built in an abandoned coalmine 100 metres (330 feet) inside a mountain on the Norwegian island of Spitsbergen, part of the Svalbard Archipelago and the most northerly place on Earth that can be reached by a scheduled flight. Conceived as a secure location for storing specimens of the entire inventory of global food-crop species, the seed vault currently houses examples of one-third of the total of known food crops, acting as a back-up to the 1,750 other such national seed banks stationed around the world.

Deliberately located well above sea level, the Svalbard seed city should be protected from even the worst estimates of sea-level rise over the coming decades, while the surrounding permafrost should also keep the seeds in the deep-cold environment that's needed to preserve them. But even here there are problems to deal with. In October 2016, unexpected rain in this sub-polar region not only demonstrated the kind of future threat to food security we may all have to face in a warming climate, but also came close to damaging the seeds being kept there as insurance for those times.

Left: Entrance to the Svalbard Global Seed Vault, Spitsbergen, Norway.

Cold War Bunker Cities

As we have seen, people have always taken refuge underground from hostile forces above. When the threat of nuclear war became a real possibility, governments built deep, bombproof bunkers where large numbers could survive until radiation had diminished to safer levels.

Project Greek Island

Most people living in democratic countries are grateful for the freedoms they enjoy, among them the societal benefits of a free press. No press culture is freer than America's, where ensuring the right to freedom of speech was the first amendment made to the US Constitution in 1789. A free press can be a gadfly to populist leaders and a nuisance to governments, as it was in 1992 when the *Washington Post* revealed the site of a secret bunker complex beneath a luxury hotel in West Virginia, which the US government would have liked to remain hidden.

It was here at The Greenbrier, beginning in the late 1950s when the bunker was built, that government operatives posing as employees of a dummy private business maintained a secure facility for more than 30 years under a programme officially known as Project Greek Island. In the event of a nuclear war, the 535 members of the two Houses of Congress would reassemble in these chambers, including two that were big enough for each of the houses to sit in plenary session. There they would continue the urgent business of government in the event that the country they served had been laid waste above their heads. The concrete walls and four blast doors of the complex were thick enough torwithstand even a nearby nuclear strike. Behind them the men and women of

Right: The 25-ton West Tunnel blast door of the bunker constructed beneath The Greenbrier, now a hotel, in West Virginia, USA.

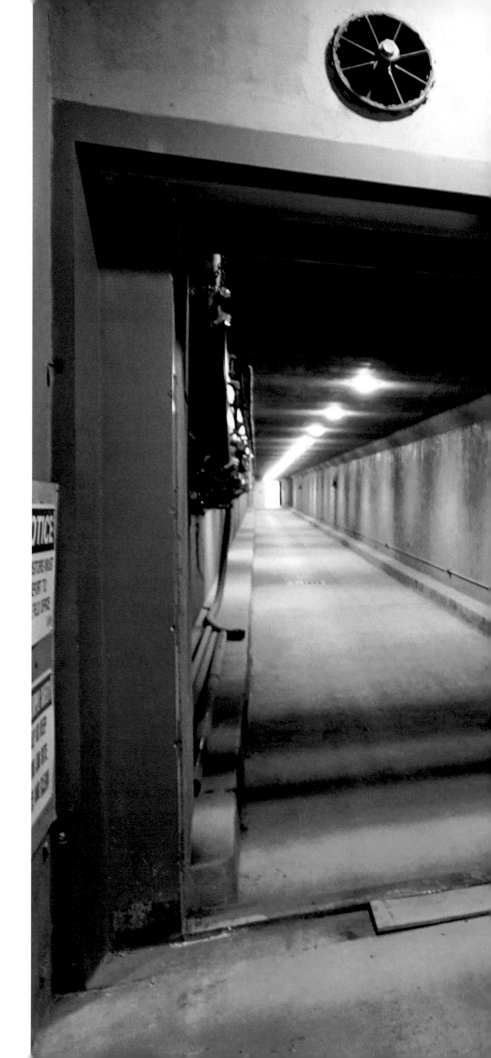

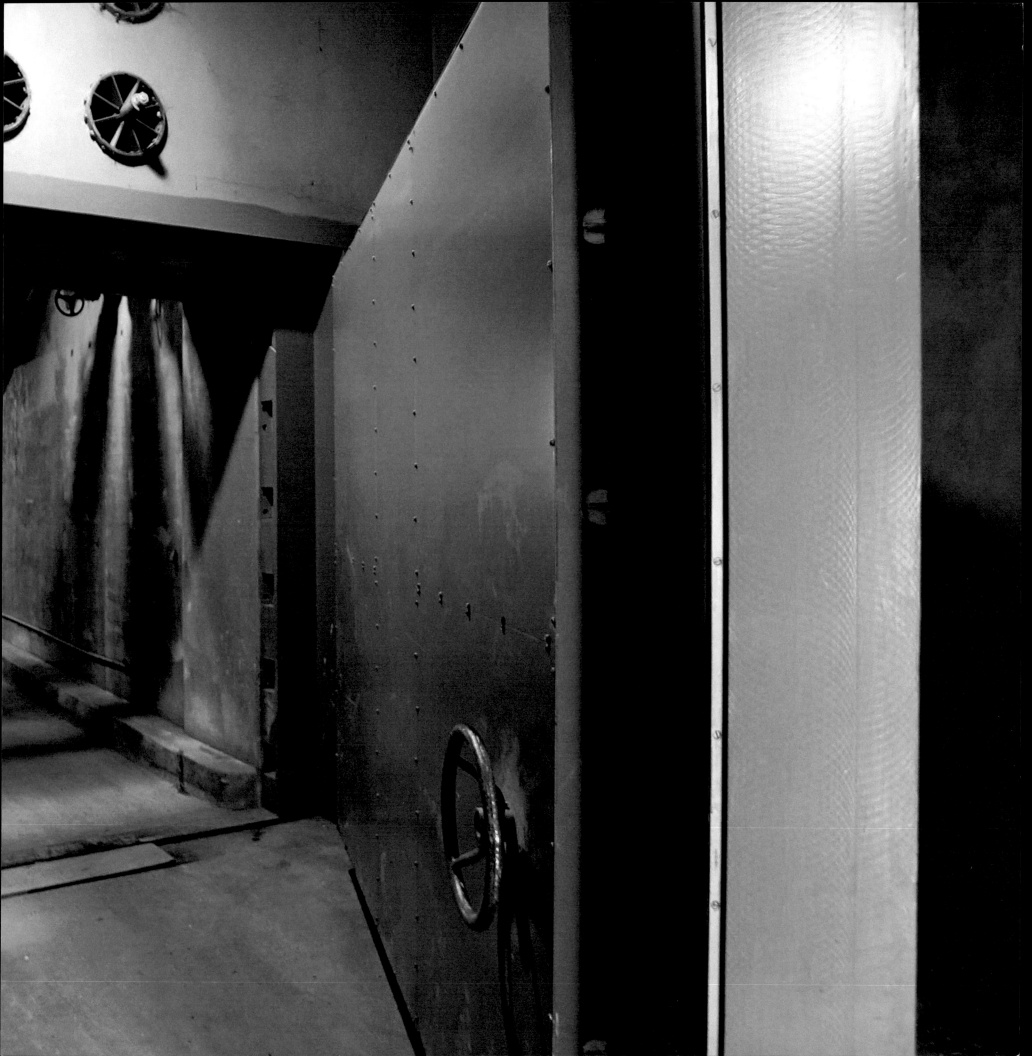

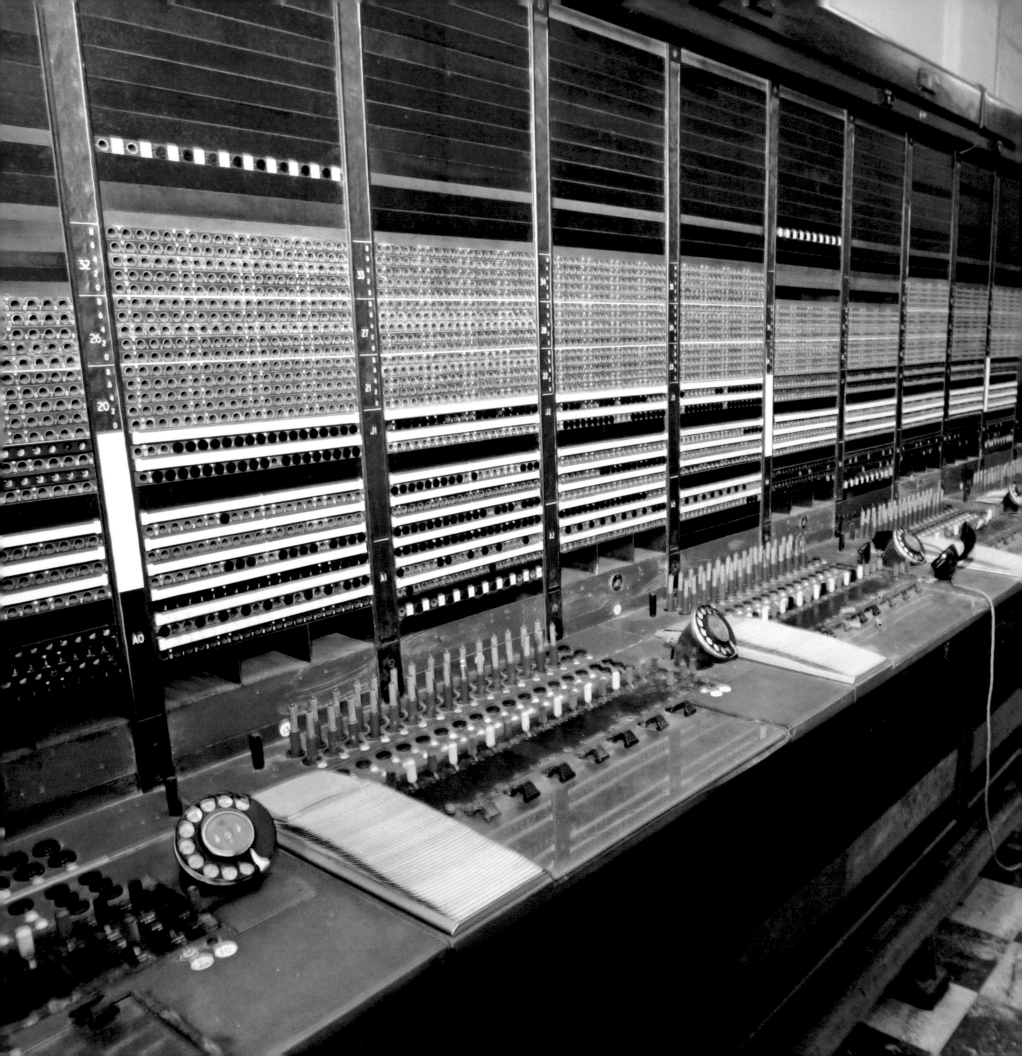

Congress could count on bunk-style living quarters and enough food for up to six months, as well as a hospital and a broadcast centre decked out to appear as if they were still in occupation of the world-famous building on Capitol Hill.

Burlington Bunker

Around the same time as construction began on the bunker at The Greenbrier, another, much bigger facility – a true underground city – was being developed below ground in an old Bath Stone quarry beneath the small market town of Corsham in the British county of Wiltshire, 160 kilometres (100 miles) west of London. Mindful of the same Cold War threat, the government of Conservative Prime Minister Harold MacMillan commissioned a secure 14-hectare (35-acre) complex, 35 metres (115 feet) below ground. There the many aspects of national government could carry on in what at the time seemed the likely event of nuclear war, until the danger from fallout had receded sufficiently to make it safe to return to the surface. The Burlington Bunker – or just 'Burlington', as it was known – featured 95 kilometres (59 miles) of roads serving more than 20 separate areas, with accommodation for some 4,000 people including quarters for members of the Royal Family, who would access the site via a specially built railway line. More importantly,

Above: *A 'street' sign in the Burlington Bunker, the now defunct government nuclear bunker built below Corsham, UK.*
Left: *The telephone exchange in the Burlington Bunker.*

perhaps, as well as the necessary working areas, there was enough food for the entire population for three months, as well as a hospital, a laundry and the second-largest telephone exchange in the UK. Someone even had the foresight to create an underground lake, to supply the anticipated workforce with fresh water, while four massive generators took care of power, lighting and a heating system that maintained a steady 20°C (68°F).

Never used, by the early 1980s the development of intercontinental ballistic missiles had made it impossible to reach Burlington from London in advance of an imminent nuclear strike, and in 2004 this secret bunker city was finally decommissioned.

Tito's Bunker

Josip Broz Tito was one of the most remarkable men of the twentieth century: the youngest sergeant major in the Austro-Hungarian Army, professional revolutionary and then legendary leader of the Yugoslav Partisans in the Second World War. From the end of the war until his death in 1980 Marshal Tito, as he was called, was Prime Minister then President of an independent Yugoslavia, which operated a particular style of moderate communism – known as market socialism – which in the 1970s and 1980s still suffered similar problems to those of the Soviet Bloc.

A dictator who was nonetheless admired by democratic leaders around the world, in 1948 Tito had dared to defy Joseph Stalin, declaring Yugoslavia to be a 'non-aligned country', separate from either the Communist East or Capitalist West. It is not entirely clear who he thought was more likely to launch missiles against his country in a nuclear war, but he took sensible precautions just the same. Over a surprisingly long period between 1953 and 1979, in the heart of a mountain behind an ordinary-looking house near the town of Konjic in modern-day Bosnia and Herzegovina, a substantial

Right: Desk in a conference room of the ARK (Atomska Ratna Komanda) Nuclear Command Bunker built between 1953 and 1979 for Josip Broz Tito in Konjic, Bosnia and Herzegovina.

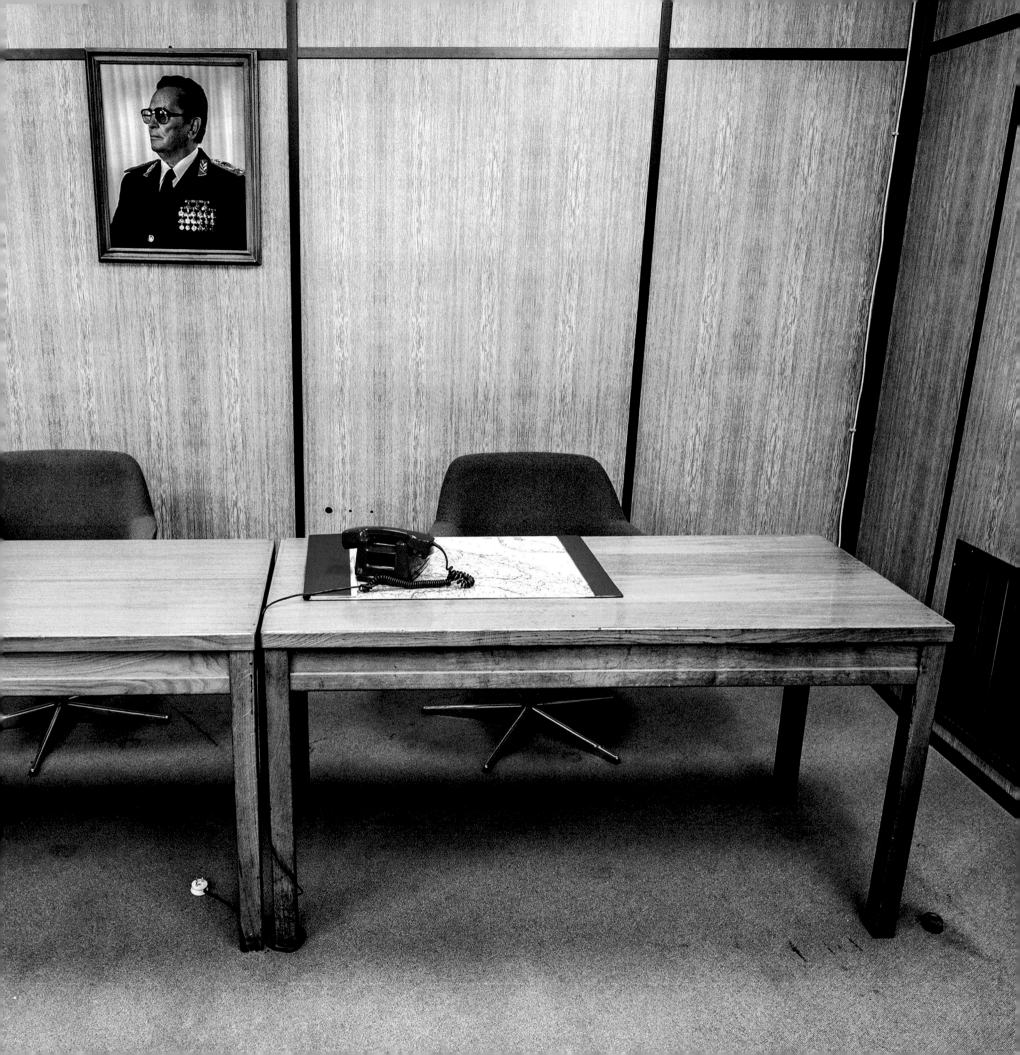

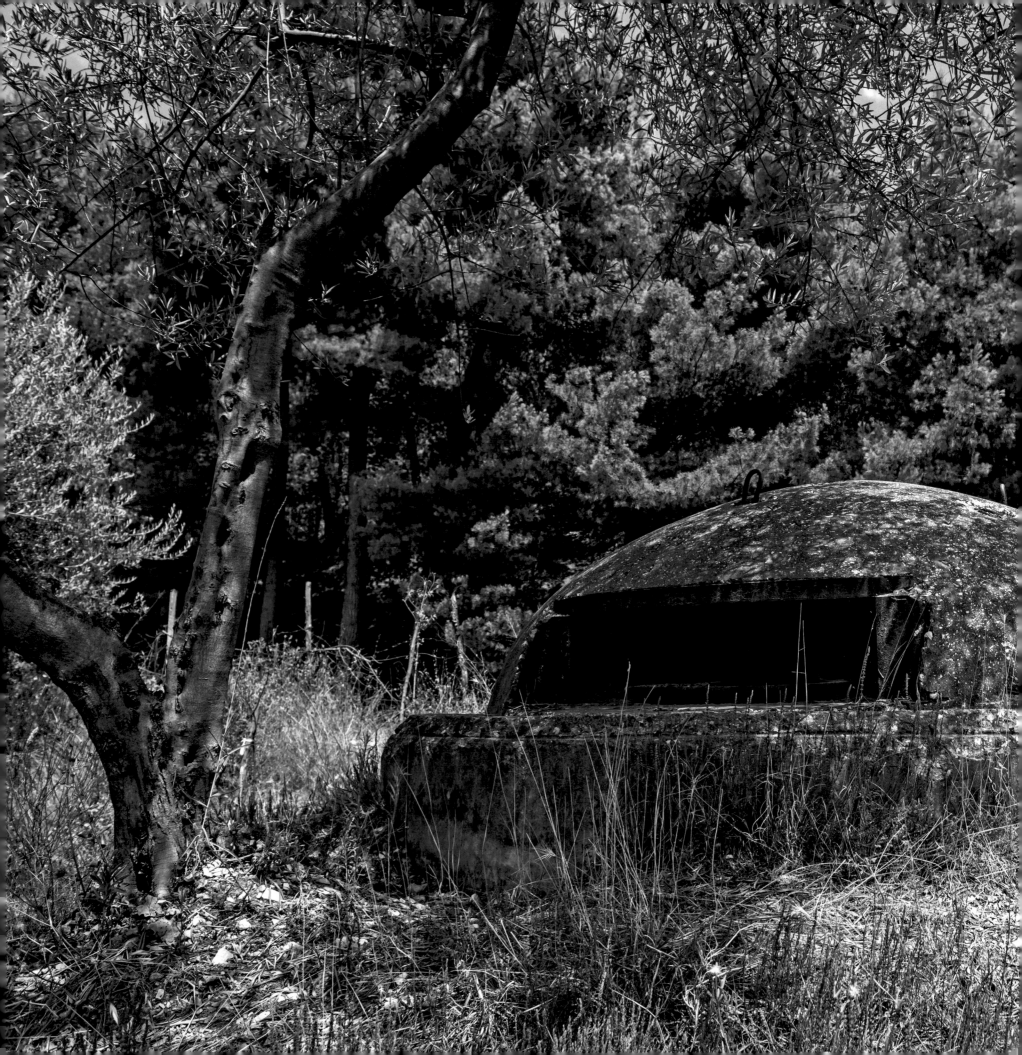

bunker known cryptically as ARK D-o was slowly and surreptitiously constructed. Intended to house up to 350 people for a period of up to six months, the bunker's existence was so secret that even the people who worked on it were blindfolded *en route*, to minimize the chance that its exact location would ever leak out. Only a handful of trusted soldiers ever knew for sure where it was, and though Tito never used it, its conference rooms and dormitories remain as testament to the preparedness and the instinct for survival of one of the most singular political figures of his time.

The Sonnenberg Tunnels

Switzerland has always been a place apart: famously neutral, landlocked, home to many global institutions; a successful modern economy with a secretive banking culture and a unique system of governance; at the heart

Left: Albanian dictator Enver Hoxha had 750,000 small concrete bunkers built as shelters for ordinary citizens of the then Communist country. Being so difficult to destroy, a huge number still litter the landscape today.
Below: Stalin came to realize a deep bunker was needed to escape the fallout that would follow any nuclear strike. So Moscow Bunker 42, covering an area of 7,000 square metres (1.75 acres), was constructed in the capital 65 metres (212 feet) underground. It is now under private ownership and used as an entertainment complex and museum.

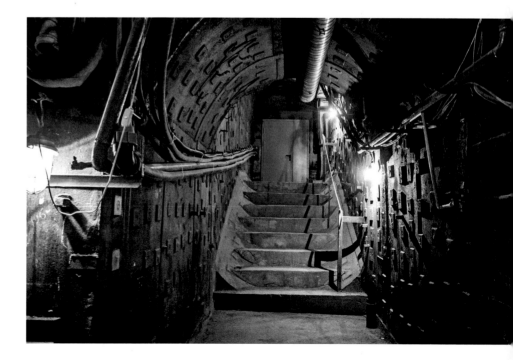

of Europe yet determinedly aloof from its politics and its wars. But even a country of such enviable prosperity and independence can be caught up in the fallout from a nuclear conflict. So, since 1963, Switzerland has had an official policy of 'bunkers for all', and more than 300,000 underground shelters have been built across the country, with the capacity to harbour the entire population (currently 8.4 million) if the worst should happen.

One of the largest, in the Sonnenberg road tunnels in Lucerne, was built to accommodate up to 20,000 people, a scenario that would see the tunnels closed to traffic while beds were set up and services activated in a seven-storey command centre constructed around the tunnels. But a test run in 1987, in the wake of the Chernobyl disaster, proved that even in a country as well run as Switzerland, the best-laid plans can go awry. Tunnels were closed to traffic, as planned, but even a week later only a quarter of the beds had been set up and one of the thick steel doors that should have sealed the tunnels from the outside world failed to close. With a new sense of realism, the shelter was downgraded to a tenth of its previous size, though doubts remain as to whether it would work were it ever to be needed.

China's Bunker Cities

Throughout the 1970s, at the height of the Cultural Revolution and China's isolation from the world, the citizens of Beijing dug an underground city beneath the capital's urban centre on the orders of their leader, Chairman Mao. Fearing attack from their fellow communists in the Soviet Union, over the course of a decade some 300,000 people using primitive picks and shovels created the sprawling subterranean complex known as Dixia Cheng, which by 1979 had expanded to cover an area of 85 square kilometres (33 square miles), between 8 and 18 metres (26 and 60 feet) below the surface. The huge hidden city was served by 90 separate entrances and would have

Right: *Red Capital Residence, a former underground bomb shelter in Beijing, China.*

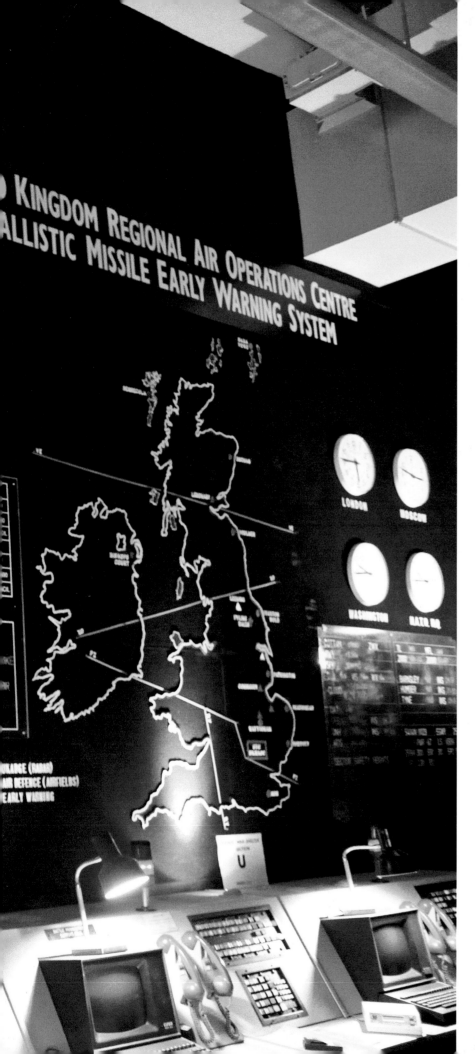

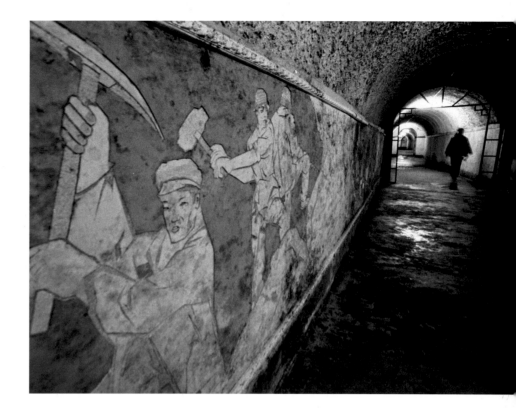

been home to hundreds of thousands, possibly millions, had it ever been used. In anticipation, it was equipped with schools and hospitals, restaurants, theatres, factories and even a roller-skating rink, though today it is officially closed.

If it is unclear whether there is anywhere else the people of Beijing can now retreat in the event of a nuclear strike, the residents of Shanghai – the lucky ones at least – are very well prepared. Completed less than 30 years later using advanced industrial methods and covering an area of some 90,000 square metres (22 acres), the underground city in China's financial hub can shelter as many as 200,000 people for up to 15 days. The range of potential threats that were cited by the city's mayor when the complex was opened included terrorist attacks and nuclear disasters, as well as deadly chemical leaks from the kinds of industrial accidents which are all too common in China.

Above: A mural dedicated to the workers who dug the tunnels that later became the Beijing Underground City in China.
Left: Warning board and computers in a decommissioned nuclear bunker in Hack Green, Cheshire, UK.

Hidden Dangers

The hide-and-seek nature of modern warfare means that it's not only people who need shelter underground – the weapons they need to fight back also need to be kept safe.

Željava Underground Airbase

Marshal Tito may belong to a different era, but the ambition of his political project can still be seen throughout the countries of the former Yugoslavia in gigantic modernist monuments to the Balkan Resistance heroes and the victims of Nazi aggression in the Second World War. More remarkable are the many secret military sites, such as the underground airbases at Slatina, near Pristina Airport in modern-day Kosovo, and Željava near Bihać, in Bosnia and Herzegovina, on the border with Croatia. Today a crumbling ruin, the Željava base – or Objekat 505, as it was known – was the largest of these, an underground airport at the centre of a network of military installations and the hub of the socialist republic's long-range, early-warning radar system.

The home base of two complete fighter squadrons equipped with Soviet Mig-21s, its four entrances were well hidden in the sides of the mountain that housed the base, enabling the aircraft to stay out of sight when stationary and to be quickly and unexpectedly launched when they were needed. The construction of the Željava base took eight years from 1957 and, when finished, its solid concrete structure could have withstood a direct hit from a 20-kiloton nuclear bomb. It could also accommodate up to 1,000 people, with provisions to survive up to 30 days inside its sealed interior.

Right: A drone shot of the abandoned airfield and underground military base in Željava, Croatia.

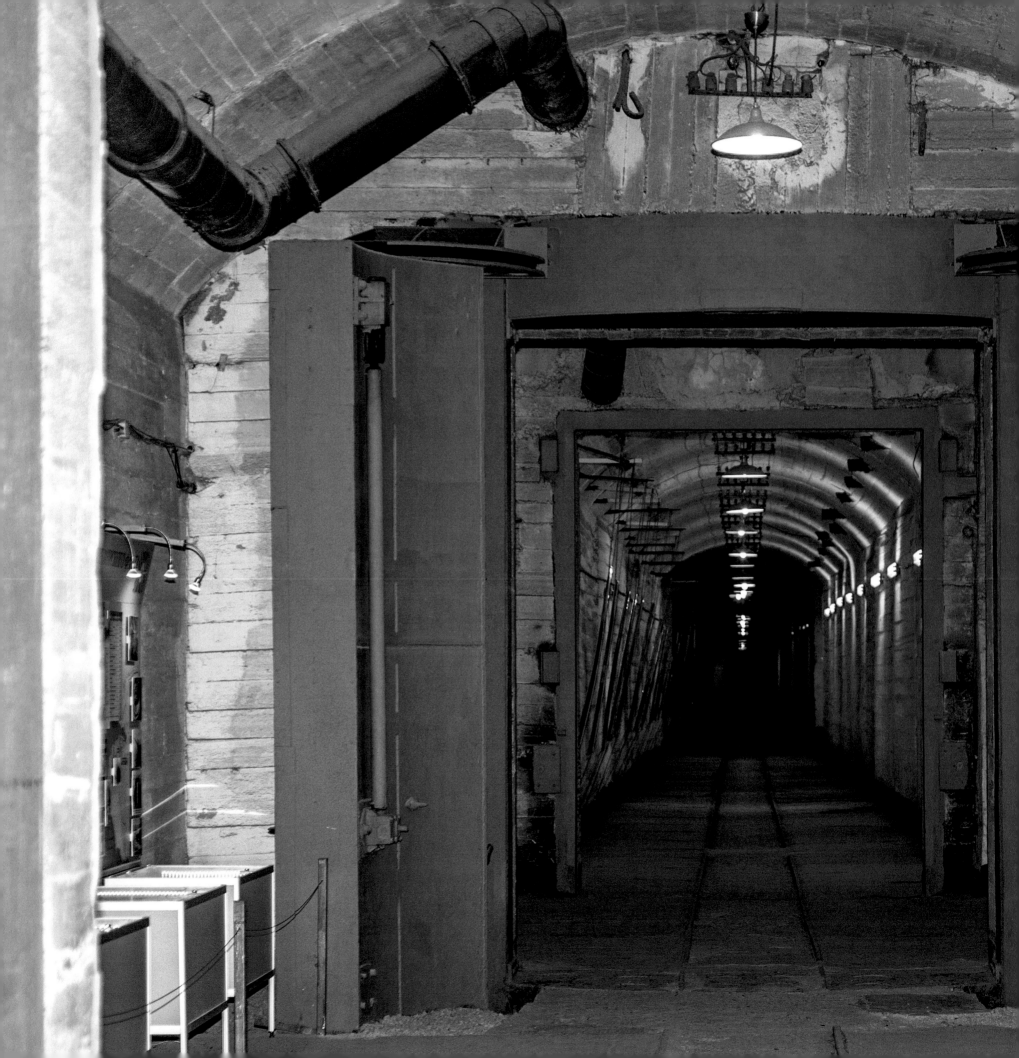

During the Bosnian War of the 1990s, the Željava base was partially destroyed by retreating Serb forces and now lies abandoned and increasingly derelict in a landscape that is littered with landmines left over from the conflict.

Aircraft Caverns of the Alps

Like Tito's Yugoslavia, Switzerland maintained an essentially non-aligned position throughout the Cold War, though since the mid-1990s the country has collaborated in peacekeeping missions with NATO, an international body to which it has chosen never to belong. But in the immediate post-war era, the Swiss were quick to recognize the collateral dangers they faced from the superpower standoff of the time, and as early as 1947 they began to use the country's challenging topography to their defensive advantage.

By the mid-1950s, the Swiss Air Force was operating from a series of hidden hangars in caves excavated in the sides of mountains at several sites in the centre and south of the country. Over the years, some of these have been greatly extended, while the national motorway system was developed to include roads built to a specification that meant they could be used as runways. Thus, for example, at the Alpnach airfield, in addition to a two-kilometre (1.2-mile) purpose-built runway, the adjacent A8 motorway could also be used when needed for the base's military aircraft. Today, of the original underground bases, including the Alpnach caverns, the only ones still in operation are at the Meiringen airfield, where a full squadron of F-18 fighters stands ready for action in tunnels that extend a kilometre (0.6 miles) inside the mountain.

Muskö Underground Naval Base

The Muskö underground naval base was at one time Sweden's most secret military installation. A turning off the main highway just 50 kilometres (30

Left: 'Object 825 GTS' was an underground submarine base and weapons facility during the Cold War in Balaklava, Crimea.

miles) or so south of Stockholm takes you into a slowly descending three-kilometre (1.8-mile) tunnel that passes under the Baltic Sea before climbing and re-emerging on Muskö, one of the 30,000 islands in the Stockholm Archipelago and for hundreds of years the home of the country's navy.

The mid-twentieth century was an era poisoned by ideological mistrust, even for a country like Sweden, which had managed to remain neutral during the Second World War, a policy of non-alignment it pursues to this day by declining to join NATO. It is a fair measure of the paranoia of those times that the Swedes chose this beautiful island on which to build one of the most secret and secure naval facilities in the world, that only a direct nuclear strike could have destroyed. An arduous undertaking over almost 20 years, its construction involved the removal of 1.5 million tons of rock in creating four caves or tunnels, going deep into the island with access to the sea, between 140 and 350 metres (460 and 1,150 feet) in length. The tunnels were big enough to accommodate submarines and ships up to the size of a destroyer, while the base as a whole extended for several square kilometres underground and had facilities for up to 800 workers. But in time, hostilities thawed and, with the Cold War having ended in 1991, the Muskö base was all but closed in 2004.

America's Fortress

If there's something familiar about the entrance to the Cheyenne Mountain Complex near Colorado Springs, then you're clearly a fan of the 1990s sci-fi TV series *Stargate SG-1*, which used shots of the exterior of this genuine military installation as the notional base of Stargate Command. Back then the complex was in fact the headquarters of NORAD, the North American Aerospace Defence Command, a joint US–Canadian operation involving the use of global surveillance information to monitor the total North American air space for missiles and foreign aircraft.

Right: *The Muskö naval base is no longer top secret.*

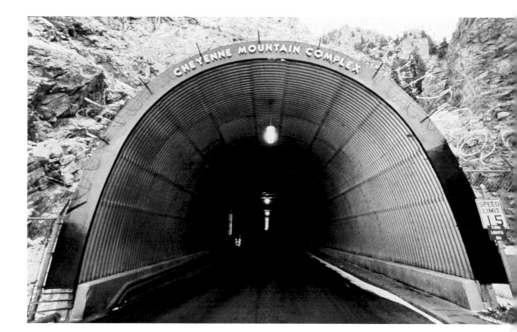

Above: The name on the arch suggests no one is trying to hide anything, but then no one is going to get past the 30-ton blast doors of the Cheyenne Mountain Complex in Colorado, USA, so perhaps it doesn't matter.
Left: Abandoned Soviet bunker.

Located in the Rocky Mountains at nearly 3,000 metres (9,840 feet) above sea level and sheltering beneath 750 metres (2,460 feet) of solid granite, 'America's Fortress', as it is still referred to, was constructed at the height of the Cold War. As more strategic defence operations were established within the complex to monitor a growing number of threats – first a ballistic missile defence centre, then a space operations defence centre – in the 1990s the complement of staff increased to something like 2,000 military personnel, who slept and worked in this underground military city, while their families necessarily lived elsewhere.

With the ending of the Cold War, it was decided to move the base's functions to another site, above ground at the Peterson Air Force Base at Colorado Springs, and the Cheyenne Mountain facility was scaled back to a skeleton staff. But recent assessment of the dangers of electromagnetic pulse attack have drawn into focus the protection afforded by solid rock from this new form of warfare, and essential systems have once again been brought back inside this sentinel mountain keeping watch over a continent.

The City Under the Ice

In the far northwest of Greenland, a former colony of Denmark, lie the toxic remnants of one of the most secret US projects of the Cold War. Since 1951, with permission from the Danish government, the US Air Force had operated a coastal base at Thule (now Qanaaq) 240 kilometres (150 miles) due west, but the new facility, at what the Americans were calling Camp Century, would be buried deep under the ice.

Officially a site for testing different building techniques in extreme conditions, this was a cover story for something far more sinister about which the Danish government knew nothing. In 1960, when the project began, tensions with the Soviet Union were approaching a peak, and a medium-range nuclear missile launched from northern Greenland could easily have reached Moscow. Project Iceworm, the real purpose behind Camp Century, would see 4,000 kilometres (2,485 miles) of tunnels constructed beneath the ice, from which up to 600 nuclear missiles could be launched in the event of a nuclear war. They called it the 'city under the ice', a romantic description, though the US government was well aware that the nuclear presence was an obvious violation of Denmark's policy of remaining nuclear-free.

The still-unfinished project was shut down in 1967, when it became clear that shifting ice made the launch and storage facilities inherently unstable. Though the US removed the missiles, all kinds of toxic and radioactive materials were left behind, presumed buried in perpetuity beneath the ice. But the recent melting of the Greenland ice sheet has raised fears that some time before the end of the century these toxic leftovers could re-emerge to threaten the fragile environment of this northern land.

Right: The US Army built a nuclear missile launching site under the Greenland ice sheet, then left it there when the project failed. But climate change will see toxic material eventually re-emerging as the permafrost melts.

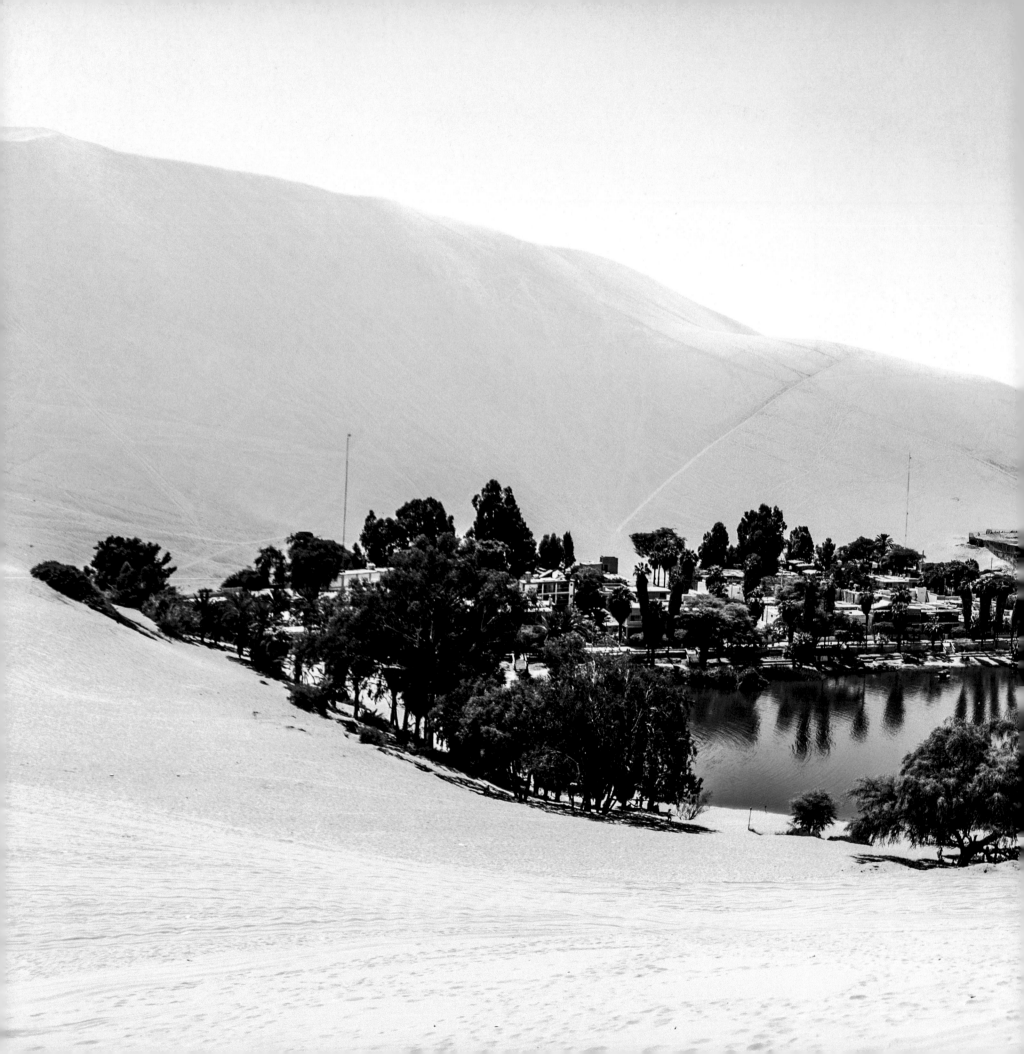

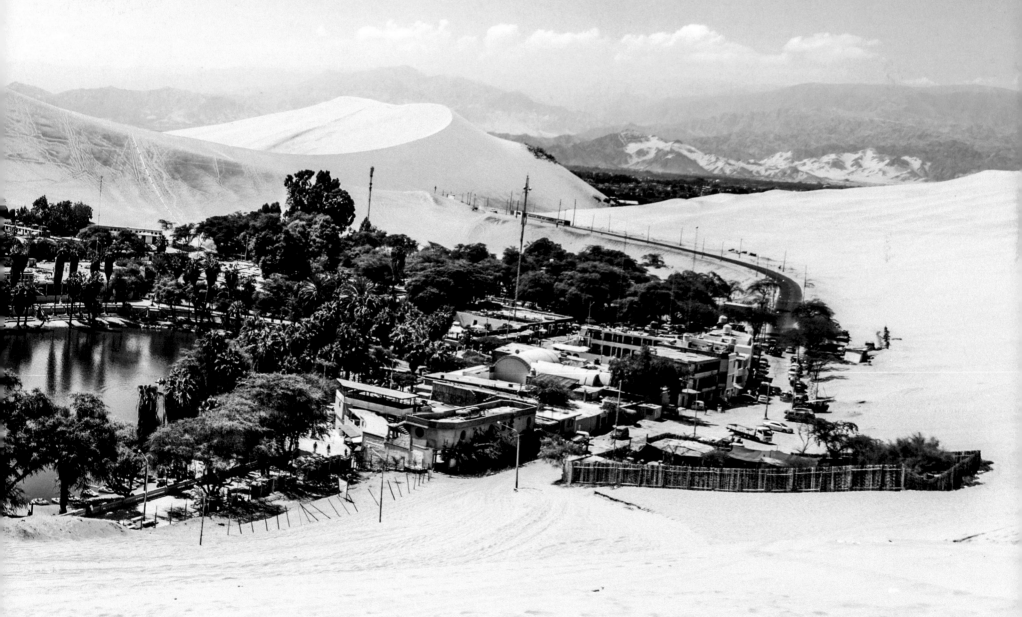

At the Ends of the Earth

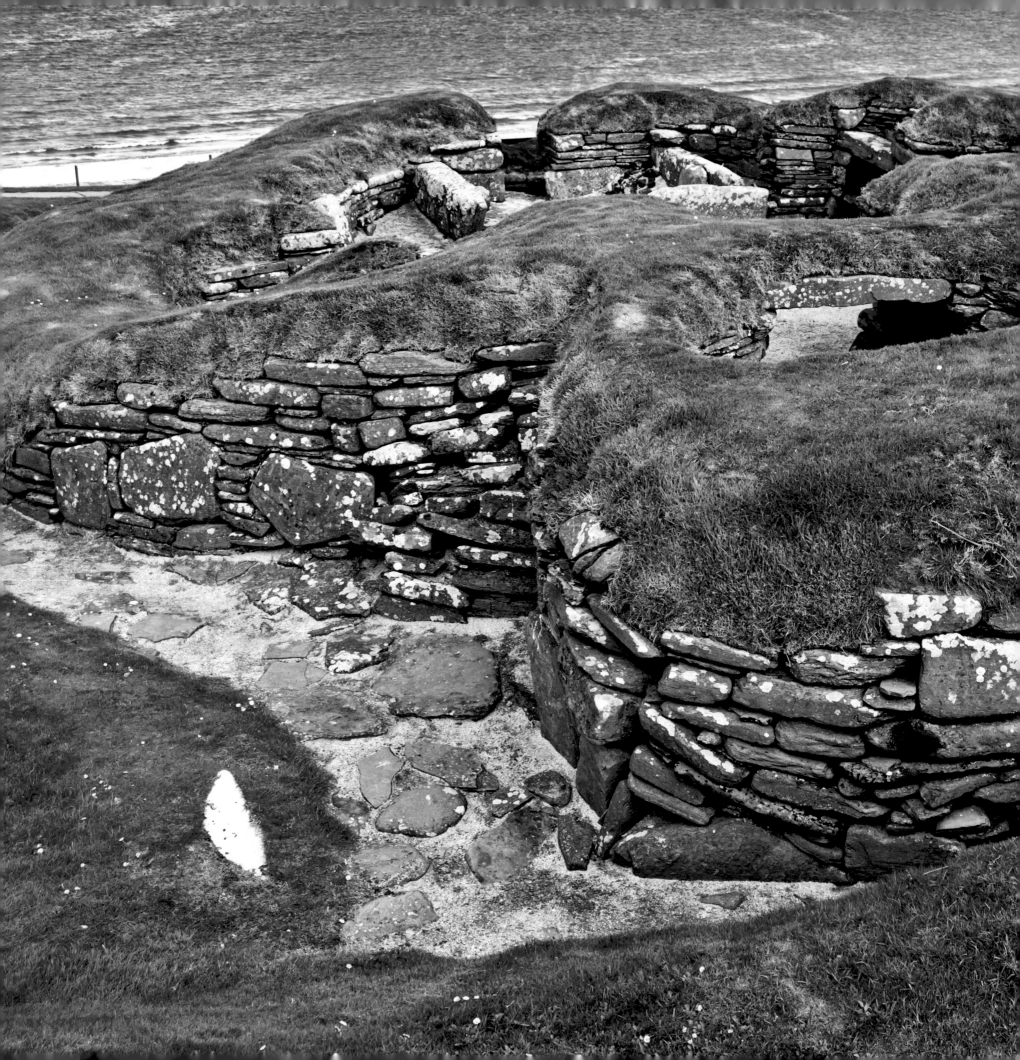

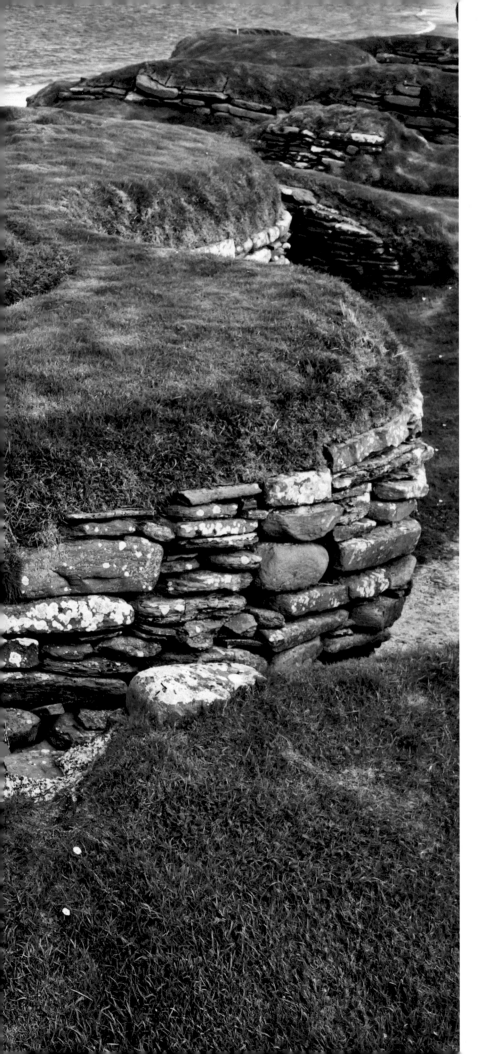

Remote Islands

For millennia people have established thriving communities on some of the farthest-flung islands in the world, at times to make use of an abundant local resource, at others unwillingly and in chains.

The Sunken Village of Skara Brae

There were no significant cities in Britain until the Romans built them, so the Neolithic settlement of Skara Brae on the west coast of Orkney, north of Scotland, was a sizeable community at the time it was built some 31 centuries before the Roman landing of 43 AD. The cluster of stone dwellings was discovered in 1850 after the earth that had covered them for centuries, or even longer, was ripped away by a violent winter storm.

Thorough excavation over the following century revealed a tight community of eight adjacent houses, sunken into the ground for protection from the fierce wind and rain, linked by covered openings between neighbouring homes. The houses, equipped with a hearth, beds and a dresser, and even a toilet and drainage system, all made of stone, are remarkably intact remains of what is thought to have been a larger settlement, the rest of which has been lost to the sea. The people of Skara Brae seem to have thrived for centuries, raising cattle and sheep, growing barley and fashioning knives and needles from the bones and teeth of animals such as walruses and whales. Nobody can say for certain what caused them to abandon their village around 2500 BC, but its existence, at the remote edge of the large and sparsely populated island we now call

Previous page: Located in the northern Atacama Desert close to the city of Ica in Peru, the palm-fringed lagoon of Huacachina, today a tourist resort, is known as the 'Oasis of America'. It's a picture-perfect vision of what a true oasis should look like.
Left: Skara Brae, one of Europe's best preserved Neolithic sites, on Orkney, Scotland.

Britain, itself so far from the first human cities of the Fertile Crescent of the Middle East, raises the prospect of extraordinary societies arising in places where we might least expect them to be.

The Vanished Capitals of Easter Island

Human migration out of Africa unfolded, we now know, over almost 200,000 years into every corner of the world. The last significant push before European colonialism was the spread of Polynesians across the South Pacific to places including New Zealand and the islands of French Polynesia. Among the most remarkable of all the Polynesian peoples are the Rapa Nui of Easter Island, one of the most remote inhabited places on Earth, whose unique culture created the huge stone *moai* – haunting, stylized human figures which embodied the spirit of their ancestors – and the monumental stone platforms, or *ahus*, on which they stand again today.

More than 3,000 kilometres (1,864 miles) west of Chile (whose territory it is), Easter Island was first occupied around 1,000 years ago. By the time the *moai* were being carved, from the thirteenth to the sixteenth centuries, the population on this small volcanic island of just 163 square kilometres (63 square miles) had grown to many thousands, reaching a peak of between 12,000 and 15,000 around 1640 when the last forest was felled. By this point two separate groups were vying for supremacy, each with its own capital. By the time that Captain James Cook arrived in 1774, many of the statues had already been toppled like the palm forests before them, a process that continued as the two groups fought over scarce resources and the population further declined. The 1,500 people taken by Peruvian slave raiders in the 1860s represented half the extant number, and some two decades later emigration and European diseases had further reduced the Rapa Nui to little

Right: *The Bronze Age settlement of Jarlshof in the Shetland Islands, off the north coast of Scotland, was established around 2700 BC and adapted first by Iron Age, then Pict, then Viking inhabitants until it was finally abandoned after 1600 AD.*
Next page: *Moai statues on Ahu Tongariki, Easter Island.*

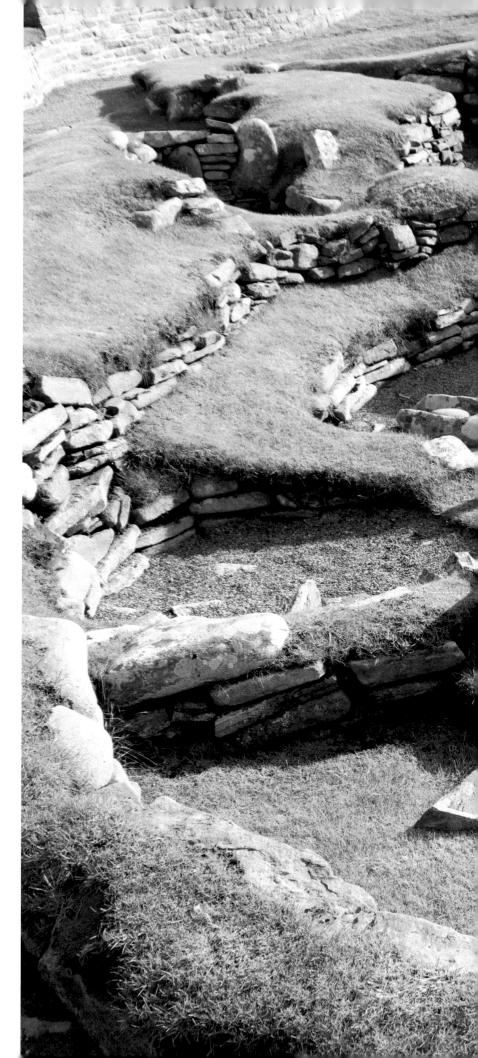

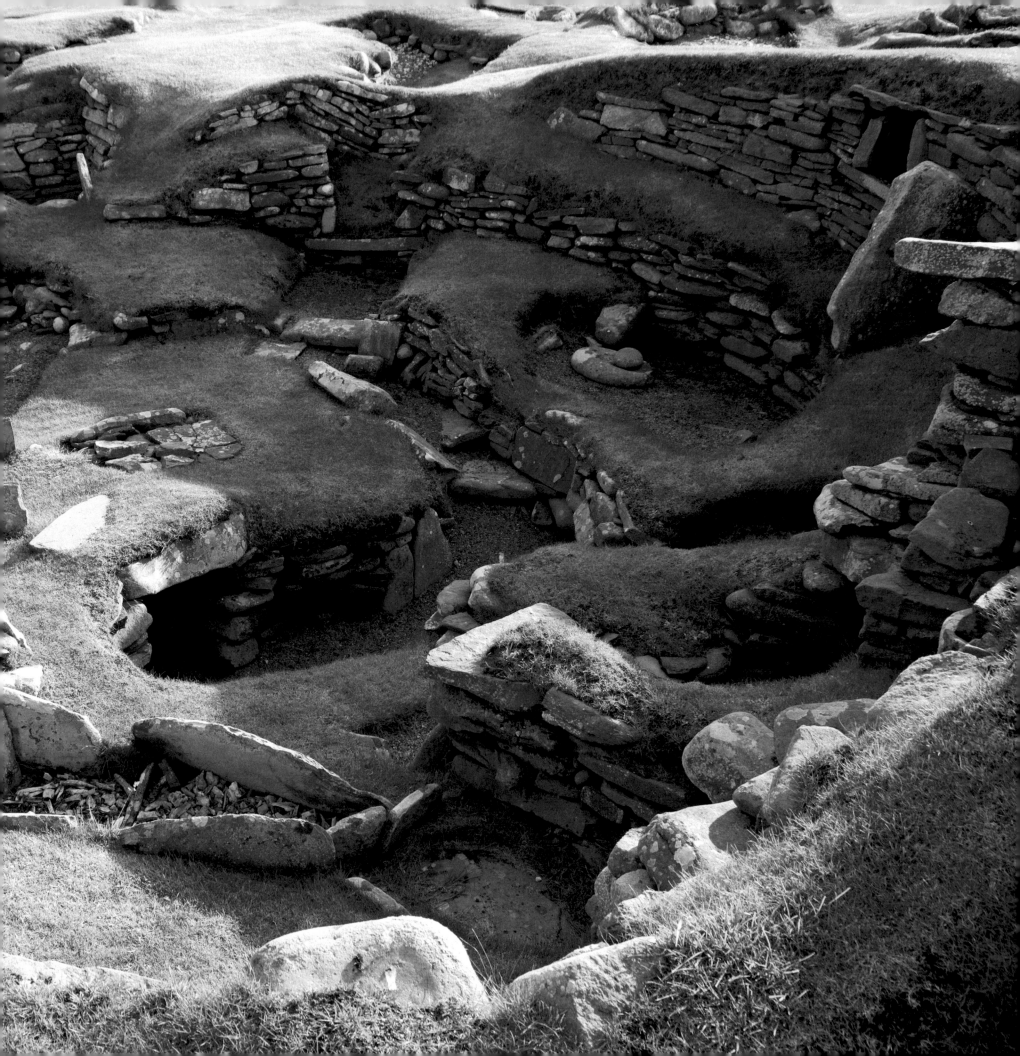

more than 100 people, their once-thriving settlements destroyed, with only the hundreds of fallen statues to remind them of what they had been.

The Artificial Island City of Nan Madol

The 607 islands grouped into four states comprising the Federated States of Micronesia, spread in a wide band 1,500 kilometres (930 miles) or so northeast of Papua New Guinea, have been inhabited far longer than Easter Island. Pohnpei Island, the largest state, is home to Palikir, one of the smallest capital cities in the world, with a population of fewer than 5,000 people. But on the other side of Pohnpei lie the ruins of a much older civilization that ruled this area for at least 1,000 years.

Nan Madol is an ancient ruined city whose construction began around 1200 AD. It is made up of more than 90 man-made coral islets distributed over an area of more than 80 hectares (200 acres) off the southeast coast of Pohnpei, on which substantial stone buildings were constructed like huge log cabins from large sections of columnar basalt. The name 'Nan Madol' means 'the space in between' in the local language, a reference to the canals that separate the various tiny islands within the ancient city, an

Above and left: The ancient ruined city of Nan Madol, Pohnpei Island, Federated States of Micronesia.
Next page: The townscape of Monemvasia in Greece – another hidden city on an island.

arrangement that has also earned it the name of 'Venice of the Pacific'. The city was the royal capital of the Saudeleur dynasty, which ruled the island of Pohnpei until it was overthrown in 1628. Thereafter Nan Madol was abandoned and is now overgrown with jungle, neglected by the people of Pohnpei, who regard the site as haunted.

So much remains mysterious about this impressive ancient capital on a small Pacific island. It's only in recent years that satellite imagery has revealed the existence of a much larger surrounding site, perhaps as big as 18 square kilometres (7 square miles), suggesting Nan Madol is a city with many secrets still to divulge.

Desolate Islands of the Empire

There is perhaps nothing that better demonstrates the geographical reach of the British Empire than the obscurity of some of the places among the swathe of territories across the globe on which, famously, the sun never set. The South Atlantic island of Tristan da Cunha and its surrounding smaller islands

Right: Edinburgh of the Seven Seas, the lone settlement on Tristan da Cunha, an island in the South Atlantic Ocean.
Below: Adamstown on Pitcairn Island, in the South Pacific, is one of the most isolated capitals on Earth. Most of its 49 inhabitants are descendants of the mutinous crew of HMS Bounty, the ship in which their ancestors landed here in 1790.

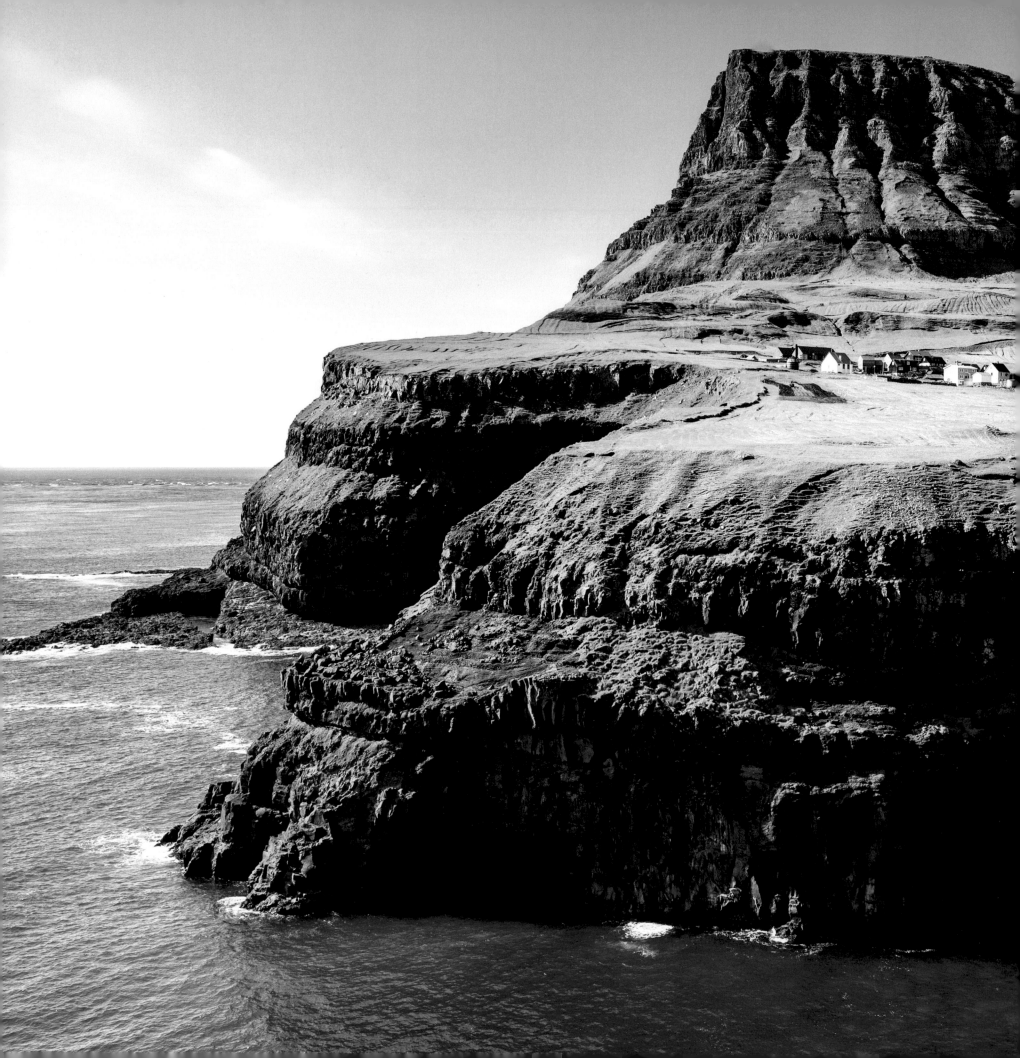

– part of the British Overseas Territory of St Helena, Ascension Island and Tristan da Cunha – is officially the most remote inhabited archipelago in the world. Association with the slightly more accessible St Helena is misleading, as the two islands are separated by some 2,400 kilometres (1,490 miles), and St Helena itself is remote enough to have been the place where the exiled Napoleon Bonaparte was forced to live out his final years.

Tristan was first settled by a group of American sailors in 1810 before being annexed by Britain six years later. Its single town, called Edinburgh of the Seven Seas, is where all the island's 270 or so residents live, making it the most isolated settlement on Earth. Tristanians are mostly descended from the original 15 colonists from Europe and Africa who settled this volcanic island 200 years ago. They still lead a simple though far from easy life based around careful farming of the limited area of fertile land, all of which is communally owned, following principles set out by the founder of the colony, William Glass, in 1817. In 1961, the eruption of the volcano led the

Above: Though only a mile from the US coast, the prison on Alcatraz Island in San Francisco Bay was famously difficult to escape from. Between 1934 and its closure in 1963, it held many of the most notorious gangsters of the time.
Left: *Until a few years ago when a tunnel and a road were built, the only way of getting to the village of Gásaldur in the Faroe Islands was by clambering up a sea cliff or hiking over a mountain more than 600 metres (1,970 feet) high.*

islanders to be evacuated to Britain, but despite the offer of a new life at the heart of the modern world, most Tristanians opted to return to their South Atlantic fastness when, two years later, they were told it was safe to do so.

Prison Islands

Islands have proved useful for governments looking for somewhere secure to lock up the most dangerous criminals or, quite often, the most dissident voices in their society. Names like Robben Island near Cape Town, Devil's Island off the coast of French Guiana, and Alcatraz in San Francisco Bay – prison cities that are all closed today – have caught the public imagination in various ways. We could add to this list Australia's notorious offshore immigration detention facility on the South Pacific Island of Nauru, where genuine refugees who have risked their lives crossing the ocean to Australia have been locked up in terrible conditions in a legal limbo that is much harder to escape than the countries from which they have fled.

Australia, of course, is a nation partly founded by convicts: the 162,000 ordinary criminals and political prisoners transported from Britain over an 80-year period from 1788 to the penal colonies of a continent on the other side of the world. Beyond the mainland colonies and the Tasmanian penal settlement of Port Arthur, the most distant colony of all was on tiny Norfolk Island, an area of less than 36 square kilometres (14 square miles), which at nearly 1,400 kilometres (870 miles) east of New South Wales and several hundred north of New Zealand was an ideal site for a prison. The walls of the original correctional facility and various other buildings still lie at the heart of Kingston, the island's capital. They remind us that the arm of the law is long enough not only to capture those who seek to evade it but also to place the convicted, or even those with fragile legal status, both out of sight and as far as possible out of mind.

Right: Ruins of the penitentiary, known in France as the 'Bagne de Cayenne', on Devil's Island off French Guiana, in the Caribbean Sea.

Frozen Wastes

For millennia, peoples like the Chukchi, the Aleut and the Sami have inhabited lands straddling the Arctic Circle. More recently, the promise of a better life or scientific knowledge has brought others to some of the coldest places on Earth.

The North Pole of Cold

The coldest temperature ever recorded was a terrifying –89.2°C (–128.5°F), logged in July 1983 at the Vostok Station, a Russian research base in Princess Elizabeth Land, East Antarctica. But Antarctica has been only recently inhabited, mostly by groups of scientists for whom the cold is part of the reason for being there. More extraordinary are those places in the Northern Hemisphere where for centuries people have lived in climates so profoundly cold as to be inimical to life. The coldest place north of the Equator, the 'North Pole of Cold', is said to be the village of Oymyakon in eastern Siberia. It was here in February 1933 that a temperature of –67.7°C (–89.9°F) was measured, making it the coldest permanently inhabited place on the planet. Even in a normal winter, lows of –50°C (–58°F) are quite routine for this settlement of around 500 people.

Some 960 kilometres (600 miles) west of Oymyakon is Yakutsk, a Russian settlement since the seventeenth century, which grew into a city after gold was discovered nearby in the 1880s. With a population of approximately 270,000 and a record low of –64.4°C recorded in February 1891, Yakutsk claims to be the coldest major city on Earth. In the 1930s a Gulag was

Left: Officially the coldest permanently inhabited place in the Northern Hemisphere, Oymyakon in the Sakha Republic of eastern Siberia has brief but warm summers – and an annual temperature range of more than 100°C (180°F).

Above: Frozen traffic light in Yakutsk, Russia.

established here to provide forced labour for extracting the gold reserves as well as building the Kolyma Highway heading east past Oymyakon to Russia's Pacific coast. With permafrost preventing the construction of a railway, the highway is the only way to reach Yakutsk by land. It is known as the 'Road of Bones', on account of the many thousands of prisoners who died in its construction, whose remains were added to the highway's constituent materials.

The Russian Far North

The other place that vies with Yakutsk for the title of the planet's coldest city is Norilsk, a conurbation of 175,000 people in Russia's forbidding far north, close to the Arctic coast. The northernmost large city on Earth, it's another built by Gulag labour on permafrost which here is so unforgiving that Norilsk,

Right: The far north city of Norilsk, Russia.

Secret Cities: The Haunted Beauty

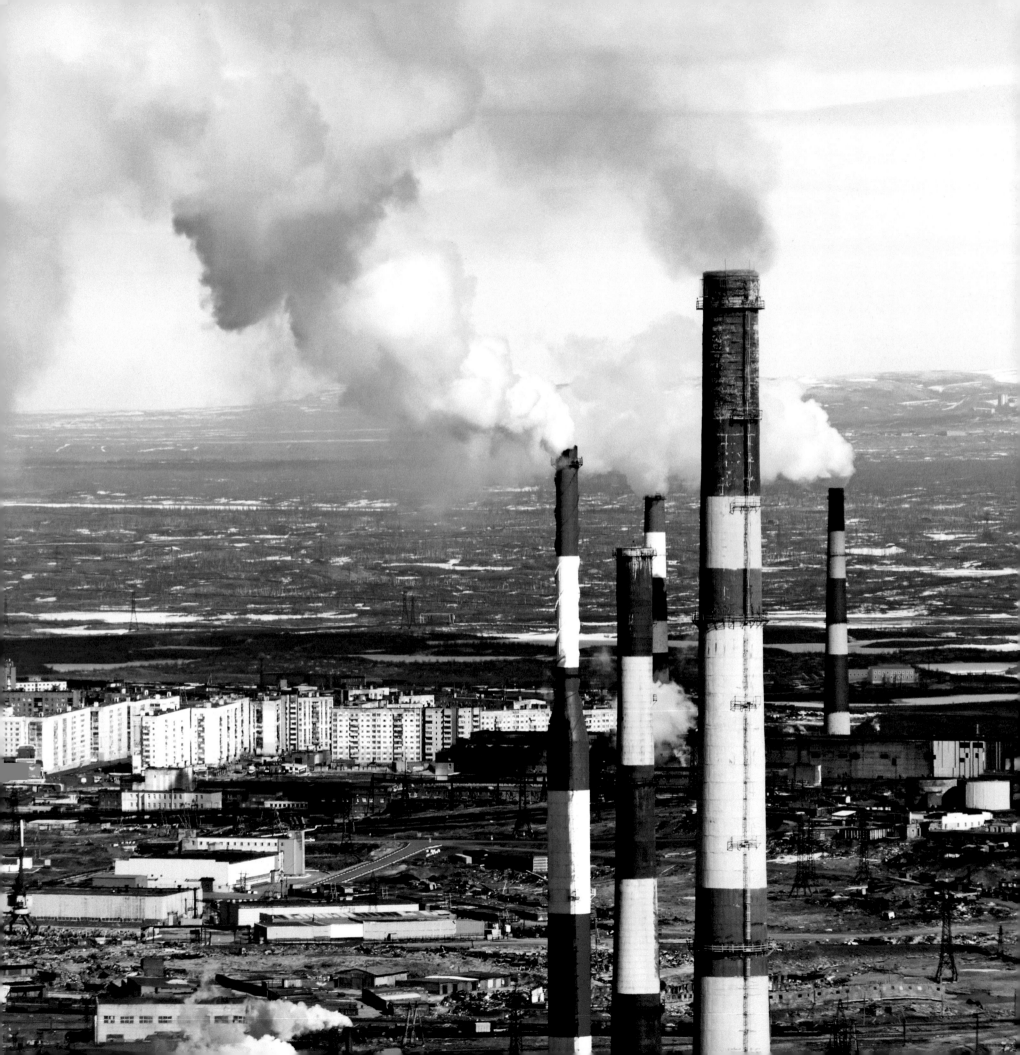

one of Russia's many closed cities, is inaccessible even by road. The vast deposits of copper, nickel and palladium discovered in the early nineteenth century – the biggest in the world – are the sole reason why such a large city could ever exist in such a desolate region. But life here takes a heavy toll, with work in the mines and toxic air from the factories and industrial plants, not to mention the psychological challenge of enduring the long polar night – two wintry months during which the sun never rises – contributing to rates of cancer and respiratory disease much higher than in the rest of Russia.

On the plus side, workers in the mines can expect to retire at 45, but with life expectancy in Norilsk, one of the most polluted cities on Earth, some 10 years lower than the Russian average (65 years for men), that is probably the least they deserve. With temperatures rising above zero only during the few short weeks of summer, leisure time is mostly spent indoors in apartment blocks that have not been renovated since Soviet times in this pitiless city of the North.

The Canadian High Arctic

The territory of Nunavut, in Canada's Far North, was created in 1999 in settlement of one of the many indigenous land claims from the country's colonial past. An area of around 1.8 million square kilometres (695 square miles) inhabited by fewer than 36,000 people, Nunavut is one of the least densely populated places on Earth. A fifth of its people live in Iqaluit, its only city, on Frobisher Bay, but even here there are no roads or railways to connect it to the rest of Canada, while sea ice prevents ships from getting in during most of the year.

The Inuit who make up the ethnic majority in Nunavut lived a nomadic life for many hundreds of years, and were only recently persuaded to move to permanent settlements, a demographic shift made more necessary as climate warming in the Arctic has made the old way of life increasingly difficult

Left: Multi-storey residential buildings in Norilsk, Russia, built on permafrost.

Above: Iqaluit is the capital of Nunavut, Canada's newest territory, created in 1999 from a huge swathe of Arctic and Sub-Arctic Canada that was formerly part of the Northwest Territories. Nunavut is one of the least densely populated administrative regions on Earth.

to sustain. However, such persuasion by the government of Canada has not always been in good faith. In the case known as the High Arctic Relocation, in 1953 at the height of the Cold War, 17 Inuit families were moved from their homes in northern Quebec to two new villages, Resolute and Grise Fiord (now Canada's northernmost settlement), thousands of kilometres further north, far inside the Arctic Circle.

They were promised a better way of life with better hunting, as well as help to adapt to the High Arctic's harsh conditions, provided by other Inuit living at Pond Inlet on Baffin Island a few hundred kilometres away. But the new arrivals were soon struggling to survive and later insisted that

Right: Grise Fiord, Nunavut, the northernmost village in North America.
Next page: The area around Nuuk, a city of some 18,000 people and the capital of Greenland, has been inhabited on and off for more than 4,000 years. With no roads or railways even today, the rest of the country can only be reached by boat or plane.

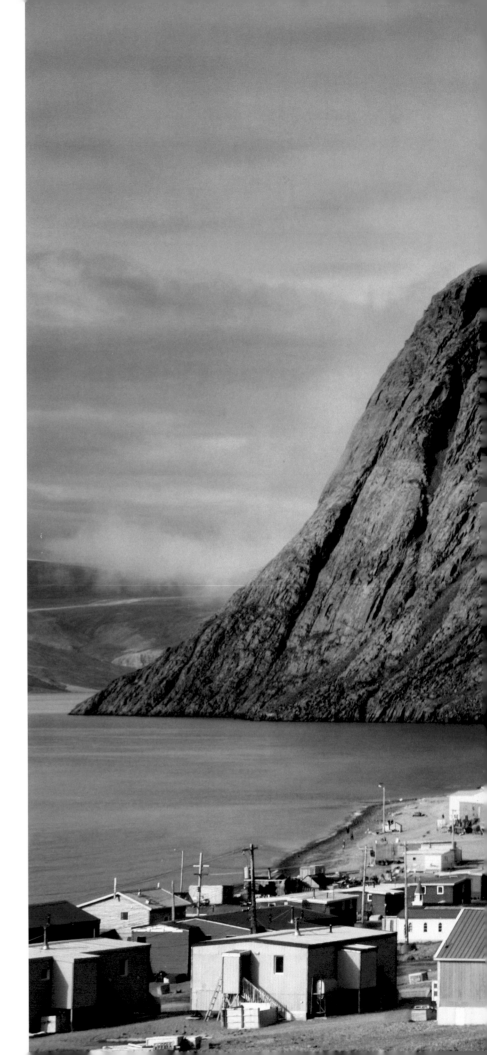

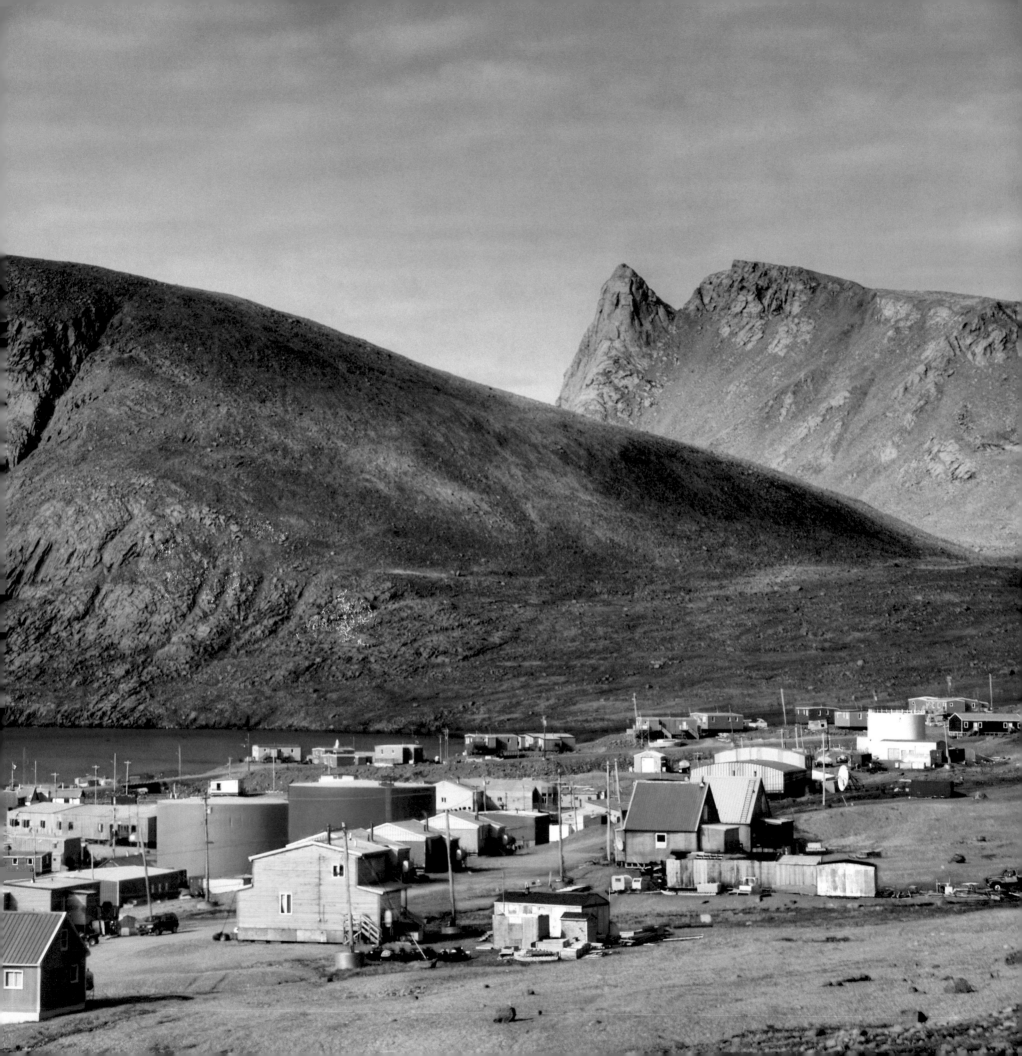

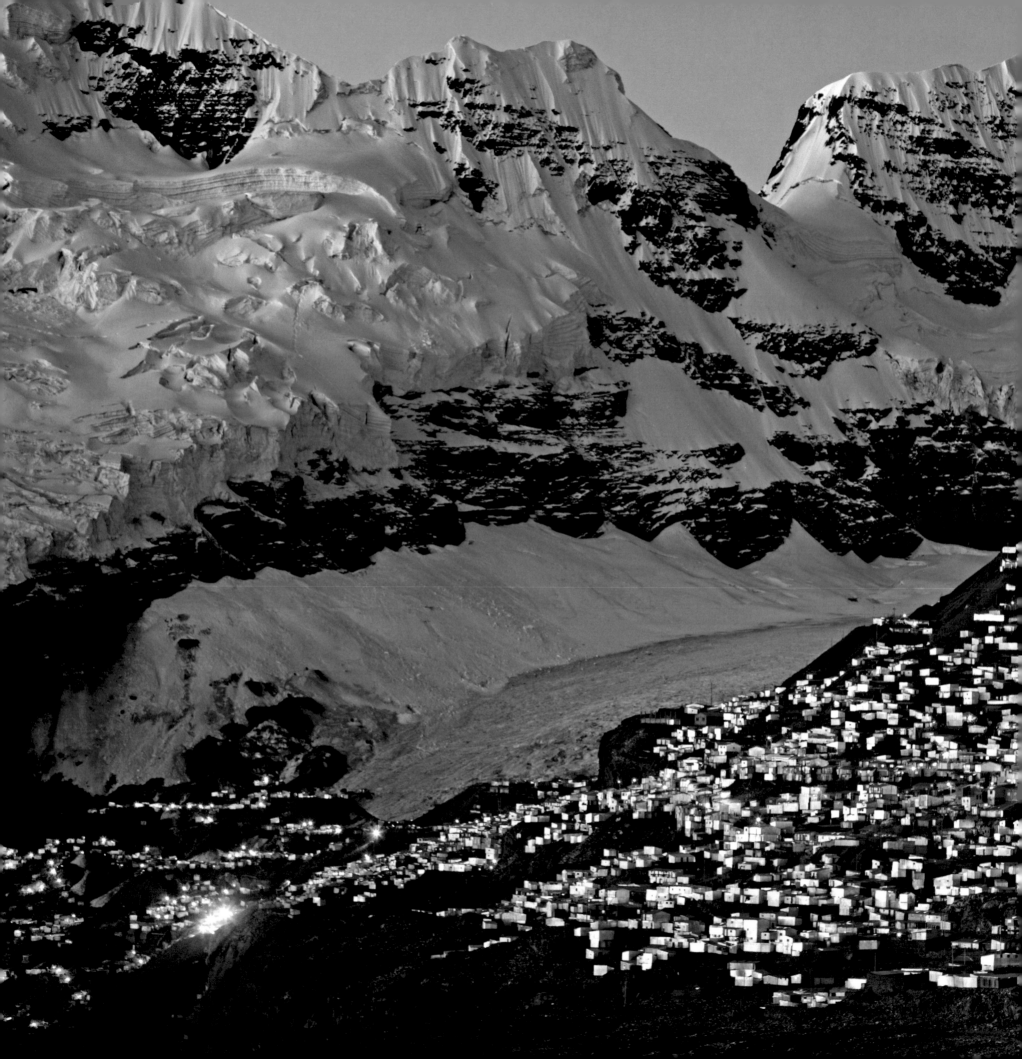

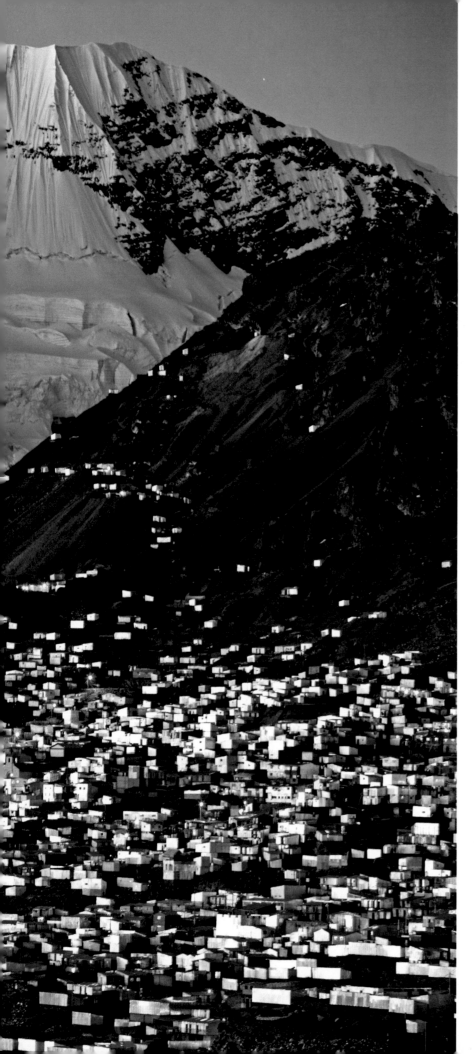

the government's main objective was the establishment of permanent communities in the Arctic Archipelago, to reinforce Canada's sovereignty in the region against insistent Soviet claims.

La Rinconada, Goldrush Town

It's hard enough even to breathe let alone to work in the High Peruvian Andes, but in recent years tens of thousands have come to La Rinconada, the world's highest city, to join the prospecting hordes hoping to make a fortune from deposits of gold revealed by the region's retreating glaciers. Working under the *cachorreo* system, men from all over the Andes arrive here to offer their labour for free to the local mining company for 30 days, and on the 31st are permitted to take away whatever they have dug out that day – as much as they can carry on their shoulders. Whether those rocks will contain the fortune in gold that each is hoping for is largely down to luck, but that's the bargain they make.

Left and below: La Rinconada, the highest permanent settlement in the world, in Puno, Peru. Though it has the status of a city, it lacks much of what constitutes one, with its ramshackle corrugated tin huts and rudimentary services.

The price of gold is now five times what it was at the turn of the century, so increasing numbers think it worth the gamble. Conditions in the mine are hot and dangerous, while the night-time temperature in La Rinconada never climbs above freezing all year round. Despite this, the city has grown from just a few thousand people in 2001 to some 50,000 today. Even the most well-appointed place would struggle to accommodate such a rapid expansion, so it's no surprise that this ramshackle mining city, at an altitude of almost 5,000 metres (16,000 feet), is squalid and overcrowded, with no sanitation, refuse collection or planning regulations to prevent the environment being despoiled or the inevitable spread of disease. But as we know from the gold rushes of the nineteenth century, desperate men don't tend to worry about such things.

Research Stations of Antarctica

It had long been suspected that a vast continent lay at the world's southern extent, but it was only in 1820 that whalers sighted Deception Island, part of the South Shetland Islands at the tip of the Antarctic Peninsula, and began making use of its excellent natural harbour for refuge against the most hostile weather on the planet. It would be another 75 years before anyone set foot on mainland Antarctica, and it was only in the dying days of the Second World War that the first permanent bases were established by British sailors on Deception Island.

More followed over the next decade as various countries around the world laid claims to different parts of the continent, until the 1959 Antarctic Treaty put a stop to any potential land grab. Since then more than 160 bases have been built for scientists from over 20 countries to carry out research in Antarctica, and close to 100 remain operational today, many of them all year round. The biggest is the USA's McMurdo Station, built in 1956 on

Right: Esperanza Base research centre and settlement, Antarctica.

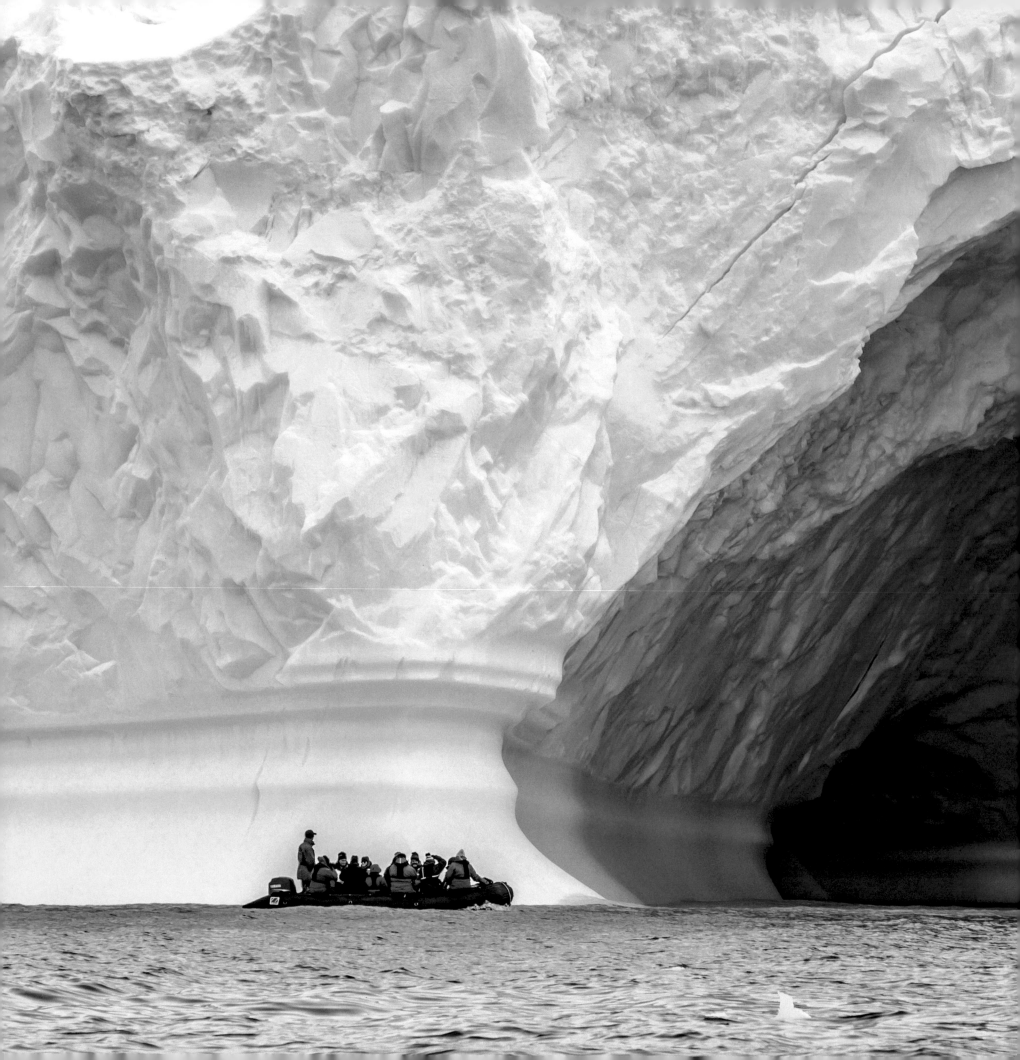

Above: Situated in a part of Antarctica known as Princess Elizabeth Land, which is claimed by Australia, Davis Station is one of three Australian bases on the frozen continent doing year-round scientific research.

Ross Island, with three airfields, a harbour and more than 100 buildings in total. The size of a small town, the station can accommodate in excess of 1,200 people.

Most intriguing, perhaps, are the Chilean town of Villa Las Estrellas and the Argentinian settlement of Esperanza, which function as research stations but were set up as civilian communities to establish whether it was possible to live a normal family life on the world's coldest continent. Today, 10 families live permanently at Esperanza Base, and it was here in 1978 that the first Antarctic baby was born, since when several more have followed. Among the smattering of brightly coloured buildings are schools for the children growing up in these remarkable towns.

Left: An enormous iceberg in Antarctica, near Esperanza Base.

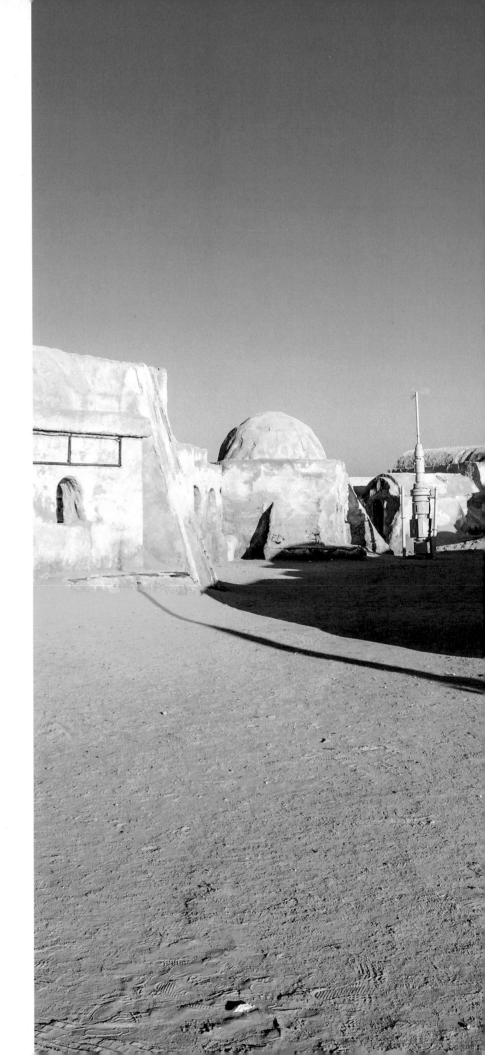

Desert Cities

The idea of living anywhere where water, a basic necessity, is scarce seems self-defeating at best. Yet millions of people over time have built cities in the world's driest regions and not only survived but thrived.

Imaginary Cities of Tatooine

If there's one real-life destination that fans of the *Star Wars* films often put at the top of their list of favourite locations, it's the region of central Tunisia that doubles as the planet Tatooine. Some 400 kilometres (250 miles) northwest of the genuine Tunisian town of Tataouine, from which director George Lucas took the name, there is a series of film sets in the area close to the towns of Naftah and Tozeur, including the Lars homestead – the modest little Skywalker igloo home from the original film. Non-fans might easily mistake this dwelling or the larger settlement of Mos Espa, which features in a later film, as indigenous to the region, as the set designers were clearly inspired by the vernacular mud-brick style in their use of white-washed low-rise domes and shallow arches. Most striking at Mos Espa are the banks of 'slave quarters' from *The Phantom Menace* (1999), troglodyte pods stacked two or three high, which were modelled on the ksour courtyard granaries distinctive to this area, such as the Ksar Ouled Soltane close to Tataouine.

The sets were meant to be taken down when filming was finished, but when this didn't happen the local tourist economy got a major boost. But the harsh desert climate also takes its toll, and even the Mos Espa complex, built as recently as the 1990s, is beginning to fall apart, while earlier sets are being

Right: Star Wars' Mos Espa set, built from nothing in the middle of the desert in Tozeur, Tunisia.

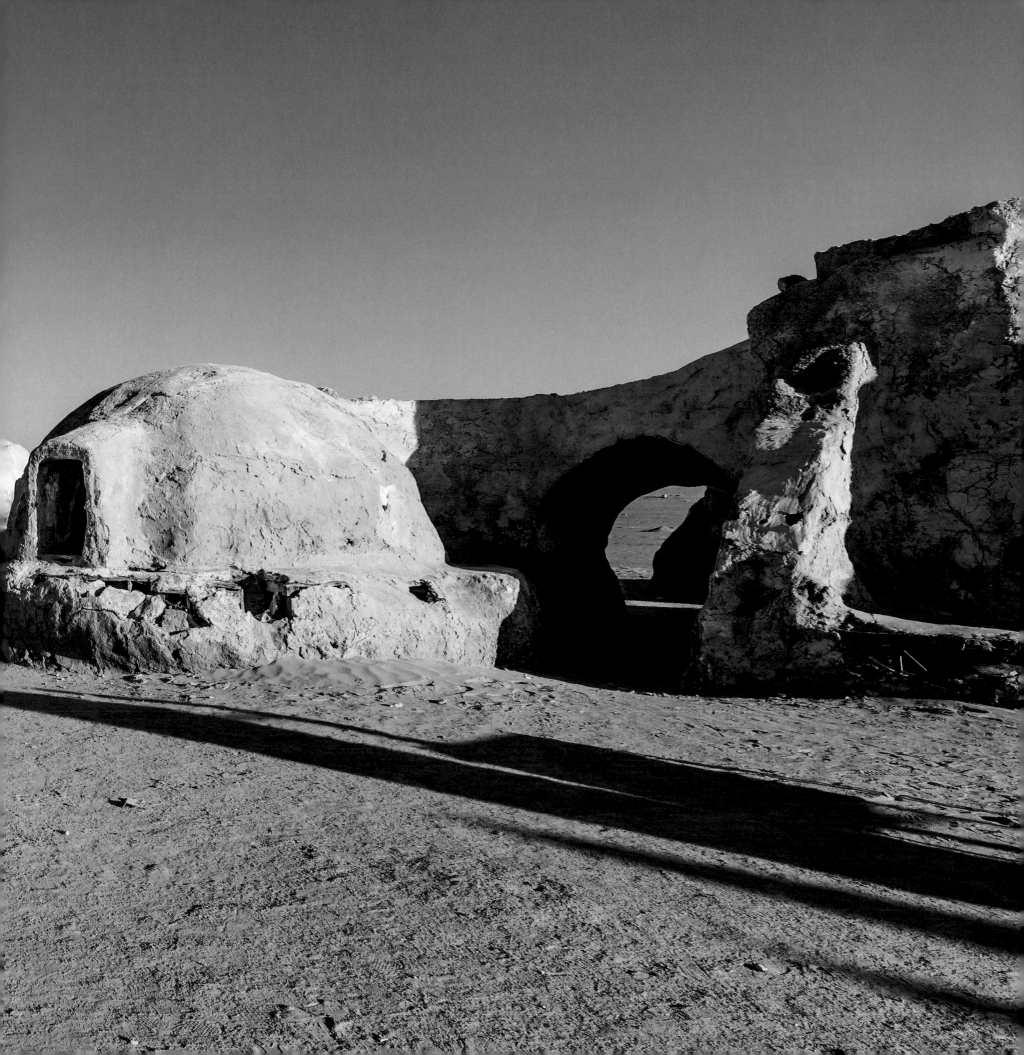

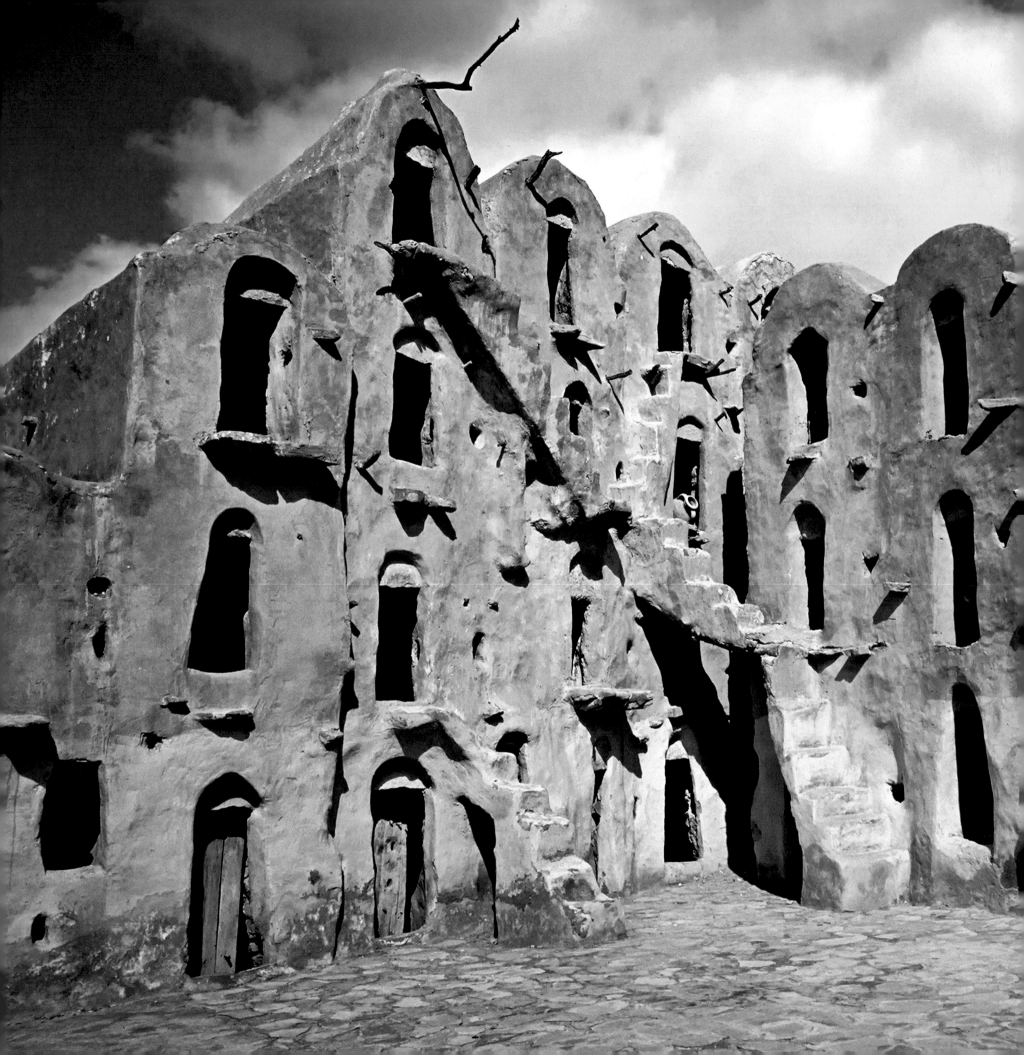

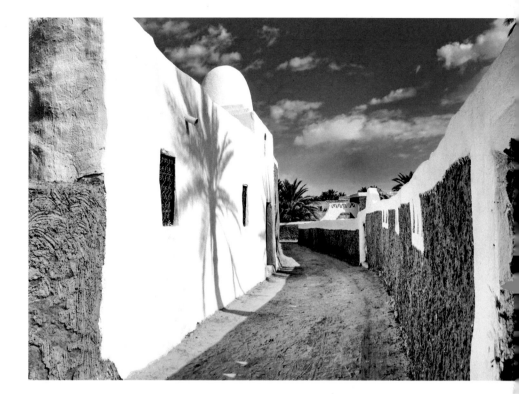

Above: Ghadamès, an ancient Berber city in Libya.

slowly swallowed by sand. Added to that, in recent years the terrorist attacks on tourists in Tunisia have seen visitor numbers slump, leaving this and other parts of the country to face an increasingly uncertain future.

Berber Cities of the Maghreb

Naftah and Tozeur are oasis towns, while Tataouine means 'water source' in the language of the Berber people indigenous to the Maghreb, the wide swathe of the northern Sahara and the Mediterranean coastal strip from Libya in the east to Mauritania round to the west. Just across the Tunisian border, the Libyan town of Ghadamès – a Berber oasis settlement in the pre-Sahara, as the desert fringe is known – has an ancient heart of low-rise white-washed buildings and covered alleys that justify the town being called 'the pearl of the desert'. The

Left: Stairs at the Ksar Ouled Soltane near Tataouine, Tunisia.
Next page: Beni-Isguen, a Berber name meaning 'sons of those who keep the faith', is the most devout of the hill towns clustered round the M'Zab oasis in central Algeria. Even today strangers are forbidden from spending a night within its walls.

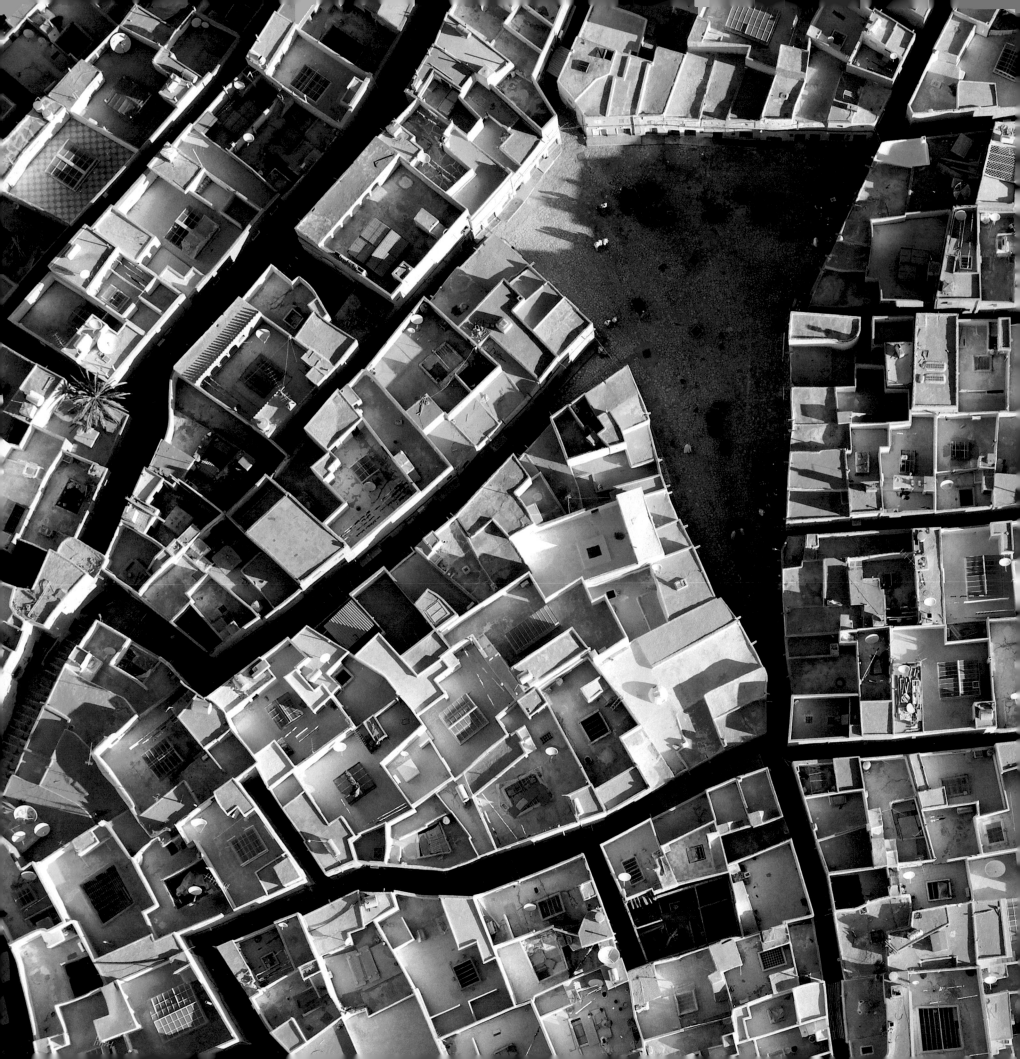

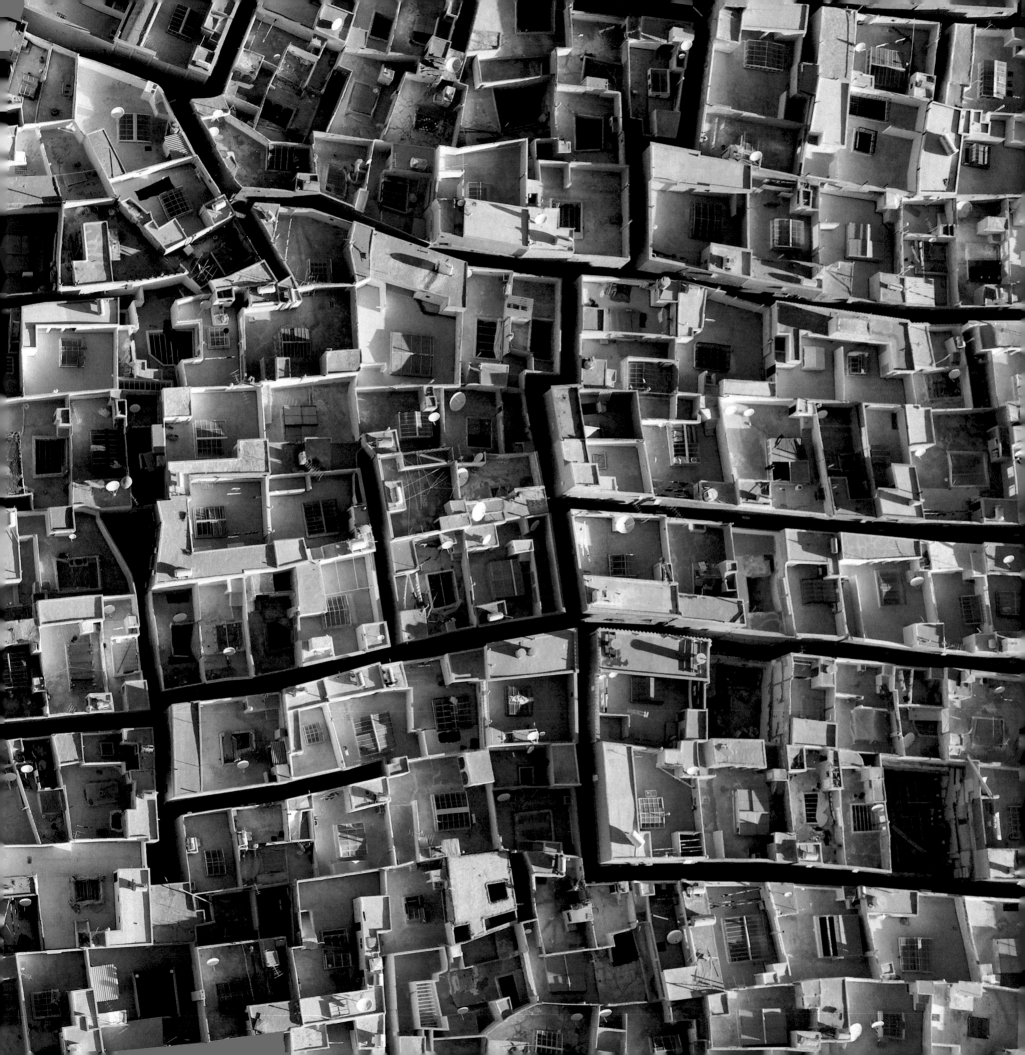

ground floors of the houses, being coolest, are where food is kept, with living quarters in the upper storeys. Depopulated in the 1990s, during the reign of Colonel Gaddafi, Ghadamès is once again home to thousands of people, though political instability in Libya leaves this city at continued risk.

Ghadamès is a subtle masterpiece of urban design, much admired by architects around the world, but in neighbouring Algeria, deeper into the desert, a series of five fortified towns in the isolated M'Zab Valley, today merging into a single conurbation, are as striking as the walled hill-top towns of Renaissance Italy. The city of Ghardaïa and its suburban towns – Melika, Beni-Isguen, Bounoura and El-Atteuf – stand out from the surrounding landscape for the elegance of their urban planning, with concentric circles of white, yellow and pink-plastered mud-brick buildings several storeys high, rising up the hillside towards a tall minaret atop a fortified mosque.

Dating from the eleventh century, though not unaffected by the Algerian Civil War of the 1990s, the unheralded oasis towns of this conservative region pursue a way of life that could only survive in a place as remote and unlooked-for as the M'Zab Valley.

Islamic Cities of the Western Sahel

In the West perhaps the most famous place in Islamic Africa is the city of Timbuktu in Mali in the southern Sahara. A romantic symbol for remoteness and obscurity – among British people, at least – the city's allure is encapsulated in the well-known English phrase, 'from here to Timbuktu'. A permanent settlement since the twelfth century on trans-Saharan trade routes, culturally it flourished during the period of the European Renaissance as the greatest centre of learning in the Malian Empire and one of the greatest anywhere in the world at the time. It was partly this reputation which led radical Islamists

Right: The Bandiagara Escarpment, near the city of Mopti in central Mali, was once home to the Tellem, a pygmy tribe whose remarkable granaries, built against the cliffs, are still used by the Dogon people who live there today.

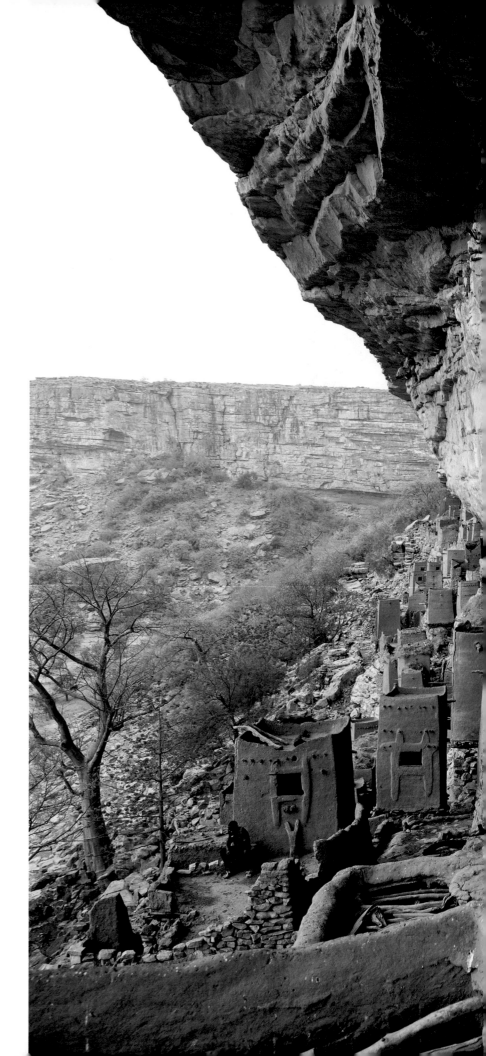

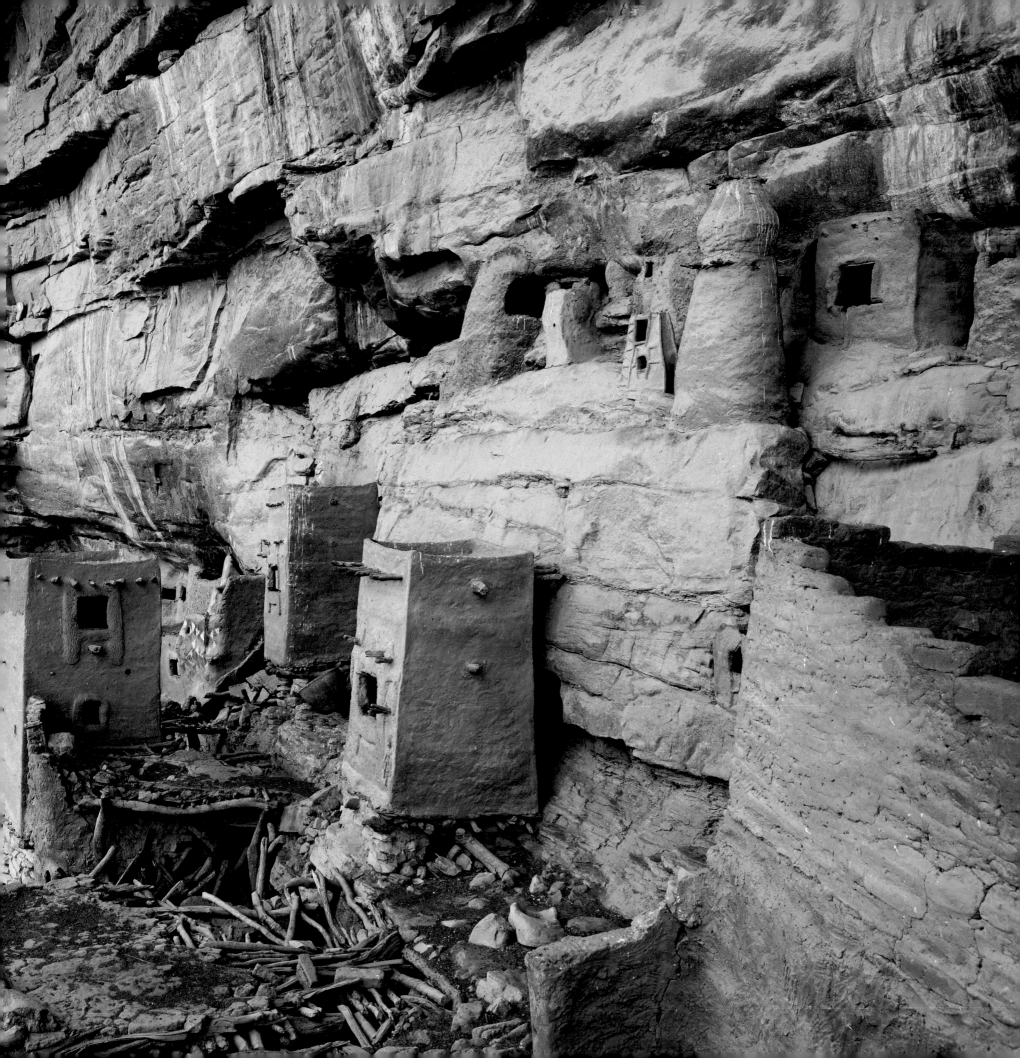

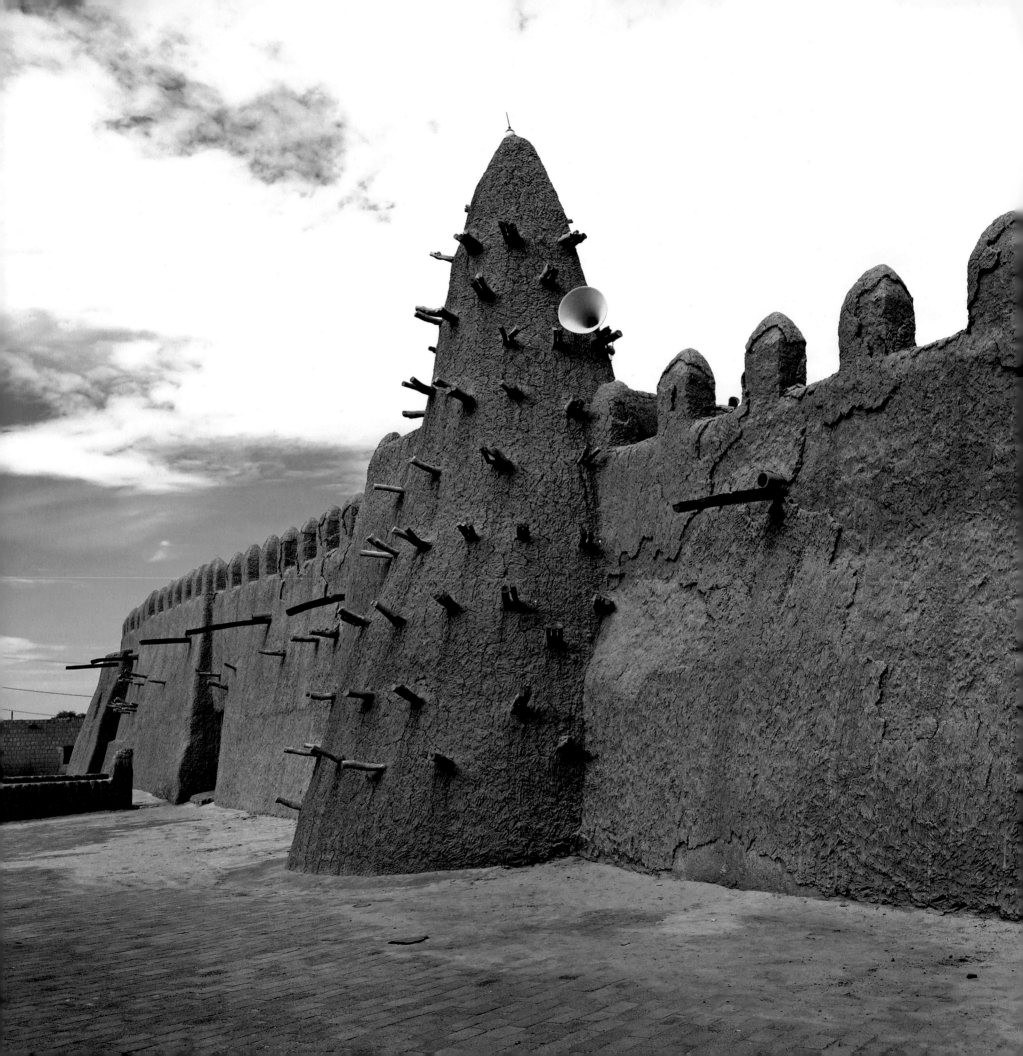

from the militant group Al-Qaeda in the Islamic Maghreb, to try to destroy the three extraordinary timber and mud-brick mosques that still comprise the University of Sankoré for which the city is renowned.

Similar architecture exists right across this part of the western Sahel: in the Malian town of Djenné, around 480 kilometres (300 miles) to the south, whose Great Mosque is the most monumental essay in the style; in Tahoua, in Niger to the west, a sprawling city of low mud-brick houses overlooked by yet another remarkable mosque; and in Agadez, the capital of central Niger still further into the desert to the west. Once among the main cities of the nomadic Tuareg people of the central Sahara, who for centuries controlled trade across the desert in precious commodities such as salt and gold, Agadez is still an important embarkation point for trade going north, though today the most lucrative annual business is the trafficking of drugs, guns and thousands of young Africans desperate for a better life.

Left: View of the restored Djingareyber Mosque, Timbuktu, Mali.

Above: The Grand Canyon village of Supai on the Hualapai Indian Reservation, Arizona, USA, is only accessible by foot, pack animal or helicopter.

Cities of the Arabian Desert

The Nabateans were a Middle Eastern trading people who thrived between the fourth century BC and the rise of Rome. They are known above all for their extraordinary capital, Petra, the exquisite rose-coloured city entirely carved from the rock, hidden behind imposing cliffs in Jordan's south-western desert. Originally nomads from the Arabian Peninsula, the Nabateans established another important settlement at Mada'in Saleh in the north-western corner of modern Saudi Arabia. Another concealed desert city, known also as Al-Hijr and carved like the Nabatean capital into bluffs rising out of the sand, it confirms the evidence of Petra that the culture of the Nabateans was among the richest in the ancient world.

Al-Hijr and Petra were stops along the spice and incense route to Gaza and the Mediterranean from the port of Aden (then Eudaemon) in Yemen. The southern Arabian country was the poorest in the Middle East even before the onset in 2015 of a brutal civil conflict which has since turned into a proxy war

Right: The monastery in the ancient city of Petra, Jordan.

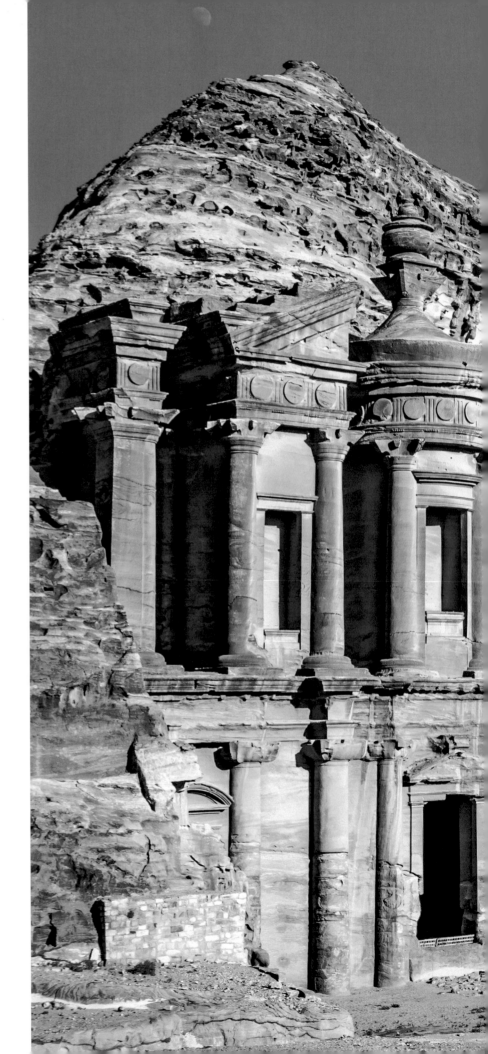

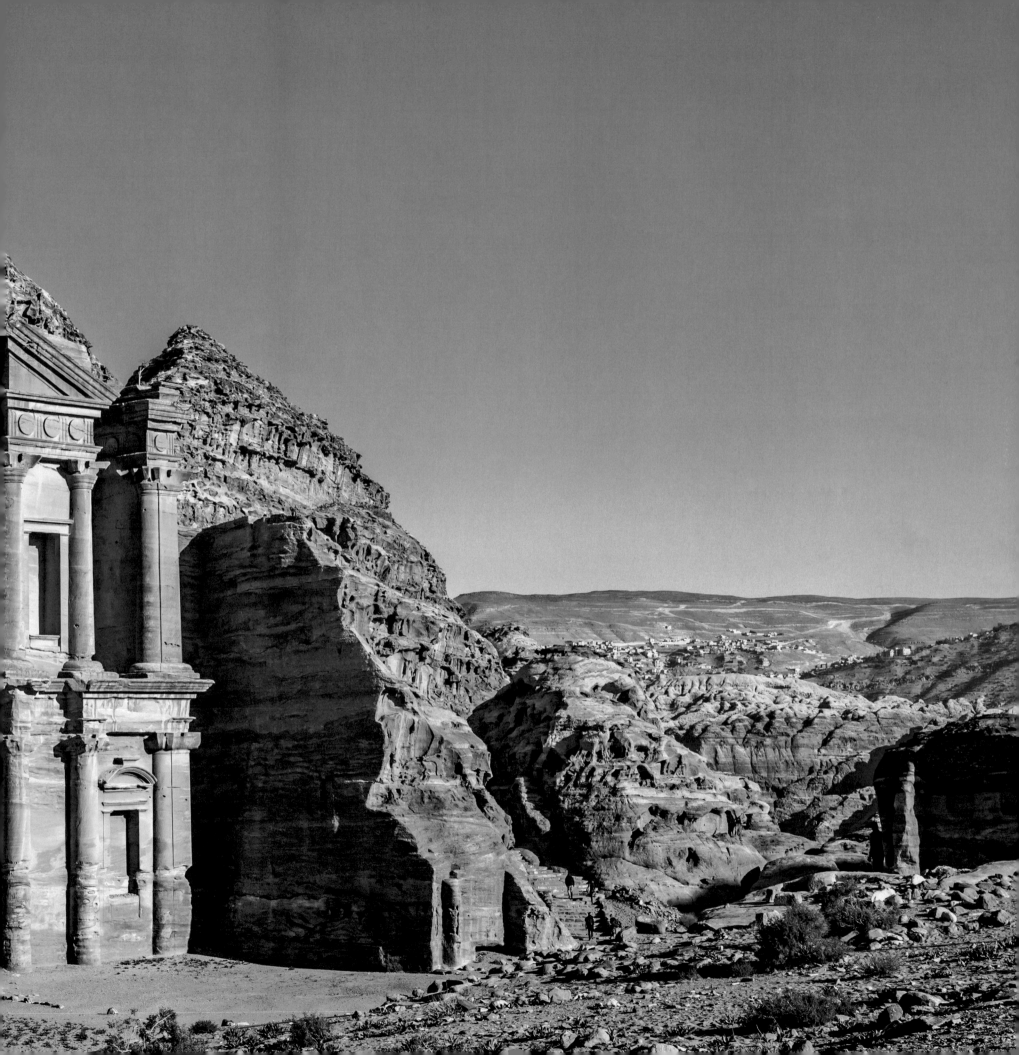

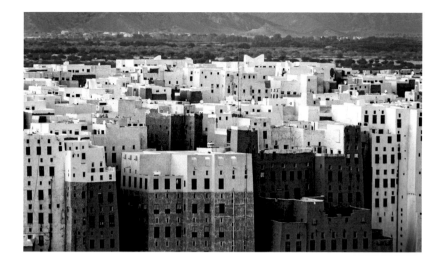

as the Saudis and the Iranians vie for power in the region. Many thousands of lives have been lost and much damage has been done to the architectural heritage of places like the capital Sana'a, a city admired around the world.

One settlement that so far does seem to have escaped the fighting is the small city of Shibam, famous for its high-rise residential buildings or tower houses dating from the sixteenth century, some up to seven storeys and 30 metres (98 feet) high. Known as the 'Manhattan of the desert', this walled city of mud-brick skyscrapers, unique in the world, is listed by UNESCO as endangered, like so many others, by the latest martial orgy of destruction.

Oasis Cities of the Silk Road

Marco Polo's *Travels* describes places along the Silk Road that still exist today and some, such as the city of Khara-Khoto or Heicheng in Inner Mongolia, which are mere atmospheric ruins. In 1271, when Polo made his great journey, after travelling through northern Afghanistan and Tajikistan he eventually arrived at the oasis city of Kashgar in western China, on the western edge of the wide Taklamakan Desert. From there the age-old route skirts the desert's southern

Left: Mada'in Saleh, Al Ula, Saudi Arabia.

Above: The ancient city of Kashgar in China is an oasis on the old silk-trading route in Xinjiang.

edge through the many oasis cities that continue to thrive there, including Yarkant, Hotan and modern Dunhuang. Known as the gateway to the Gobi Desert, Dunhuang is famous for the Mogao Caves of the Thousand Buddhas, an ancient hermit city that once rivalled that of Bamiyan, and for the Moon Crescent Spring, an oasis surrounded by the Gobi's endless singing sands.

Kashgar was where the north and south routes met and as such could be described as the heart of the old Silk Road. Today more than half a million people live there, some 80 per cent from the region's Turkic-speaking Muslim Uighurs who have flourished here for centuries, mostly in the huge Old City of densely packed houses and crowded bazaars where some hundreds of thousands lived. Then in 2009, the Chinese government decided upon a plan perversely described as 'preservation' – in reality the targeted destruction of an ethnic minority culture like that inflicted on Tibet – since when 220,000 people have seen their old homes (some 65,000 in total) demolished and replaced with modern houses, with only a small section preserved as a theme park with a $5 entry fee.

Right: Crescent Lake in Dunhuang, China.

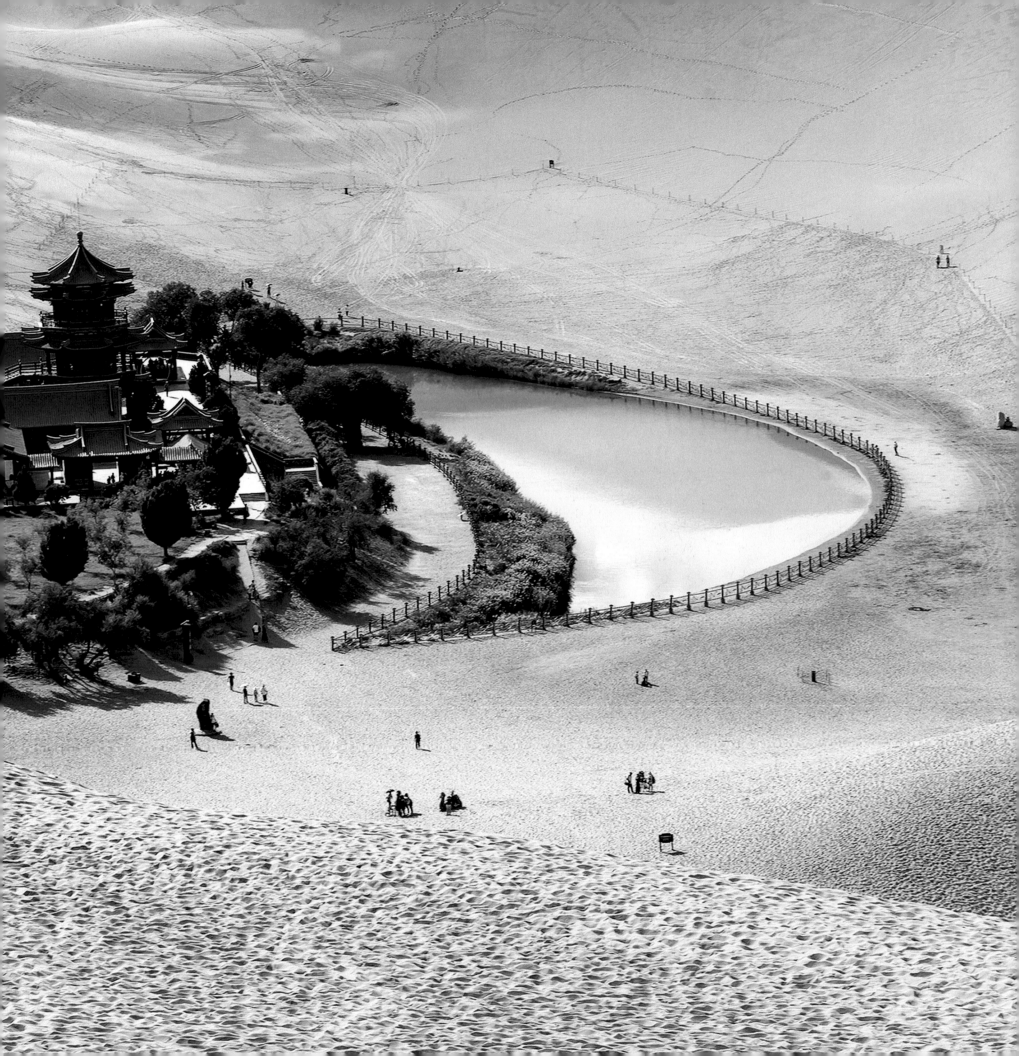

Water Worlds

Modern dependence on the internal combustion engine can make it hard to believe there are still major cities where access by water is normal but the roads don't go, or even communities built over water where they never will.

A Passage to Juneau

When gold was discovered in 1880 at a remote site in the Gastineau Channel in southern Alaska, the prospectors who founded the town of Juneau there the following year gave little thought to its connections to the outside world. The breath-taking mountains which surround this spacious coastal city had huge deposits of the most prized of all commodities, so the idea that one day they might prove a hindrance to its prospects couldn't have been further from their minds.

Juneau's early riches persuaded the 49th state to make it the new state capital in 1906. But even today it remains as cut off from the rest of the state, let alone the lower 48 or Canada to the east, as it was a century ago when the idea was first mooted of building a road into the city. Today, while Juneau has acquired an airport, the only other way into or out of this atmospheric city of 32,000 people is by boat or cruise ship via the Gulf of Alaska or along the Inside Passage, the narrow channel between the mainland and the many islands that hug the northwest coast of North America between here and Vancouver to the south.

Yet talk of a road has never completely gone away despite study after study, the last one as recently as 2014, concluding that the cost of the tunnels and

Left: Aerial view of the Gastineau Channel and Douglas Island in Juneau, Alaska.

Above: Until 1988, there was no way in to the village of Undredal, in the fjord country of Norway, other than by boat. With the introduction of a road, this previously remote settlement has become a well-known tourist haunt.

bridges needed, as well as the regular risk of rock fall and avalanche along the one feasible route, make it a luxury the state doesn't need and can't afford. For the majority of the people of Juneau, who cherish their secluded paradise, that's a prospect they'll gladly take.

Amazon River Cities

Manaus, the state capital of Amazonas in Brazil, is home to some two million people. Yet the only year-round road out of the city heads north into Venezuela, from where getting back into Brazil is a long and tortuous journey through several neighbouring countries. The only other major road heads south to Porto Velho, but is so badly maintained that in places it is hazardous to drive, even in an SUV, and impassable during the long rainy season. So all traffic into Manaus comes either by aeroplane or, as it has done since the city was founded in 1669, by boat up the longest river in the world.

Right: The river city of Manaus, Brazil.

Secret Cities: The Haunted Beauty

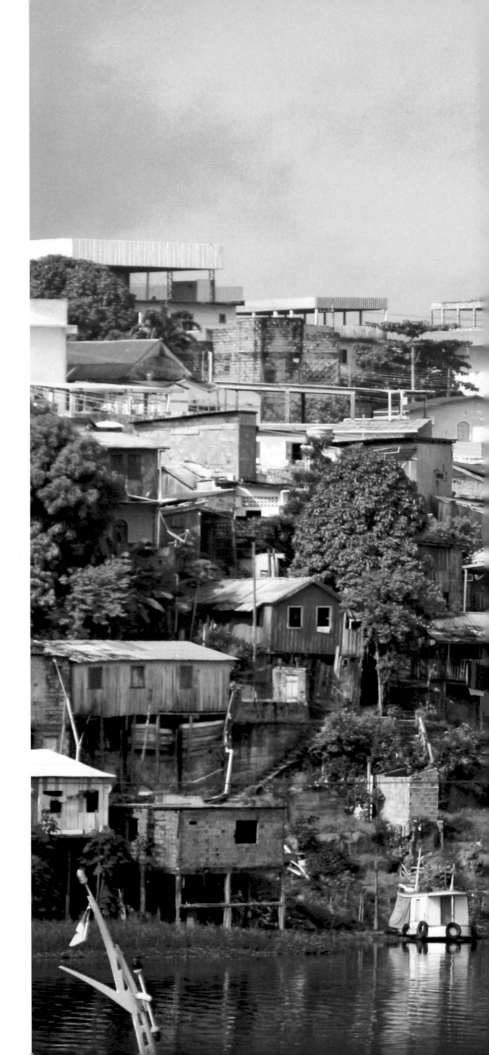

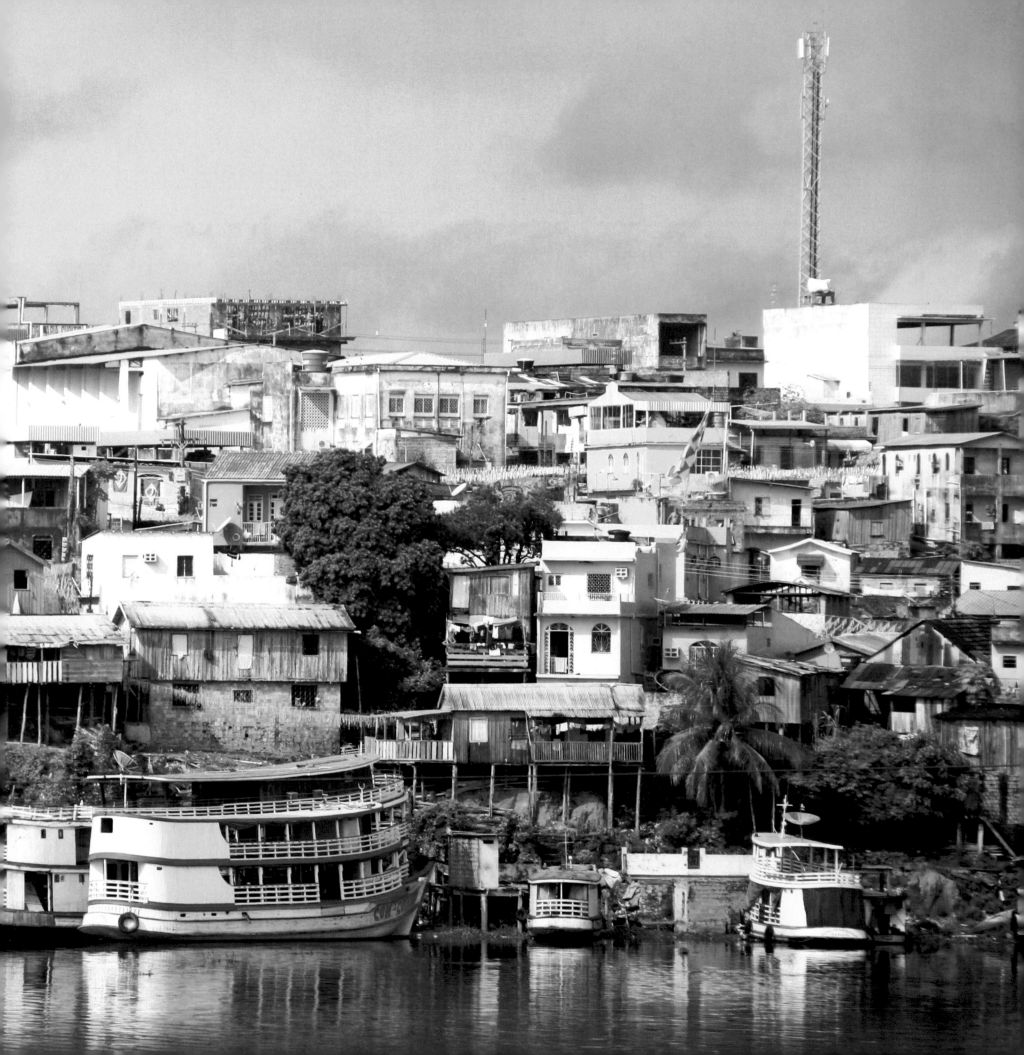

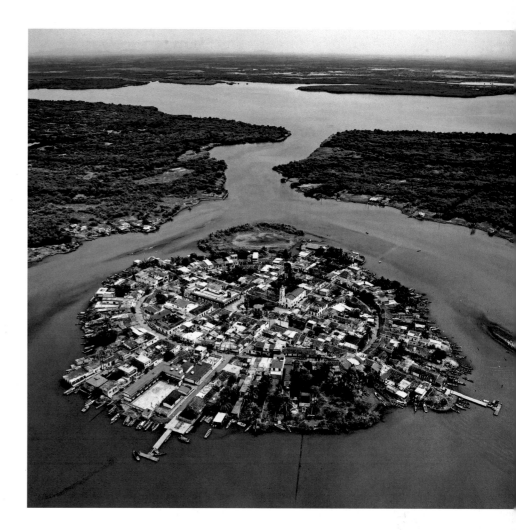

Above: Known as the 'Mexican Venice', Mexcaltitán de Uribe – or Mexcaltitán – is a village on a man-made island inhabited by some 800 people amid wetlands in the state of Nayarit on the west coast of Mexico.

Manaus grew rich during the Amazon rubber boom, a 34-year harvest of the plentiful Amazon plant, which lasted until the First World War. The same was true of Iquitos in the Peruvian Amazon, which like the Brazilian city acquired its own opera house and a range of palatial mansions, reflecting the fortunes that were made from the demand for rubber in the new age of the motor car. Founded in 1624, even earlier than Manaus, today Iquitos is a city of 470,000 people that can only be reached by boat. Described by locals as the 'Venice of Latin America', in fact it may not be cut off for much longer, as a road to the city is planned for completion in 2021. But as this is part of

Left: Houses on stilts in the slums of Iquitos, Peru, in the Amazon rainforest.

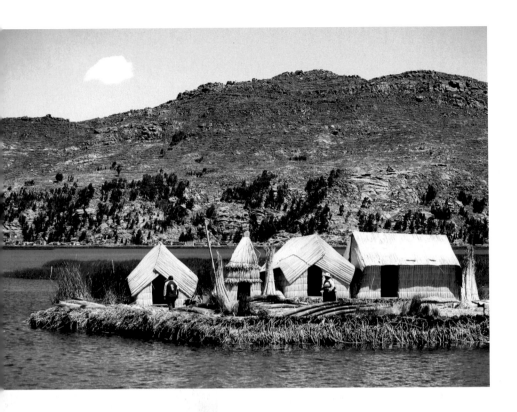

Above: The Uros people of Lake Titicaca, on the border of Bolivia and Peru, have lived for centuries on floating islands made of totora reeds harvested from the surrounding lands. The islands are replenished periodically as the reeds rot from below.

a wider programme of road-building through pristine rainforest proposed by the government of Peru, Iquitos's gain may very well be a considerable loss to the region's Indigenous peoples and to the world.

Stilt Cities

Among the architectural variety evident in Iquitos are the stilt houses lining the river in Belén, the city's poorest district. One of the oldest styles of architecture, their use dates back at least 5,000 years, as we know from the remains of piles at the sites of 111 stilt villages from the Neolithic to the Bronze Age, found in lakebeds around the European Alps. Being an obvious solution to a range of problems, dwellings of this kind can be seen today not only across the Amazon but all over the world.

Right: Fishing village of Ko Panyi in Phang Nga Bay, Thailand.

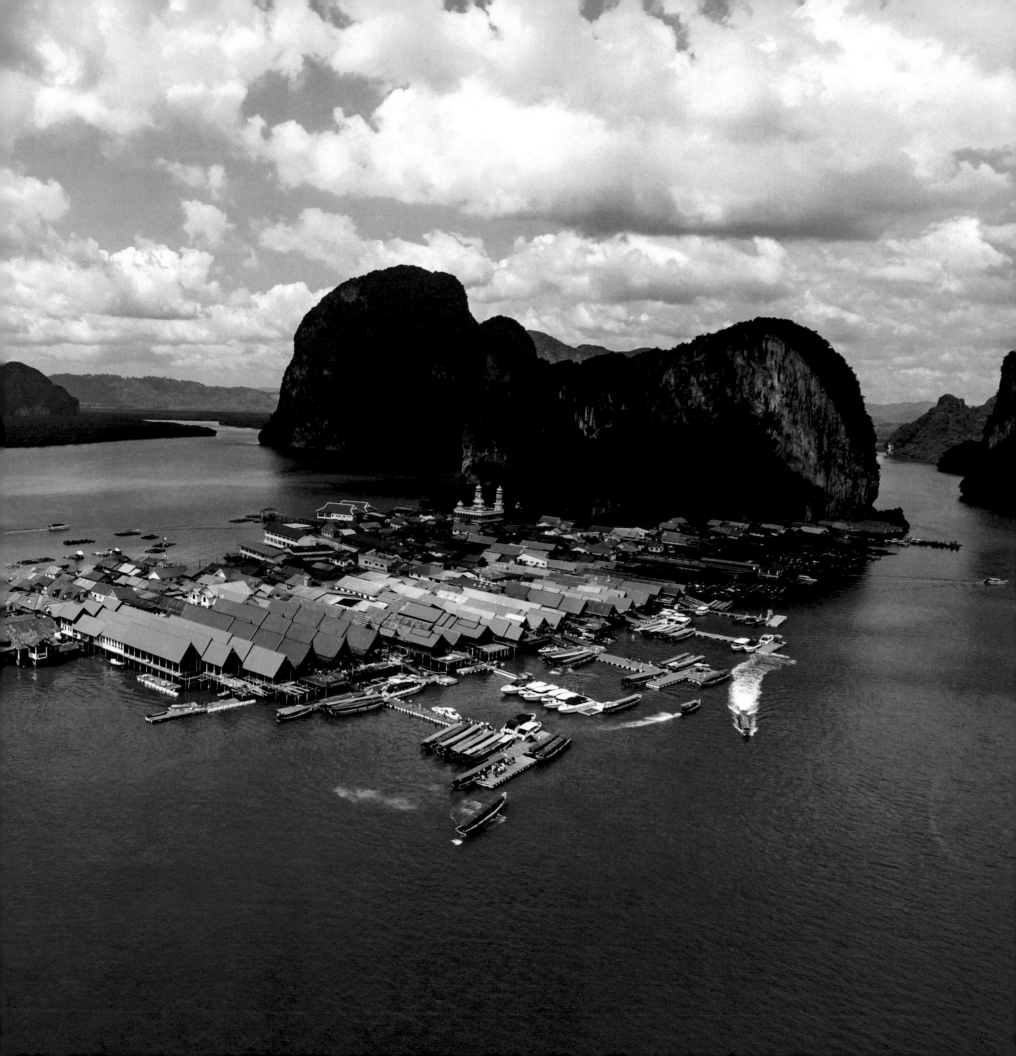

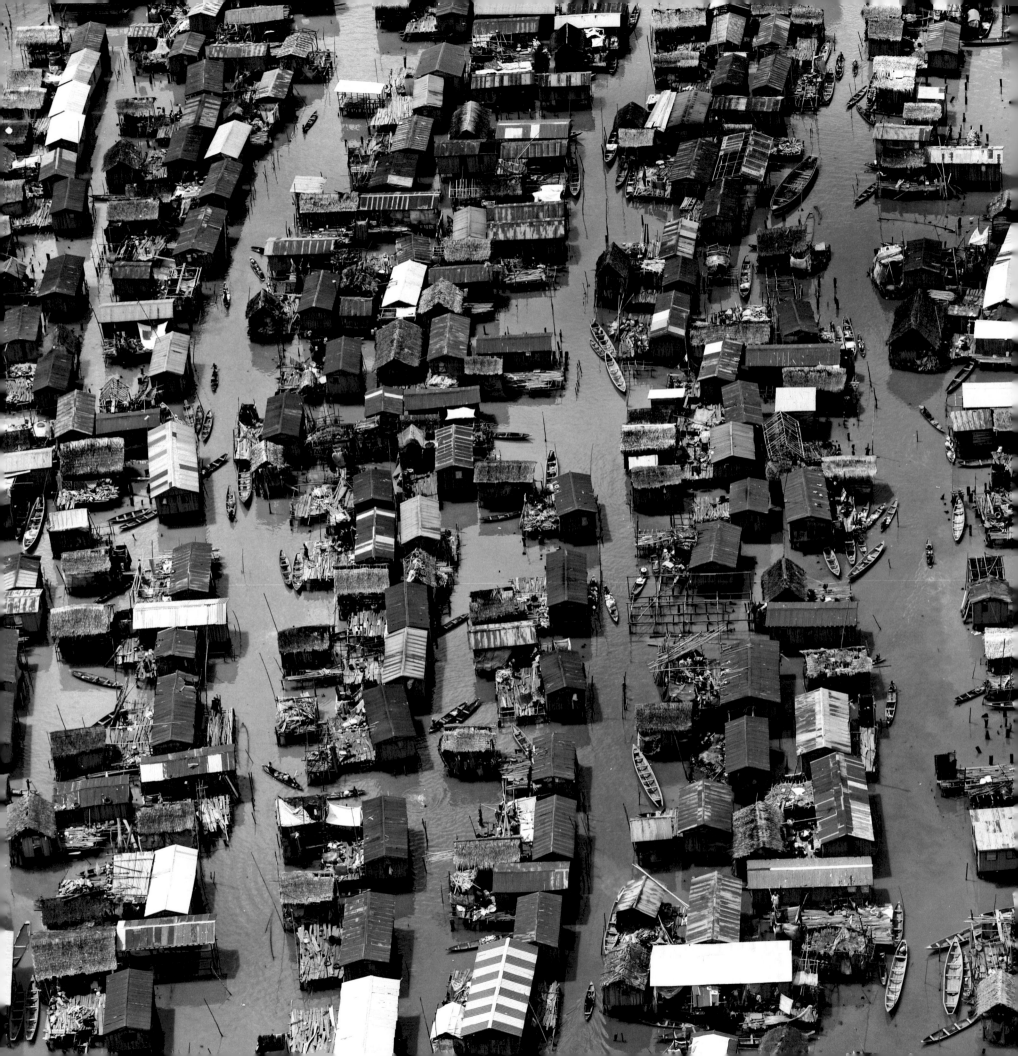

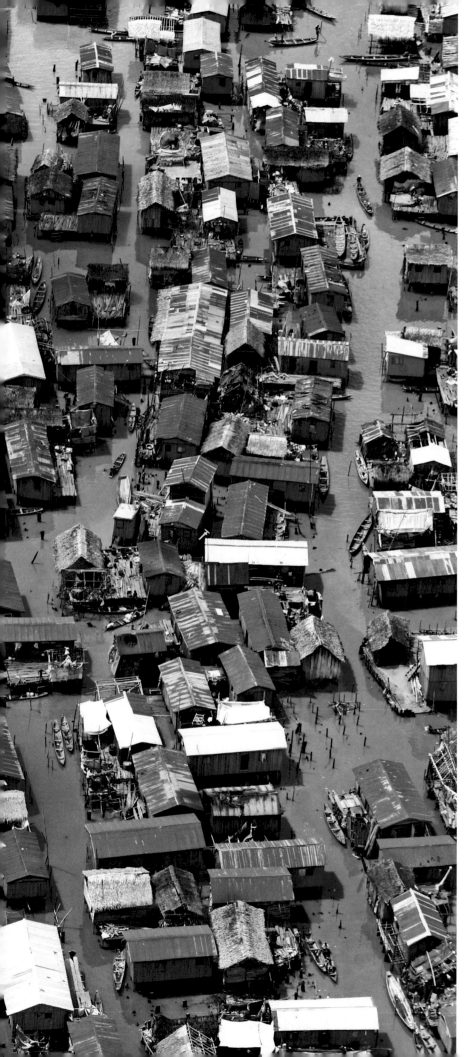

Above: Houses on the water of the Inle Lake, Myanmar.

In Southeast Asia, stilt villages and towns exist in most countries. In Thailand, the stilt village of Ko Panyi in Phang Nga Bay is inhabited by 1,700 people descended from two Muslim families in the eighteenth century – Malay fishermen who, as non-Thais, were refused the right to buy land. In Myanmar, at Inle Lake, the huge stilt village of Ywama is made up of 17 hamlets comprising 70,000 people, with floating gardens where crops like tomatoes are grown on beds of vegetation fixed to the lakebed with bamboo poles, then sold at the regular market that takes place each time at a different location on the lake.

In West Africa, the stilt village of Ganvie, a settlement of 20,000 people on Lake Nokoué in Benin, was established as long ago as the sixteenth

Left: The stilt houses of Makoko shantytown in the Lagos Lagoon, Nigeria.

century by the Tofinu people, to evade capture by warriors of the Fon who thought nothing of selling fellow Africans to the burgeoning European slave trade. But the most remarkable of all these places is Makoko, a stilt city of possibly as many as 300,000 people in the heart of Lagos, Nigeria's largest metropolis. A coastal shantytown of absolute poverty, Makoko is nonetheless described as the 'Venice of Africa'.

The Water Towns of the Golden Triangle

Makoko is not the only place to invite the comparison, as we have seen, and there are Venices of one kind or another in places all over the world. One country, China, contains not one or two but as many as a dozen 'Venices of the East', most of them in the cluster of eastern cities close to Shanghai. Two in particular, the venerable cities of Suzhou and Hangzhou, are lavished with praise by Marco Polo, with thousands of bridges at one time passing over their bustling canals. Today the many water towns of the 'golden triangle' bounded by the modern megacities of Suzhou, Hangzhou and coastal Shanghai are fragile survivals from that time, oases of the past amid the high-speed efficiency of contemporary urban China.

Among their number, Zhouzhuang, surrounded by lakes and rivers, is more than a thousand years old, while Zhujiajiao, a town of 60,000 people closer to Shanghai, dates back some 1,700 years. Here the best mode of travel is still one of the punted wooden gondolas that pass beneath the town's 36 ancient bridges. Wuzhen, which has almost as many, can trace its own history back to the eighth century. It is among the last of the many towns and cities through which the Grand Canal of China, both the longest and the oldest in the world, serenely glides on its epic passage between Beijing in the north and Hangzhou, 1,800 kilometres (1,120 miles) or so away to the south.

Right: *Zhouzhuang Old Town, near Suzhou, China.*

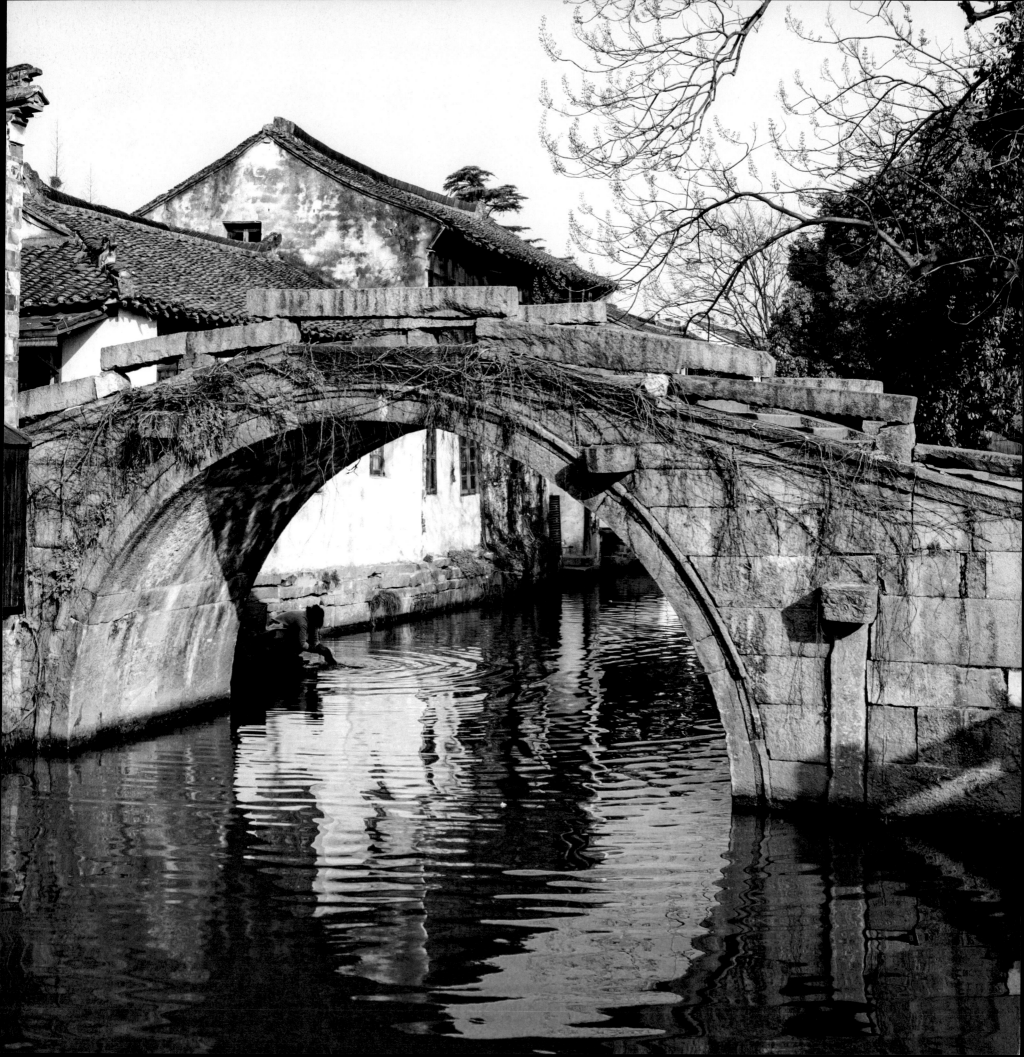

The Secrets of Venice

Across the whole of this region of eastern China, the number of canals, lakes and major rivers point to a complex, ancient, urban way of life on water with which only one other place on Earth can truly compare. But then Venice, the Adriatic city of so many secrets, is a world in itself, with both horrors and marvels concealed among the minuscule cities on some of the 118 islands in the Venetian Lagoon: on Murano, a city renowned for its glass; on Burano, famous for its lace; on Lazzaretto Vecchio and Lazzaretto Nuovo, one-time cities of lepers and the plague; on San Servolo, a former city of monks and the mentally ill; on Torcello, a city once inhabited by tens of thousands which gave up its people and buildings for the birth of Venice; and on Isola di San Michele, a city of the many Venetian dead.

Perhaps all the other Venices around the world hint at some essential secret, aside from being on water, which in the original we can almost touch – some aspect of peace or ineffable beauty which even the hordes of tourists who invade the place can never wholly dispel. For Venice has become not so much a city as a symbol, an ideal – the embodiment of a half-remembered dream. As with many places whose reality is eclipsed by their fame, we bring to it a boatload of expectations that can never be fulfilled and, more importantly, may not be what we seek.

That being the case, perhaps the real secret of any city is just this, ourselves: our hopes, our worries, our plangent longing for an awakening moment where, if we happen to pay attention, a glimpse or an encounter we weren't expecting might just show us exactly what it is we want.

Left: A covered walkway in the Church of Santa Fosca, Torcello island, Venice, Italy.

Index

The Chicago Pedway is a system of tunnels, allowing people to access stations, shops and restaurants without having to brave Chicago's bracing weather.